FRIPP
ISLAND

FRIPP ISLAND

A History

Page Putnam Miller

Published by The History Press
Charleston, SC 29403
www.historypress.net

Copyright © 2006 by Page Putnam Miller
All rights reserved

Cover Image: A portion of a painting by Nancy Ricker Rhett from her book *Beaufort and the Lowcountry* portrays her family camping in the 1950s on Fripp Island. *Courtesy of Nancy Ricker Rhett.*

First published 2006
Second printing 2007

Manufactured in the United Kingdom

ISBN 978.1.59629.169.0

Library of Congress Cataloging-in-Publication Data

Miller, Page Putnam, 1940-
 Fripp Island : a history / Page Putnam Miller.
 p. cm.
 Includes bibliographical references and index.
 ISBN-13: 978-1-59629-169-0 (alk. paper)
 ISBN-10: 1-59629-169-9 (alk. paper)
 1. Fripp Island (S.C.)--History. I. Title.
F277.B3M55 2006
975.7'99--dc22
 2006023899

Notice: The information in this book is true and complete to the best of our knowledge. It is offered without guarantee on the part of the author or The History Press. The author and The History Press disclaim all liability in connection with the use of this book.

All rights reserved. No part of this book may be reproduced or transmitted in any form whatsoever without prior written permission from the publisher except in the case of brief quotations embodied in critical articles and reviews.

*To Charlie Davis, my husband,
whose love of the sea
greatly influenced our decision
to move to Fripp Island
and whose steady support of
my work helped make this book a
reality.*

Contents

Introduction by Pat Conroy 9
Acknowledgements 11

Chapter 1. A Place for Hunting 13
Chapter 2. Prelude to Development 29
Chapter 3. Kilgore's Vision 45
Chapter 4. A Community Takes Shape 63
Chapter 5. Coming Together 89
Chapter 6. Residents at a Crossroads 113
Chapter 7. The Gay Nineties 135

Epilogue 163
Notes 171
Index 181
About the Author 189

Introduction

I have known Fripp most of my life. My novels all smell of seawater. I have written, in part, to honor a landscape I carry with me wherever I go. Though I have traveled all over the world, it is the smell of the tides and marshes of Fripp Island that identifies and shapes me. Its seeds and grasses grow along the margins of my books. Its soft mosses hang like laundry from my high-strung prose. I've made a career out of praising the Sea Islands that form the archipelago that makes Beaufort County the loveliest spot on earth to me.

The Sea Islands of South Carolina shoulder up against the Atlantic, and the trees and the vegetation on these islands are wind-shaped and salt-burnt and stunted by the great storms and swells resulting from this initial encounter with the continent. They are the first line of defense against hurricanes and those deep-throated storms out of the Northeast. There are other beaches, other oceans, but my mother Peg Conroy, who was living on Fripp until she died in 1984, staked out Fripp forever for her children. She taught us that the beach was an abundant, profligate text that never tired of serving up mysteries to explore. For the last five years of her life, my mother walked the shoreline of Fripp every day and collected basketfuls of seashells that she would place in the clear globes of lamps. Those lamps are now treasures her children keep because we love to associate our mother with the sea, the crashing of waves, the gathering up of beauty and of light itself.

Some years ago I bought my own house on Fripp where I can look out on a saltwater lagoon and watch ospreys hunt fish in my backyard, then take their catch up into the trees to eat them heads first. I have seen great blue herons kill and eat snakes and huge eels. I woke up one bright fall morning and counted three hundred egrets surrounding my lagoon in some mating ritual that looked like a dream of snow.

Introduction

Because of my deep appreciation for Fripp Island, I am grateful that Page Miller, my neighbor and great friend, has written a history of this special place that I call home.

Pat Conroy

Acknowledgements

In many ways this book has been a team effort, for I have received help, suggestions and photographs from a countless number of people. Some have provided me with exceptional assistance. George Douglass, who lived on Fripp for over thirty years and was the first president of the Fripp Island Home Owners Association, gave me his Fripp files with minutes and letters that proved invaluable. Another longtime resident, Dick Anderson, gave me his collection of early newsletters and mailings from the resort. Dixie and Bill Winter, Grace Maxwell, Gini and Griff Reese and Bill and Barbara Robinson, all of whom purchased property on Fripp in the 1960s, have most generously taken time to tell me about the early days on Fripp. Among those who moved to Fripp in the 1970s, Al and Gina Schaufelberger, Knobby Walsh and Lou Cashdollar have been extremely helpful. The staff of the Fripp Island Property Owners Association has provided important information and access to back issues of the *Trawler*. A number of Fripp's developers have granted me interviews. Charles Lesser of the South Carolina Department of Archives and History and Grace Cordial, the specialist on local resources at the Beaufort County Library, gave expert archival assistance. As I have sought to refine the manuscript, I am most grateful for the counsel of my friends Arlene Jacquette, Karen Adams and Teresa Hergert. Julie Hodgson graciously volunteered many hours to help me with the photographs. I am indebted to my husband, Charlie Davis, who has proofread many drafts and served as a valuable sounding board.

I am extremely privileged to have two people who comprehend the Lowcountry so well contribute to this book. Nancy Ricker Rhett painted the cover illustration and Pat Conroy wrote the introduction.

From my days in Mrs. Lupold's history class at Dreher High School in Columbia, many teachers have contributed to my study of history and its role in helping us understand our communities, nation and world. Numerous individuals have

Acknowledgements

encouraged me in this undertaking. On one of my first visits to Fripp, I asked Dora Edwards, who then had a gift shop on the island, if there was a history of Fripp. She told me that there were no books on Fripp and suggested that I write one. My hope is that this book will aid visitors and residents of Fripp to better understand and appreciate this special island.

Chapter 1
A Place for Hunting

A small jewel of sheer beauty along the Carolina coast, Fripp Island has been shaped by the ebb and flow of tides, the fortunes and difficulties of developers and fluctuations in the residential community. With a three-and-a-half-mile beach and narrow landmasses interspersed with marsh, the island claims only two square miles above sea level. For much of its history it has stood in the shadow of its larger neighbors, St. Helena and Hilton Head Islands. Fripp's remote location has discouraged commercialization and favored a family-oriented resort. The many children who have traveled to Fripp on vacations have prevented it from becoming solely a retirement community. Lush tropical vegetation, powdery white sand of the ever-changing dunes, an expansive beach and the abundance of wildlife have for many years drawn people to this exceptional place.

In a part of the South Carolina Lowcountry where hundreds of islands form a jigsaw puzzle divided by rivers, marshes and tidal creeks, Fripp is one of the barrier islands that serves as a buffer between the ocean and those islands closer to the mainland. Unlike islands that have the same bedrock as the mainland, barrier islands are formed from sand dunes that expand toward the ocean. The buildup of river sediments flowing to the sea creates small landmasses that become barrier islands. These islands lack geological stability and are active formations, experiencing constant sand migration as wind and tides transform their shores.

Fripp Island encompasses the unique characteristics of Lowcountry barrier islands. Creeks and tidal marshes lie on the backside of the island. Ridges of tall pines, live oaks, palmettos and wax myrtles grow along the core of these islands, and a series of dunes protects the main landmass of the island from the ocean. Fripp lies on an approximately thirty-degree diagonal that extends from the southwest, usually called south, to the northeast, known as north. The Fripp Inlet with Hunting Island less than one-third of a mile away borders the northeastern

Fripp Island

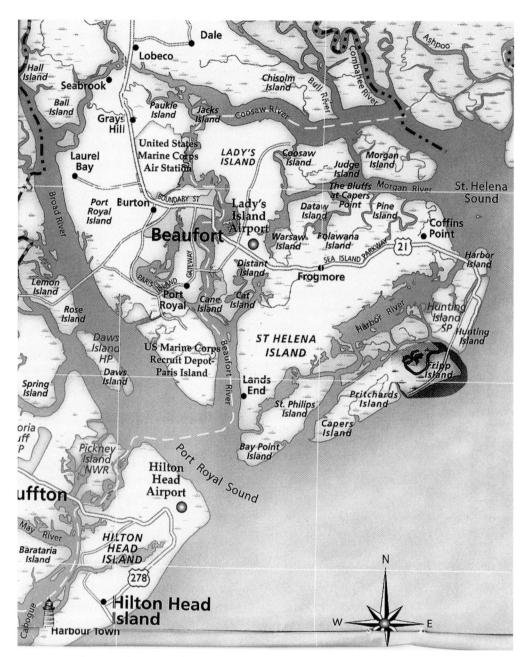

A 2004 map showing a large part of Beaufort County highlights Fripp Island's location on the Atlantic Ocean twenty-one miles from Beaufort, South Carolina. Fripp is sixty-five miles from Savannah, Georgia, and ninety-six miles from Charleston, South Carolina. *Courtesy of LowcoutryHomeReview.com.*

end. The southwestern tip is adjacent to Skull Inlet with Pritchards Island a stone's throw at low tide.

In the early eighteenth century English settlers moved into what is now Beaufort County. St. Helena Island, a large forty-five-square-mile island between Fripp Island and the town of Beaufort, cast the primary shadow over Fripp. Although the owners of St. Helena cotton plantations considered Fripp Island too small for habitation or for cultivating crops, they did use it as a hunting outpost.[1]

By the mid-twentieth century, the dominant influence over Fripp shifted to Hilton Head Island. One of the largest barrier islands along the southern coast with forty-six square miles of land, Hilton Head was becoming South Carolina's premier resort island. By the 1970s it boasted numerous hotels, golf courses, racquet clubs, marinas and hundreds of restaurants and shops. In contrast, Fripp Island's small size has limited its potential as a tourist resort and has fostered a residential community that is committed to preserving the natural environment of wildlife, sand dunes, winding creeks, marshlands and tropical vegetation.

Early History

While relatively little is known about the early history of Fripp Island, a rich oral tradition and some documents shed light on the distant past. The first visitors to Fripp Island were Native Americans. They lived in loosely organized tribes, whose names—Edisto, Ashepoo, Combahee, Wando and Yemassee—mark the Lowcountry. They migrated with the seasons in dugout canoes to search for food, relying heavily on seafood, particularly shellfish. Archaeologists digging along the South Carolina coast have identified pieces of pottery and arrowheads as well as burial mounds and large rings of oyster shells that date from 2000 BC. While no officially designated archaeological sites related to Native Americans have been discovered on Fripp, some residents have found arrowheads and pottery.[2]

Spaniards, the first Europeans to have recorded contact with the South Carolina Lowcountry, began visiting the area in 1521. A Spanish explorer gave the area the name of Santa Elena, later anglicized to St. Helena. The Spanish chose this name because they went ashore on May 22, 1525, the day on which the Catholic Church remembers the life of a young martyr named Santa Elena. A few decades later, in 1562, Captain Jean Ribaut of France came to the area.[3]

It was almost one hundred years after the Spanish arrived that Charles II of England granted a charter to eight Englishmen, called Lords Proprietors, for the establishment of a colony to be named Carolina. In 1670 a group of colonists founded Charles Towne, which by 1700 had become a trading center, a small Southern outpost that was growing but not yet in a position to rival the older, more established port of Boston. Yet with its bustling harbor, Charles Towne attracted increasing numbers of Englishmen who chose South Carolina as the place to build

their future. Because of the difficulty of travel to attend governmental meetings, the Lords Proprietors divided the colony in 1710 to create North and South Carolina.

The Fripp Family

Among those who ventured to the new Carolina colony was John Fripp. Born in Wales in the 1670s, he immigrated to Edisto Island, about forty miles south of Charles Towne, in 1690. He married Sarah Frampton, probably the daughter of Richard Frampton of Edisto Island, and had one son, John Fripp Jr. The senior Fripp became involved in local politics and in 1702 served as high sheriff of Colleton County, a position that made him the county's chief judicial officer.[4]

The oldest existing documents to mention John Fripp and "ffrips Island" are in the Carolina colony's records of stock marks, or cattle marks. Livestock in the new colony was increasing. Since the animals roamed freely, in 1694 the colony passed a records act that established a system of identifying and marking ownership by particular brands or slits on the animals' ears. A February 5, 1695 stock mark record states that "This Day cam Richard Benett of ffrips Island and recorded his marke for Cattle and Hoggs." And a May 12, 1699 entry notes that "This Day Came John ffripp and recorded his Marke for Cattle & Hoggs." Since land grant records establish that both Richard Benett and John Fripp lived at this time on Edisto Island, it can only be assumed that this "ffrips Island" was one of the many islands bordering Edisto Island and was part of John Fripp's holdings. A well-established custom in the Lowcountry gave islands the names of their owners. Because individuals moved and acquired new lands and islands, this method of identifying islands was confusing. However, the "ffrips Island" of cattle mark records was not the island we know today as Fripp Island.[5]

In 1711 the Lords Proprietors ordered the establishment of Beaufort Town and a seaport on Port Royal Island. This provided increased stimulation for new settlements on adjacent Lady's and St. Helena Islands. John Fripp had by this time increased his political influence and was able to secure passage in the South Carolina Colonial Assembly on June 12, 1714, of an act that authorized the building of a road from Edisto Island to the Beaufort area.[6]

The groundwork had thus been laid for the Fripp family to move southward. The first settlers to St. Helena arrived around 1700. In 1724 John Fripp purchased from John Cowan a 480-acre tract of land on St. Helena Island. This land, part of Cowan's land grant from the Proprietors, is near what is today called Fripp's Point, on the east side of St. Helena and a little northwest of Coffin Point. In 1734 John Fripp purchased another parcel of land on St. Helena Island. The plat for this acquisition included a nearby island, designated as John Fripp's Island, but that may well have been what we know today as Hunting Island. Most colonial maps of the Beaufort area labeled all of the barrier islands together and simply called them the

"Hunting Islands." Yet early maps do clearly mark the water between Hunting and Fripp Islands as Fripp's Inlet.[7]

Sarah Harriet Reynolds Prentiss Fripp

The owner of Fripp Island in the late eighteenth century, however, was not a Fripp, but William Reynolds, whose daughter subsequently married a Fripp. Relatively little is known about Reynolds. He was born on St. Helena Island about 1750, fought in the Revolutionary War and owned a plantation as well as a nearby island known then as Reynolds Island. William Reynolds married Anne Capers and they had two children, a son who died at age five and a daughter, Sarah Harriet. When William Reynolds died in 1798, Sarah Harriet inherited his entire estate, including Reynolds Island.[8]

During the entire nineteenth century the ownership of what we now know as Fripp Island remained in the hands of Sarah Harriet Reynolds Prentiss Fripp or one of her immediate family. When she was seventeen years old, Sarah Harriet married Jeffrey Otis Prentiss, the owner of a nearby plantation and the overseer of the Reynolds's plantation. The following year Prentiss successfully petitioned the court to release his wife's entire inheritance to him. The name of Reynolds Island then changed to Prentiss Island. However, four years later Prentiss died, leaving Sarah Harriet a widow at age twenty-one with four small children and ownership of the island once again. Two years later in 1820 she married William Fripp, a fourth generation descendant of John Fripp. Ownership of the island passed to her second husband, and Prentiss Island became Fripp's Island.[9]

Born in 1788, William, known as "Good Billy," was an ardent Baptist, widely respected as a generous and honorable man. He and Sarah Harriet had six children and by 1830 had acquired sufficient wealth to build a handsome home called "Tidewater" in Beaufort. The family lived on one of their St. Helena Island plantations from October to April and then in the warmer months moved to their Beaufort townhome. Among the wealthiest of the Carolina seacoast aristocrats, "Good Billy" traveled extensively, including trips to Europe. The 1857 U.S. Coastal Survey of the St. Helena Sound designated the island between Fripp's Inlet and Skull Inlet as Fripp's Island. This association with Fripp has stuck.[10]

There is a persistent legend that offers a more colorful account of the naming of Fripp Island than the one found in existing historical documents. This legend tells the story of privateer Captain John Fripp, who defended the new English settlement and used the island as a base for his attacks on Spanish and French ships. In return for Fripp's service to the mother country, King Charles II of England granted him land that included Fripp Island. There are, however, several problems with this account. Charles II's reign ended in 1685, almost twenty-five years before the settlement of Beaufort. Furthermore, the first royal land grants in South Carolina

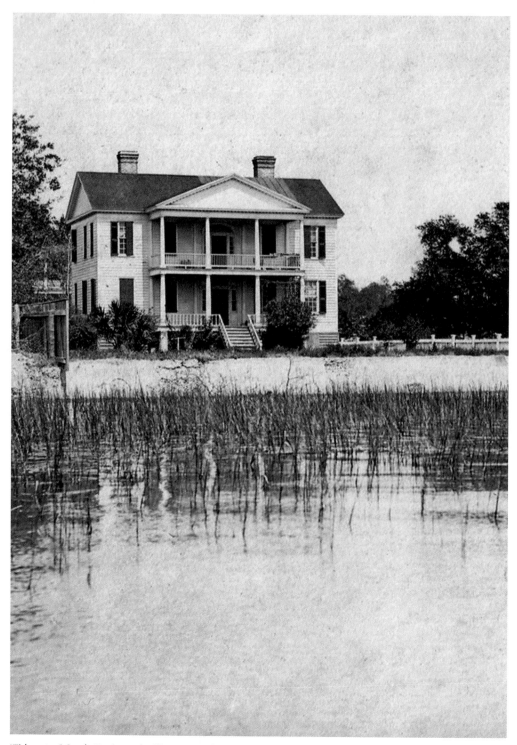

"Tidewater," Sarah Harriet and William Fripp's home from 1830 to 1861, is located in a neighborhood called "The Point," part of Beaufort's National Historic Landmark District. It has a two-story portico that faces the Beaufort River. *Courtesy of Historic Beaufort Foundation.*

A Place for Hunting

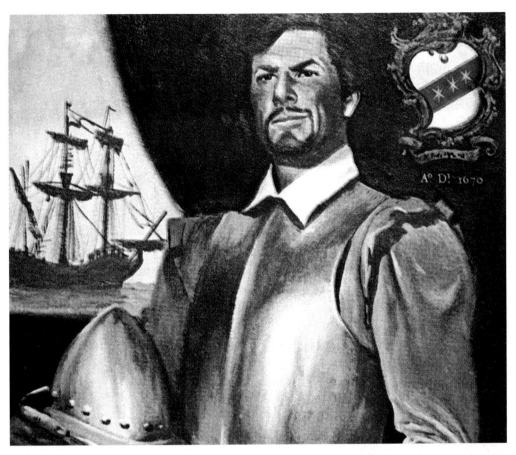

A fanciful portrait that appeared in the early resort brochures of the alleged swashbuckling John Fripp whose hearty band of privateers operated from Fripp Island. *Courtesy of Jack Kilgore.*

The Fripp Island Resort's letterhead during the 1960s featured as its logo a silhouette of the legendary privateer Captain John Fripp drawing his sword. *Courtesy of Jack Kilgore.*

19

occurred after Charles II's death. Although no documentation for a land grant to Captain John Fripp has been found, Fripp descendants continue to recount the story and the early developers of Fripp Island Resort used a silhouette of dashing John Fripp the privateer as a resort logo.[11]

Legends of Pirates and a Count

The rich lore about pirates on Fripp Island, however, does not end with privateer John Fripp. There are also stories about Blackbeard, the pirate known by a number of names including Edward Teach and Edward Thatch. Blackbeard operated from the Bahamas and the Carolinas and terrorized English and American ships from Maryland to South Carolina for several years prior to his death in 1718. As Charles Town and Beaufort were establishing an English foothold along the southern Atlantic coast in the early eighteenth century, pirates posed a major threat to Carolina's burgeoning trade routes. The barrier islands of South Carolina provided excellent hiding and staging places for pirates. There is historical documentation that both Blackbeard and Stede Bonnet, another well-known pirate, entered the Charles Town harbor in June of 1718 and seized eight or nine ships as well as a number of prominent Charlestonians, whom they eventually released in exchange for medicine.[12]

There is only speculation that Blackbeard sought shelter on Fripp Island. However, the legends of Blackbeard and Fripp Island are treasured lore. The oral tradition of Blackbeard's plundering of ships in the Charles Town harbor includes the tale that while marching through the town to obtain medical supplies, he passed the house of a lovely and high-spirited young woman who waved gaily to him. After exchanging the prisoners for the medical supplies, Blackbeard circled back by the door of the young lady who had waved. He swooped up the maiden and carried her fighting and screaming to his ship. Despite her pleadings, he married her during a stopover in North Carolina and then sailed to Fripp Island, where he had buried much of his treasure. He left his new wife and valued treasure on Fripp under heavy guard and returned to the sea to resume his piracy. But as the romantic tale has it, affection grew between Blackbeard and his lovely captured wife, and they sailed together to the West Indies, where they subsequently lived. Since a military expedition sent out by Governor Spotswood of Virginia captured and killed Blackbeard about five months after his adventures in Charles Town, there is little chance that the story is true.[13]

Another more gruesome tale of Blackbeard's adventures on Fripp Island centers on the hand of a young woman's sweetheart. In this legend, Blackbeard also kidnapped a young woman from Charles Town. Furious that she was grieving for the young privateer whom she loved, Blackbeard captured her sweetheart's ship, cut off his left hand—on which he wore a ring the young woman had given him—and threw

A Place for Hunting

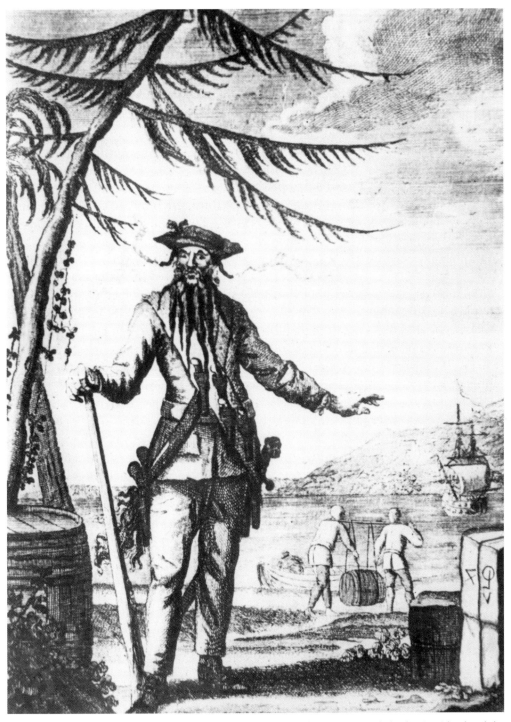

Blackbeard, one of the most notorious pirates of the eighteenth century, used the barrier islands of the Lowcountry to lay in wait as he prepared to attack poorly armed merchant ships and seize their cargos. This eighteenth-century illustration corresponds closely to a written account of his appearance. *Courtesy of the North Carolina Office of Archives and History.*

him overboard to drown. Returning to Fripp Island, where he had left the young woman captive, Blackbeard placed the young man's hand in a satin-lined jeweled box and presented it to the young woman. On seeing her love's disembodied hand, she shrieked and ran into the ocean where she also drowned. The legend concludes that sometimes on moonlit nights with incoming tides, there is a shimmering light on what appears to be a man and a woman walking out of the ocean. The woman is holding the handless arm of her love to her heart.[14]

A later legend about Fripp Island that has gained credence over the years is about the Revolutionary War hero Count Casimir Pulaski. Like Lafayette from France, Pulaski of Poland descended from nobility. After fighting to free Poland, Pulaski arrived in America in 1777 with a letter of introduction to George Washington from Benjamin Franklin, whom he had met in Paris. After serving under General "Mad" Anthony Wayne, he organized his own cavalry unit, the Pulaski Legion, and fought in many battles against the British. He was mortally wounded in 1779 in the siege of Savannah.[15]

While there is agreement about Pulaski's involvement in this battle, there is strong disagreement about what happened to his body. One account holds that he died and was buried at Greenwich Plantation, a few miles from Savannah. Another very different account of Pulaski's death and burial asserts that after being wounded, he was taken on board the American ship the *Wasp*. When Pulaski's wound became inflamed with gangrene, his leg was amputated and he subsequently died. Charles Litomisky, a fellow soldier from Poland, claimed that he helped to bury Pulaski's body under a large tree about fifty miles from Savannah, upon the bank of a creek leading from Savannah to Charleston. Additional evidence appeared in 1962 when workmen with bulldozers on Fripp Island working near Old House Creek uncovered a human skull and a pile of bones with only one leg. The developers of the Fripp Resort called the Beaufort County sheriff's office, which issued a report stating that the bones were over one hundred years old and not of interest to them. Further research of the bones provided no conclusive evidence for linking them to Pulaski. Yet the account of Charles Litomisky combined with the discovery of the bones on Fripp Island have added tantalizing fuel to the suggestion that this story is believable.[16]

St. Helena Island Planters

The best-documented history of Fripp Island is that of a hunting and fishing outpost for the planters who lived on St. Helena Island. Not as dazzling as the legends of pirates and counts, the planters' references to the barrier islands do have a richness of their own. In the decades prior to the Civil War, the white community on St. Helena numbered about 350 and the number of slaves was approximately 2,000. While sea-island cotton, a very fine strain of cotton that required special care in growing, was the principal crop on St. Helena, most planters also grew several crops of sweet

potatoes and corn each year. There were no farms on St. Helena cultivated by free labor. All but a very few of the plantations had their own wharves and boats for shipping goods to market, fishing and providing transportation to Beaufort and other nearby destinations. The uninhabited islands were excellent hunting grounds.[17]

It was not cotton or food crops but trees that enhanced the value of the barrier islands. The demand for durable seaworthy vessels heightened the worth of the barrier islands' live oaks, known for their great strength and unusual density. Wood from the graceful live oaks became the preferred lumber for building the beams and ribs, the parts of the ship's hull that experience the greatest stress. *Old Ironsides*, a frigate built for the U.S. Navy in 1797, achieved a reputation of invulnerability to cannonballs because of the strength of its live oak timber hull. There is documentation that Ebenezer Coffin of St. Helena Island had a contract around 1816 with a New York shipbuilding firm to cut live oak timber. Some harvesting of these live oaks possibly occurred on Fripp.[18]

One of the best accounts from the 1840s of the ordinary lives of St. Helena planters and their visits to the Hunting Islands comes from the personal diary of Thomas B. Chaplin, written between 1845 and 1858 when he was living at Tombee, his plantation home that derived its name from his first name and his middle initial. From the 1720s when the Chaplin family first settled on St. Helena, three major families—the Chaplins, the Jenkinses and the Fripps—formed the major white kin groups. Their extended families frequently intermarried, beginning with Thomas Chaplin's grandfather's marriage to John Fripp's daughter, Elizabeth.[19]

In 1984 Theodore Rosengarten published a biography and journal of Thomas Chaplin in the award-winning book *Tombee: Portrait of a Cotton Planter*. Chaplin's journal details his experiences on the Hunting Islands, and Rosengarten's biography emphasizes how significant these activities were in the lives of the planters. Hunting was not only a major sport but also the source of much coveted food, particularly venison in winter. Since there was little game remaining on St. Helena Island in the 1840s, Chaplin made frequent hunting or fishing trips to the barrier islands. The most coveted animal on the hunting expeditions was deer; however, the planters also shot duck, plover and boar.[20]

Chaplin never hunted alone. Sometimes he went with a group of other planters, often his cousins, including the brothers William "Good Billy" Fripp and Captain John Fripp. A number of slaves would accompany them to row the boats, carry the gear, set up the tents, care for the dogs, chase the deer toward a narrow passage and clean the deer that had been killed. Chaplin experienced some disappointment because his only son did not take to deer hunting. Thus he often went hunting with Ben, his favorite and trusted slave, who he allowed to use a gun. Ben proved a very skilled and able companion. On February 26, 1845, when Ben killed his first deer, Chaplin practiced the ancient ritual of initiating novices into the community of hunters by smearing on his body blood from the animal. Chaplin wrote in his journal, "Ben killed a very fine fat doe. Though he always gets a shot, this is the first deer he has ever killed. I had him well debaubed with blood for his luck."[21]

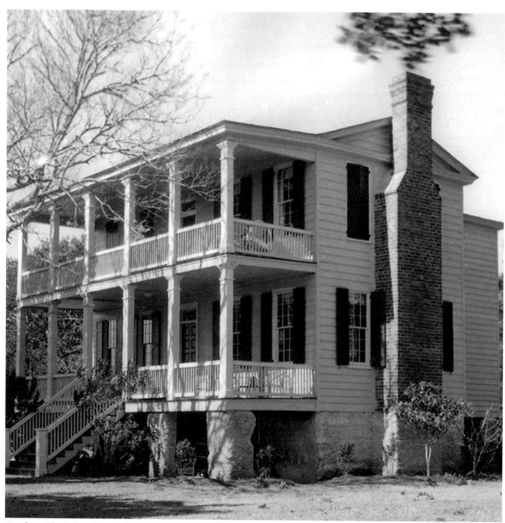

Tombee Plantation, located on St. Helena Island, was Thomas B. Chaplin's family home. When Chaplin fled St. Helena in November 1861 after the Confederate forces were defeated at Port Royal, one of the few items he took with him was his journal. In 1975 Tombee was listed on the National Register of Historic Places. *Courtesy of the South Carolina Department of Archives and History.*

Fishing stories compose an almost equal number of passages in Chaplin's journal. In the summer, Chaplin fished for sheepshead and in the fall for bass while carefully recording in his journal the number of his catch. Oysters and clams were easy to rake in the mud flats of the marsh, but Chaplin did not like getting in the mud and assigned that task to his slaves. Even though Chaplin was well acquainted with the waters around St. Helena, he—like everyone else before or after him—occasionally went aground. He wrote in his journal on September 30, 1845: "Intended going home very early this morning, but the boat got aground and we could not get her off before flood tide. Did not get to the plantation until after sunset."[22]

Chaplin's accounts make clear that hunting on the barrier islands and fishing in the waters surrounding them were some of the most delightful aspects of his life as a St. Helena planter. His brief entry of December 26, 1849, captures the special role that the Hunting Islands played for him: "Went to Skull Inlet with E. Capers, Frank, Gabriel and Dr. Kirk. Caught a good chance of fish. Killed one deer, and spent a very pleasant time." St. Helena was Chaplin's home. It was where he oversaw the planting of a wide variety of crops, raised numerous animals, supervised slaves, maintained his buildings and boats and cared for his family. Although he had been born of privilege, he squandered much of his wealth in poor business decisions and overindulgence and was often in serious debt and despair. For him, the Hunting Islands offered a retreat, a place to relax and seek refuge from daily demands.[23]

The Civil War

Life on St. Helena changed dramatically on November 7, 1861, called by African Americans living in the area at the time "the day of the gun-shoot at Bay Point." On that day, during the Battle of Port Royal, which took place near the southwest end of St. Helena, the Union navy captured the Confederate forts that protected the entrance to the port of Beaufort. Confusion reigned in Beaufort and on St. Helena as plantation owners hastily made plans to evacuate. Captain John Fripp, the brother of "Good Billy," who was not only one of the richest landowners but also a Union sympathizer, gathered his slaves for some parting advice. According to noted historian Willie Lee Rose, he told them to forget about growing cotton and to grow crops they could eat, for otherwise they may starve. Over one hundred years later, the resort developers on Fripp would name the ocean condominiums Captain John Fripp Villas, a name they undoubtedly associated with the legend of the eighteenth-century privateer and not the nineteenth-century planter.[24]

Although the slaves on St. Helena Island were not officially freed until January 1, 1863, when Lincoln issued the Emancipation Proclamation, the Battle of Port Royal in effect liberated them. Within a few years, many of them became owners of small plots of land. During the Union occupation of Beaufort in 1863, the U.S. Tax Commission sold abandoned lands and houses in much of the Beaufort area for

Fripp Island

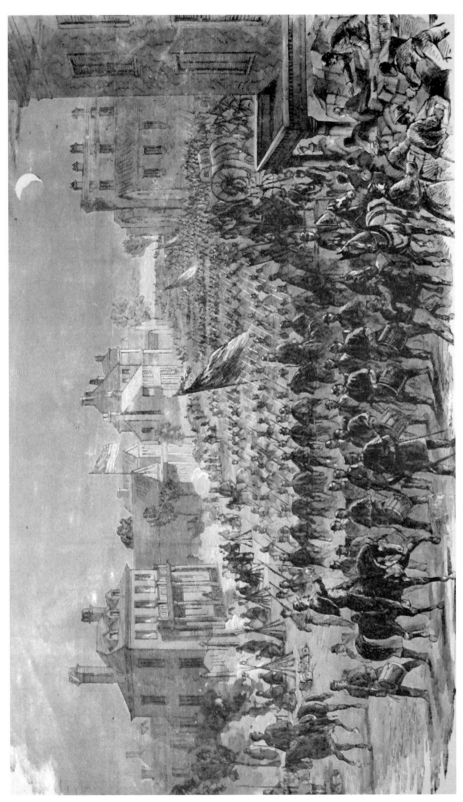

This nineteenth-century engraving from an 1861 *Frank Leslie's Illustrated Newspaper* depicts General Stevens's brigade marching down Bay Street and taking possession of Beaufort, South Carolina, on the evening of December 5, 1861. Unlike Charleston, which fell to the Union army at the very end of the Civil War, Beaufort and the surrounding area were captured early in the war. *Courtesy of author.*

failure of the owners to pay property taxes. The Federal government bought some of the land and divided it into small farms for the former slaves.

At this time Juliana Mathilda Prioleau, the daughter of Sarah Harriet Reynolds and William "Good Billy" Fripp, owned Fripp Island, which the U.S. Tax Commission valued at $200 in 1863. Because Fripp Island was primarily a jungle and not considered desirable for agricultural purposes, no one had paid the back taxes to acquire it. Following the Civil War, Prioleau was able to pay the taxes of $6.67 to retain her ownership. She continued to hold title to Fripp Island for the remainder of the nineteenth century.[25]

Very few planters returned to St. Helena following the Civil War. Former slaves were now the farmers of St. Helena Island. They survived by growing vegetables, particularly sweet potatoes and corn. Additionally they raised chickens and a few hogs and cows. Like the planters before them, they supplemented their diet with fish and game. During the latter part of the nineteenth century, the residents of St. Helena continued to frequent the Hunting Islands, seeking food and the enjoyment of the sport of hunting and fishing. Fripp Island, along with the other Hunting Islands, remained in the shadow of St. Helena and was a place to visit but not to live.[26]

Chapter 2
Prelude to Development

The ownership of Fripp changed hands four times in the first six decades of the twentieth century, yet the island remained a distant outpost with limited human activity. There were occasional hunting, fishing or camping parties and two brief periods of lumber harvesting. The lack of bridges connecting the island to Beaufort required a time-consuming journey by boat and ensured Fripp Island's striking natural appearance due to its isolation. The only time people came for a lengthy stay was during World War II, when a coast guard unit occupied the island for almost two years.

Purchase and Sale of Fripp Island: 1903–1954

1903	James McLoughlin buys for $2,000 from Fripp heirs
1933	William Dorman buys for $4,500
1937	McLeod Lumber Company buys for $15,000
1954	16 Beaufortonians buy for $40,000

Hunting Preserve

In 1903 Eula Prioleau, the widow of William "Good Billy" Fripp and Sarah Harriet Reynolds's grandson, sold Fripp Island for $2,000 to James G. McLoughlin of New York for a hunting preserve. A wealthy New York publisher, James was a part owner in McLoughlin Brothers, a family publishing firm that specialized in children's and religious books. McLoughlin lived on 13 East Sixty-fifth Street, a fashionable area in close proximity to Rockefeller's home.[27]

One can only speculate how James McLoughlin happened to buy Fripp. During the late nineteenth and early twentieth centuries, there was considerable interest among wealthy Northerners in acquiring hunting preserves in the South. National prosperity and the expanding railroad had made it possible for the Rockefeller, Carnegie, Macy, Pulitzer and Morgan families to build extravagant houses on secluded barrier islands near their scenic hunting grounds. One of the most noted private preserves was the Jekyll Island Club established in 1888 off the coast of Georgia.

Only a few months after purchasing Fripp Island, McLoughlin made a hunting expedition to his newly acquired preserve. In early December 1903, his handsome steam yacht, the *Trionyx*, arrived at Beaufort's dock having sailed from New York. The *Beaufort Gazette* reported that the large yacht had only its crew aboard and that her owner "is expected here in the near future with a party to enjoy hunting on his preserves, which are located on Fripp and Story Islands." McLoughlin's hunting party included friends from New York and his two sons as well as a local guide, John N. Wallace, who was one of Beaufort's most experienced sportsmen. Accompanying the party was a pack of local hunting dogs. During the stay in Beaufort, the McLoughlin party sailed to Fripp aboard the *Trionyx* several times. They returned from the first trip with eight deer and on the next expedition shot seven more. According to the *Gazette*, McLoughlin was "quite a favorite" with all who met him.[28]

Following McLoughlin's death in 1918, his widow, Cornelia Cole McLoughlin, inherited Fripp Island and owned it until her death in 1932. Thus Fripp Island continued, as it had during much of the post-Civil War period, to have an owner who did not live nearby and who visited infrequently, if ever. An absentee landlord allowed local folks who had the time and a seaworthy boat to treat Fripp Island as a beach and woodland preserve for their occasional recreational use.[29]

Vacationing on Fripp Before the Bridge

Prior to the use of motorboats and cars and before the building of bridges, the trip to Fripp Island from Beaufort involved a day or two of difficult sailing. Even with the introduction of motorboats around 1900, trips to Fripp Island were often up to

Prelude to Development

six hours long and had to be well timed to accommodate the tides. The usual plan involved leaving Beaufort about two hours before low tide to have the ebb tide assist in carrying the boats down to Station Creek and flood tides for the rest of the trip. The most difficult part of the journey would be the final approach to the southern end of the island against the tide in Skull Inlet. However, a fairly deep channel in Skull Inlet next to the Fripp shore facilitated the landing and unloading of boats.

Mills Kinghorn, a Beaufort native, recounted his first trip to Fripp in a *Beaufort Gazette* article: As a young boy in 1920, he traveled aboard the *East Wind*, a large houseboat owned jointly by several Beaufort families. On this trip there were four adults and six children along with two hired hands who ran the boat and cooked. They anchored in Skull Inlet for a week at the beach. The following year the Beaufort group sold the houseboat because it was too expensive to maintain and jointly built a four-room camp house on Fripp. They made the trip in two World War I surplus twenty-four-foot navy lifeboats. One was configured as a launch and powered with a two-cylinder, eight-horsepower Palmer marine engine. It towed the second boat, which was filled with equipment, food and supplies.[30]

Kinghorn described the rustic house as standing on the south end of Fripp Island with a view of high sand dunes that extended three hundred yards inland

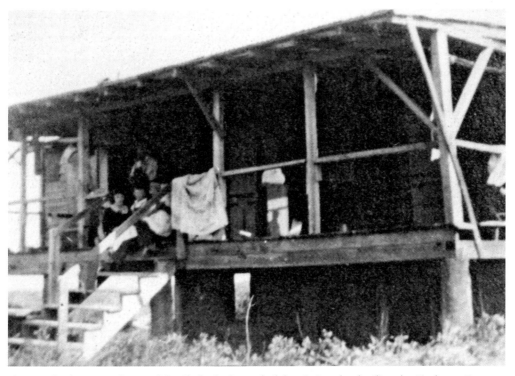

Photograph taken around 1924 of the Skull Inlet house built by six Beaufort families: the Kinghorns, Danners, McLeods, Luthers, Elliots and Griffins. It had three bedrooms and a large all-purpose room. The house burned down around 1930. *Courtesy of the family of Louise Kinghorn Firth.*

Fripp Island

from the beach. Made of rough pine lumber, it stood on palmetto posts and had a wide front porch. A small kitchen extended off the rear and the back porch had a built-in icebox, insulated with sawdust. An outhouse stood about fifty yards away. For a ten-day to two-week stay, the families would bring three 300-pound blocks of ice covered in burlap and packed in sawdust for the trip. The vacationers also brought their own drinking water and used the rain that ran from the gutters into a cistern for washing. Kinghorn remembered that the cistern water contained "an ample supply of mosquito wigglers." While they brought along some canned goods and staples, such as rice, grits, flour, sugar and lard, Kinghorn recalled that they depended on catching fish, crabs and shrimp to provide the primary part of their meals.[31]

The major entertainment on Fripp, Kinghorn wrote, was "fishing in the surf, and pulling the seine, crabbing and walking the beach, picking up shells and articles washed up on the beach." Early in the morning, the boys would survey the beach looking for turtle eggs, for as Kinghorn observed, this was long before the word "conservation" had entered the vocabulary. One time they found a nest of 212 eggs. Kinghorn noted that when turtle eggs were cooked the whites never got hard and the yolks had the consistency of sand; however, turtle eggs were useful in making biscuits. Some days they would row over to the beach on Pritchards Island and drag the seine in the large holes and tidal pools there. In the evenings, they would sit on

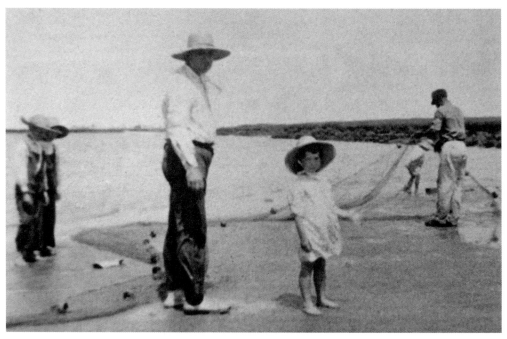

Photograph taken around 1920 shows the Kinghorn family fishing on Fripp Island near Skull Inlet with Pritchards Island in the background. They would drag their 250-foot seine through the tidal pools and shallow waters and sometimes catch bushels of fish. *Courtesy of the family of Louise Kinghorn Firth.*

the porch with a marsh grass fire to repel mosquitoes. Unfortunately, after some years of use the camp house burned to the ground.[32]

The bridge over the Beaufort River connecting Beaufort to Lady's Island built in 1927 reduced Fripp's isolation. Before the Civil War, a Cowan Creek causeway provided land transportation between Lady's and St. Helena Islands, but prior to the Beaufort River Bridge only a ferry connected Beaufort and St. Helena Island. The new bridge made it possible for a car to pull a boat from Beaufort to the south end of St. Helena for a much quicker trip to Fripp Island.

New Owners

After the death of James McLoughlin's wife in 1932, her three children inherited the island but quickly sold it in 1933 for $4,500 to William R. Dorman of New Brunswick, New Jersey. Dorman, whose father had valuable real estate holdings in New York, was only twenty-four years old when he purchased Fripp. Bill, as he was called, learned about Fripp on a trip to Beaufort to visit Adam and Natalie Haskell, who were friends of his parents. The Haskells operated a guesthouse in Tidalholm, an elegant antebellum mansion built by Edgar Fripp. While at Tidalholm, Dorman fell under the spell of the beauty of the Lowcountry and had a real estate agent show him the barrier islands. Not only did Dorman purchase Fripp, but he also bought St. Phillips, Old, Pritchards and Bay Point Islands.[33]

Julian Levin, a Beaufort lawyer, recalled his outings to Fripp as a young boy with Dorman and the twin sons of the Haskells. Dorman usually came South around Thanksgiving. They would sail to Fripp in Dorman's thirty-five-foot, two-masted sailing vessel for a week to ten days, staying in a camp house known as Old House, which perhaps gave its name to the creek on the backside of Fripp. Although Old House may conjure up images of a handsome antebellum home, it was a small rustic cabin. Dorman and the three young boys were usually alone on Fripp to fish, swim and explore the beach and the marsh creeks.[34]

Like Levin and Kinghorn, a number of other lifelong Beaufortonians have written about their experiences on Fripp Island when it was still undeveloped. Pierre McGowan in *The Gullah Mailman* wrote a number of stories about his father, Sam McGowan, as well as his own adventures on Fripp. In 1924 Sam became the rural postman on St. Helena Island and his family was among the approximately sixty-five white residents on the island among five thousand black inhabitants. The McGowans lived back from Seaside Road in a house that overlooked several barrier islands, including Fripp. Sam loved the water and taught his three sons from an early age to handle boats with great skill. To give a sense of the idyllic nature of the islands, Pierre McGowan wrote that from the time he was about ten years old, his mother would let him, his brothers and their black friends head out on a Friday afternoon in a boat for the barrier islands for a weekend of camping unaccompanied by any

Fripp Island

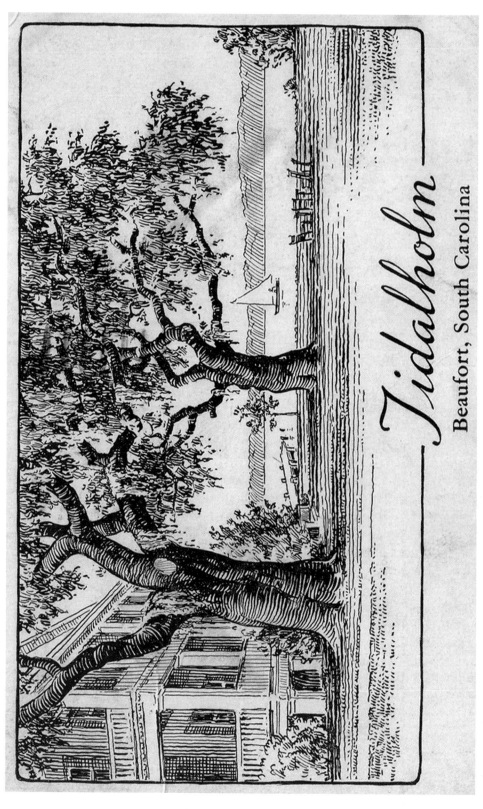

In the 1850s Edgar Fripp built his summer house "Tidalholm," located in Beaufort a few blocks from Sarah Harriet and William Fripp's home. During the Civil War the house served as a hospital and in the 1930s became a popular guesthouse frequented by artists, authors, statesmen and William Dorman, who for several years owned Fripp Island. *Courtesy of Historic Beaufort Foundation.*

Prelude to Development

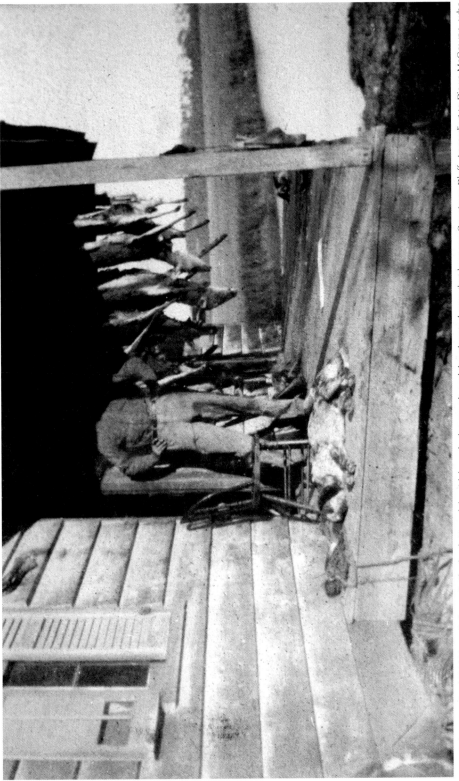

A 1920 photograph of "Old House" shows in the background the tidal creek, the marsh and the elevated area that became Sawgrass Bluff. According to Pierre McGowan, who spent many nights as a boy in "Old House," it was located right on the shore of the second bend of the tidal creek that cuts through the center of Fripp near what is today the end of Blue Gill Road. *Courtesy of the family of Louise Kinghorn Firth.*

adults. However, she never allowed her boys to play football, for she considered that too dangerous. McGowan also stayed many nights as a boy in Old House, which was located, as he recalled, right on the edge of the second bend of the tidal creek that runs through the center of Fripp. Although McGowan couldn't remember what happened to Old House, he thinks the cabin simply fell into the water after the creek slightly changed its course sometime in the 1940s.[35]

In 1937, when Bill Dorman was planning a visit to Beaufort, he asked his friend Sam McGowan to organize a deer hunt for him and his wife. Sam arranged to have "standers" posted about the island and "drivers" accompanied by dogs to move the deer along. Noting that Fripp in 1937 was much wider than now and mostly a jungle, McGowan wrote that his father selected a place called The Narrows—with the ocean on one side and the marsh on the other—to situate Mrs. Dorman. This location, near the current tennis courts, proved to be a most advantageous spot for her to bag an eight-point buck with her twenty-gauge double-barrel shotgun.[36]

J.E. McTeer, who served as sheriff of Beaufort County from 1926 to 1963, recounted in *Adventure in the Woods and Waters of the Lowcountry* his early hunting experiences under the tutelage of E.B. Rodgers, known as Burt, who was the clerk of court in Beaufort County. Burt was a superb woodsman and frequently organized a "big hunt" to Fripp Island after a frost had killed the mosquitoes.

The development of Fripp has greatly reduced the natural habitat for Fripp's herd of approximately six hundred deer that feel the island belongs to them. *Courtesy of Julie Hodgson.*

Prelude to Development

The expedition that McTeer described involved twenty-four men: sixteen hunters, a cook and helper, four drivers and two deer totters. The cost per hunter for the weeklong hunting trip was $16.50. Burt, with McTeer's assistance, planned the excursion. All the dogs and men assembled at the county jail at 5 a.m. on Saturday morning and returned the following Saturday. The hunting party drove to Freeman's landing at the old Tombee plantation on St. Helena and then went in four flat-bottom rowboats on Station Creek to Fripp Island, where they raised the tents and set up camp.[37]

McTeer devoted a whole chapter in his book to one particularly haunting experience that he had with a friend on Fripp. The two men were camping near The Narrows and had spent an exhausting day fishing in the surf for large red bass. After eating dinner and resting, they had a walk along the deserted beach to see what may have washed ashore. As they walked along the high tide mark, they saw the footprint of a barefooted person. Both men were over six feet tall and had large feet, but they estimated the tracks they saw were over eighteen inches long. They followed the fresh footprints for over a mile until the footprints circled a turtle nest without disturbing the eggs and then disappeared into the woods. McTeer and his friend knew the few landing places on Fripp and quickly scouted them out for signs of a boat. But they found no boat or tracks. The two men decided to break camp and sleep on their boat. McTeer wrote, "We were not scared, just cautious." Some

July 1924 photograph shows the Kinghorn families in a twenty-four-foot launch pulling a boat loaded with supplies for a two-week vacation on Fripp Island. *Courtesy of the family of Louise Kinghorn Firth.*

years later, McTeer learned that several other folks had encountered the "big foot"; however, no one seemed to have a clue as to who or what could have made the large imprints in the sand.[38]

For enterprising young lads, outings to Fripp were not only pleasurable; they were also a source of some spending money. Ned Brown, a native of Beaufort who became a photographer, recollected hunting as a boy for raccoons on Fripp and other barrier islands. In the 1930s raccoon coats were the rage. Ned would go hunting with Pierre McGowan and his brothers, tracking and shooting raccoons. Sam, Pierre's father, took the raccoon pelts to Savannah where he sold them for one dollar each to an agent of Sears, Roebuck.[39]

Lumbering

In 1937 William Dorman sold Fripp for $15,000 and made a handsome profit, having purchased it just four years earlier for $4,500. The purchasers, the company of R.L. McLeod and Sons, were from Robeson County, North Carolina. Their sizeable lumbering business included extensive holdings of rich timberland in South Carolina as well as two sawmills at Ravenel and Rantowles, two small towns located on the outskirts of Charleston on the railroad line between Charleston and Savannah.[40]

A year after purchasing Fripp, R.L. McLeod and Sons established three sawmills on Fripp, one near the marina, one on the south end of the island and the third midway between the other two. Their interest was in Fripp's longleaf yellow pine trees. The company built a makeshift timber loading dock where barges would tie up to load the logs. Some of the large yellow pine pilings from the old loading dock can still be seen under the marina boathouse. Yellow pine was used at that time because it was just as effective as treated wood for discouraging the teredo worms that ate away at most wood submerged in the water. McLeod and Sons began by cutting the tall pines on the south end and along the island's perimeter. However, soon after they began the operation, lumber prices fell sharply. They ceased operations hoping for better prices, which failed to materialize.[41]

The isolation of Fripp was further reduced when the Works Progress Administration (WPA), which had been established during the Depression to provide work for the unemployed, built bridges across both the Harbor River and Johnson Creek. A plaque on the lengthy drawbridge connecting St. Helena and Harbor Islands notes the date as 1939, the president as Franklin D. Roosevelt and the project as the "St. Helena–Hunting Island Bridges." It was the Depression-era project of building bridges to extend Highway 21 to the new Hunting Island State Park that set the stage for the development of Fripp Island as a resort.

Prelude to Development

World War II

World War II brought to Fripp for the first time people who did not just visit but who lived for an extended period on the island. In June 1942, coast guardsmen in New York and Florida intercepted German spies who had come ashore in rubber boats from German submarines cruising the American shoreline. The intent of these Germans was to use explosives to cripple the industrial and transportation centers in the United States. The capture of these German spies and saboteurs exposed the vulnerability of the American coast. Government officials debated the best method to protect America's extensive coastline from infiltration by the enemy. In September 1942, the navy authorized the mounted beach patrol, and it became operational two months later with thousands of men aided by horses and dogs protecting the shore.[42]

The commander for the Coast Guard Mounted Patrol, Sixth Naval District, which extended from Wilmington, North Carolina, to Jacksonville, Florida, was J.E. McTeer, the Beaufort County sheriff who had led hunting expeditions to Fripp Island in the 1930s. McTeer recruited eighteen-year-old Ned Brown, who as a boy had hunted for raccoons on the islands. Brown served on Hunting Island, where the patrol lived in the cabins that the Civilian Conservation Corps (CCC) constructed in 1938 for the new state park. Jack Woods, whose father had worked for Waterhouse Grocery on St. Helena Island and who was also familiar with the barrier islands, worked on the boat that ferried supplies to the patrol unit on Fripp and other islands that had no bridges.[43]

Woods recalled that on Fripp the recruits had in a few days hastily constructed the patrol's barracks, located near Skull Inlet. The building was of rough timber, oblong in shape and without indoor plumbing. Since there was no well on Fripp, water had to be brought along with the other supplies. The nine men who made up the patrol on Fripp served three shifts of eight hours each. The dogs were mostly used on the night shifts and always worked under leash. The purpose of the patrols was to report activities along the coastline rather than to function as a military force to fight hostile armed troops. With notification and communication at the core of mission, the coast guard laid fifteen hundred miles of new telephone circuits that provided reporting stations at quarter-mile intervals along the Atlantic beaches.[44]

Because of the small size of Fripp Island, the patrol had dogs—all German shepherds—and no horses. The military had acquired these dogs from patriotic citizens who loaned them to the government for this special mission. The kennels on Fripp were as important as the barracks and the men took considerable care with the dogs. The district's official newsletter, titled *Hoof Prints*, provided advice on caring for the animals, such as keeping them in the shade after 10:00 a.m. on hot summer days unless they were on patrol.[45]

Every other day a supply boat, a forty-foot motorized whaleboat with an open hull, came to Fripp with mail, water and food. The Parris Island Commissary supplied

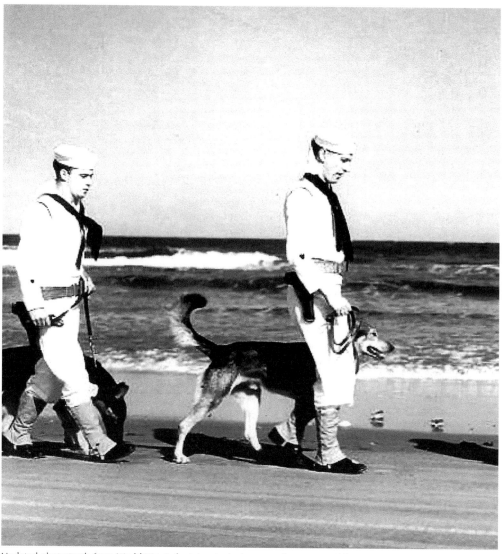

Undated photograph from World War II depicts a typical scene of two men of the coast guard engaged in an antisaboteur dog patrol along the ocean. *Courtesy of U.S. Coast Guard Historian's Office.*

Prelude to Development

the food and a cook prepared the meals for the Fripp unit. The men supplemented their routine rations with fish, shrimp, duck and deer. There were two small docks on Skull Inlet, one for delivering supplies to Fripp and the other for Pritchards Island. Besides anticipating the arrival of the boat, the men had few activities to break the monotony of the daily patrols. Commanding Officer McTeer encouraged swimming from April to October and also instituted a program of competitive sports. There were boxing contests and basketball tournaments between the various posts in the Sixth Naval District.[46]

The Fripp patrol ended in the fall of 1944, about two years after it started. With the dissipating threat of U-boats and the Allies' progress in Europe, the military called a halt to all coastal patrols. Although they never captured any spies or saboteurs, the presence of the coastal patrols deterred further landings by the enemy. Those engaged in the patrols often found debris and empty rafts along the shores, reminders that German submarines were not far away.[47]

Post–World War II

With the departure of the beach patrol, the abandoned barracks provided a shelter for outings to Fripp. There was a kind of squatters' rights system practiced, whereby whoever found the barracks empty could use them for lodging. "Many happy and successful camping and fishing trips," Pierre McGowan wrote, "were made through the use of these facilities." In addition, the end of World War II meant that Hunting Island could once again become a state park with a public road to its boat ramp. This made Fripp Island, located just one-third of a mile across the Fripp Inlet, easily accessible by boat. The combination of ease of access and the possibility of housing instead of tents increased the numbers of people who visited Fripp Island, particularly fishermen who considered Fripp a paradise.[48]

Visitors occasionally came to Fripp by private plane. William Hardee McLeod, who was related to the McLeod truck farming family of Seabrook and not the McLeods of the North Carolina lumber company, recalled boyhood memories of Fripp. McLeod's father and Jack Pollitzer, who had been a tail gunner during World War II, would fly to Fripp from a private airstrip located on what is now the Marine Corps Air Station in Beaufort. The plane would land on the beach at low tide—just in time for the first hours of the incoming tide, the best time for fishing in the surf for bass. On at least one occasion, McLeod recalled, there was a hair-raising departure as the high tide left little beach for getting airborne.[49]

McLeod also reminisced about the annual two-week summer camping trips that his family had on Fripp during the late '40s and early '50s. It took a full day, as he remembered, for them to come in a Lightning sailboat with an old outboard motor, pulling a bateau loaded with supplies, tents, fishing equipment, water and ice. They set up camp near Skull Inlet. His father would fly down several times during the

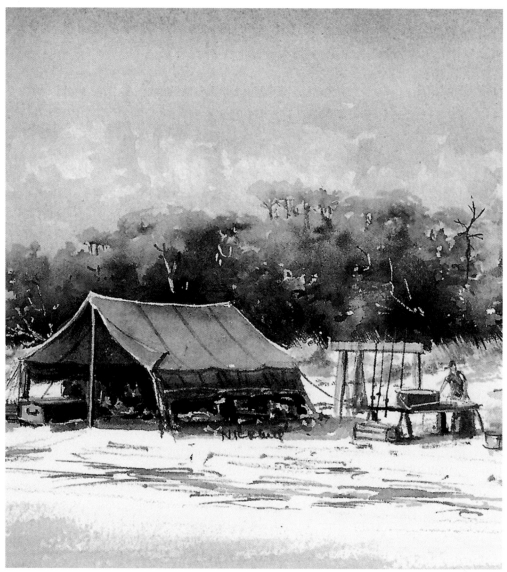
A portion of a painting by Nancy Ricker Rhett from her book *Beaufort and the Lowcountry* portrays her family camping in the 1950s on Fripp Island. *Courtesy of Nancy Ricker Rhett.*

Prelude to Development

week with Jack Pollitzer to fish and to check on the family. As McLeod looked back on these days of his youth, he reminisced: "We swam, fished, ran footraces, told stories, ate and slept." And during the whole two weeks, he noted, they never saw another boat or person except for the offshore shrimp boats.[50]

In a delightful watercolor, local artist Nancy Ricker Rhett captured the experience of her family camping on Fripp in the 1950s. Using old family photos as a source, she painted a cluster of picturesque canvas tents, many of which had been made by her great-grandfather. A careful examination of Rhett's painting suggests the location of the tent camp was on the beach near Skull Inlet. Such a spot assured sea breezes and minimum mosquitoes. Rhett describes in her book *Beaufort and the Lowcountry* these trips to Fripp and how a room-sized oriental carpet was spread out on the sand as a play area for the youngest children. With an assortment of tents and cooks and nurses for the children, the family camped, as Rhett noted, in "grand style."[51]

Robert Graves, a commercial shrimper and supply preacher who lives on St. Helena Island, has fond memories from his boyhood of camping and hunting on Fripp. One of his most exciting experiences was being chased by a wild hog and seeking refuge in a tree. The site of Old House, which by the 1950s was no longer standing, was a favorite spot for pitching their tents, for it was easily accessible and somewhat protected. He recalls fighting off the mosquitoes with an ample supply of bug spray and use of mosquito nets. In answer to the question of whether there were ever stills on Fripp, Graves said he had never seen any on Fripp and speculated that the hogs would have eaten up the corn mash before it had time to become liquor.[52]

On September 9, 1954, McLeod Lumber Company sold Fripp Island for $40,000 to the Fripp Island Corporation, which was made up of a group of sixteen Beaufortonians who purchased it for a private hunting and fishing preserve. The group included local leaders such as Sheriff McTeer, Claude McLeod, Harold and John Trask, G.G. Dowling and Brantley Harvey Sr., men who over the years had been hunting, fishing and camping on Fripp, many of them since childhood.[53]

The group of sixteen never built any houses on Fripp, but they did sell timber rights. On September 3, 1957, they signed a timber deed with W.H. Greene and E.J. Schumpert. In return for $25,000, the Fripp Island Corporation sold the rights to cut all of the pine trees on Fripp Island having a stump diameter of ten or more inches. The timber deed forbade the cutting of any hardwood trees, placed a limit of twenty-four months on the agreement and gave permission to cut needed roads and build a dock for the removal of timber. Language in the deed also admonished Greene and Schumpert to use due care to prevent damage or injury to the trees and timber not covered by the deed, encouraging them to make every effort to protect wild game and wildlife on the island. Fortunately, most of Fripp Island remained a veritable jungle with a heavy growth of saw palmetto, wax myrtle, cedar, oak, tall palmettos, many uncut giant pines and occasional large live oak trees.[54]

Fripp Island

Within months of the 1959 termination of the timber deed, the Fripp Island Corporation began negotiations with developer Jack Kilgore for the sale of their hunting preserve. In reflecting on the years preceding the building of a bridge to Fripp, William Hardee McLeod declared, "I feel I had the opportunity to enjoy the best of the last of the hunting and fishing in Beaufort County."[55]

Chapter 3
Kilgore's Vision

From the first moment Jack Kilgore saw Fripp Island, he envisioned a premier private island community and resort, a dream that would soon end Fripp Island's isolation. On a weekend in March 1960, Kilgore went on a fishing trip to Beaufort County with Mitchell Ott, who was in the watermelon business and bought trucks from Kilgore. While fishing on the Broad River during the morning, their guide mentioned a barrier island with terrific fishing and a gorgeous beach. Kilgore asked to see it. That afternoon their guide drove them to Russ Point Landing on Hunting Island, launched his boat and took them to Fripp Island. Kilgore, who had never been in Beaufort County, found the tropical island and beach stunning. With a low tide and sand dunes stretching out for several miles, Kilgore immediately "fell in love with the island." Here was an opportunity, he thought, for an extraordinary adventure on a paradise island that could make him a wealthy man. But converting this dream to a reality was a formidable task for the thirty-two-year-old sales manager of a truck and heavy equipment company in Columbia.[56]

Kilgore had little in his background to prepare him for transforming Fripp from a jungle into a resort community. A native of Anderson, South Carolina, and the son of a textile mill worker, Kilgore served a tour in the navy and then enrolled in the University of South Carolina, where he received a degree in business administration in 1951. After graduation, he and his wife, Anna Jean, who went by A.J., settled in Columbia and by 1960 had three sons. He worked six years for the local branch of the Commercial Investment Trust Corporation and then accepted a position with Southeastern Equipment. After three years selling trucks, Kilgore was ready for a new challenge.[57]

What Kilgore lacked in professional training, he made up for with passionate determination and skills of persuasion. He was a "big idea" man who dressed and talked the part of a resort CEO. Returning to Columbia from that unforgettable

visit to Fripp Island, he began discussing with friends and colleagues his vision. Kilgore had no development experience and little money—only the equity in his home and less than $10,000 in savings. But he possessed a firm resolve and contagious zeal. His first converts were two good friends: attorney Ray Berry, a Lambda Chi Alpha fraternity brother, and Alderman Duncan, who had previously headed the Columbia bureau of the Associated Press and was at that time president of Southern Publishers. "They were the only ones," Kilgore said, "who didn't think I was crazy."[58]

Two national trends contributed to the idea that Fripp Island could be a viable enterprise. In 1959 Del Webb had successfully launched his first Sun City retirement community. Webb believed that the restless "fifty-five and better" group, as he called them, would pick up stakes and move hundreds of miles from home to a community that offered golf, pools and a chance for a second childhood during their golden years. In addition to changing notions of retirement, there were shifts in attitudes toward vacations. Since the advent of the automobile in the early twentieth century, growing numbers of South Carolinians had been vacationing in the summer at seaside communities such as Myrtle Beach, Pawley's and Edisto Islands and Ocean Drive. Vacationers stayed in modest cottages that dotted the shore and relaxed on the broad, gently sloping beaches and swam in the surf. However by 1960 this concept of "going to the beach" was undergoing a transformation. Indicative of this transition was the upscale, environmentally sensitive development of Hilton Head, which offered a planned community that appealed to middle-class and wealthy folks from instate and out-of-state for the beach as well as the golf courses, tennis courts and fine restaurants. For Charles Fraser, who pioneered the Sea Pines Plantation on Hilton Head, development was not about the first and second rows of oceanfront houses but accentuated the natural environment of a whole island, creating parks and open spaces while building attractive accommodations and recreational facilities.[59]

Kilgore clearly thought of Hilton Head Island as a model. In May 1956, a $1.5 million toll bridge authorized by the state legislature opened to connect Hilton Head with the mainland. The following year, two hundred thousand people visited the island, the development company sold more than three hundred lots and one hundred houses were built.[60]

Negotiating the Purchase

A week after seeing Fripp for the first time, Kilgore returned to Beaufort "to check out the owners of the island." He learned that a group of sixteen Beaufortonians owned the island as a hunting preserve and that John Trask "was the ringleader" of the group. Kilgore made a reservation at the Sea Island Motel that John Trask had recently built on Bay Street and called Trask to invite him for a drink. Trask

arrived at 6 p.m. and by the time he left, Kilgore had the names and background information on all the owners. While in Beaufort, Kilgore made another visit to Fripp. This time his guide was Jack Woods, who served during World War II in the coast guard patrol that brought supplies to Fripp Island and was now working in the real estate company of his father-in-law, Sheriff J.E. McTeer. Coordinating the trip to coincide with high tide, Woods took the boat up a tributary from Old House Creek that cut through the middle of the large marsh behind the center point of the beach. The high tide assured navigable water and a docking point that was just a short walk to the beach. Kilgore's appreciation of the beauty and potential of the island increased.[61]

Returning to Columbia, Kilgore worked quickly to create a business structure. On May 7, 1960, Kilgore and his initial two supporters, Ray Berry and Alderman Duncan, established the First Security Investment Corporation, which would serve as a preliminary organization for purchasing the island. They elected Kilgore president, Duncan vice-president and Berry treasurer. With incorporation papers and an option to purchase in hand, Kilgore went back to Beaufort to see John Trask and make an initial offer of $300,000. After some deliberation the two agreed on an amount and Trask offered Kilgore some tips on how to proceed in gaining the signatures of the other fifteen owners.[62]

A photograph from the 1960s showing the wide beach and large sand dunes that attracted Jack Kilgore to Fripp Island. *Courtesy of Ernest Ferguson, Photo Arts, Inc.*

Assuming he could get all to agree to sell, Kilgore would need money for a down payment. His enthusiasm was an essential ingredient in finding investors. With friends talking to friends, he scouted to find fifteen people to invest in the new resort. Kilgore put up $10,000 of his own money, which required all the family savings, and found fourteen other investors who were also willing to put up $10,000 each. They included a Spartanburg textile executive, a Greenville lawyer, a Charleston real estate broker and a Beaufort banker.[63]

With a total of $150,000, he was in a position to make a firm offer for the purchase of Fripp Island. He then began the laborious task of meeting with each part owner of the Fripp Island Corporation. In this group were some distinguished members of the Beaufort community: attorney and banker G.G. Dowling; Bob S. Merritt, a banker and owner of an automobile dealership; Sheriff McTeer; attorney Brantley Harvey Sr.; and Elizabeth Campbell, owner of a plantation in Sheldon. Having purchased the island in 1954 for $40,000 and having recouped $25,000 of that amount from selling in 1957 the rights to harvest pine trees, the group was in a position to make a sizeable profit. However, it took many trips to Beaufort and months of cajoling to reach an agreement with the owners. "One owner warned me," Kilgore recalled, "that the individuals involved couldn't agree on the time of day."[64]

One can only speculate about the factors that contributed to the owners' decision to sell: they were not actually using the island very much; the mosquitoes were so terrible they didn't want to go to the island during the warmer months; they considered the island worth little without a bridge and fresh water; they didn't think anyone would be able to raise the necessary funds to build a bridge and provide water; and they had an opportunity, after holding the property for only six years, to make an extremely handsome profit that just a few years earlier seemed inconceivable.

With the purchase on the horizon, Kilgore needed a person with financial expertise on his team. He found this in Roy Krell, the president of a Columbia investment firm. Dubose Edmonds, a Fripp resident and retired banker, recently reminisced about Krell. "He was a soft-spoken man with exceptional organizational skills," Dubose said, "who also had a reputation for financial credibility; when Krell talked about money matters, people listened." Krell brought the fiscal experience needed to put together a stock offering and immediately became a vice-president and director of Kilgore's board. Buying the island was the first step, but the second step of securing the required capital for the development of the island was equally important. Even before a preliminary agreement to sell the island had been reached, Krell was making plans to underwrite an upcoming initial offering of 250,000 shares of stock. Krell became not only the agent for the sale of stocks but also the manager of the sale of lots on the island.[65]

Just six months after visiting Fripp Island for the first time, Kilgore had made amazing progress toward purchasing the island, an achievement that would have been unthinkable for most thirty-two year olds with limited incomes. The September 29, 1960 *Beaufort Gazette* in its front page story, "Fripp Island Sale

This headline from the *Beaufort Gazette* on September 29, 1960, made public Jack Kilgore's intention to buy and develop Fripp Island.

Announced Here," described the down payment as "substantial" and the final price as "in excess of half a million dollars." The article also stated that the prospective owners were engaged in negotiations for the construction of a privately owned bridge and had developed plans for selling lots and building a yacht club, church conference ground and shopping center.[66]

On November 10, 1960, Kilgore, Krell and Berry met in Beaufort with representatives of the sixteen owners of Fripp to transfer ownership in a signing ceremony, a picture of which appeared in the *Beaufort Gazette*. At a press conference that evening at the Sea Island Motel, Kilgore asserted: "It is our intention to develop a resort that will reflect the gracious traditions and charm of historic Beaufort County." He also stressed that suggestions and guidance would be sought from the former Fripp owners and other local residents.[67]

Despite a public signing ceremony and a picture in the newspaper, the transfer of ownership to Fripp Island did not occur in November 1960. The index of deeds in the Beaufort County Courthouse lists the transaction of First Security Investment Corporation, Kilgore's group, with the Beaufortonians as "void." Additionally the designated page for the deed in the county deed book is missing.[68]

Three months after the ineffectual signing ceremony, Kilgore's group finally gained control, not through a deed but in an "Agreement of Merger." On March 22, 1961, the sixteen Beaufortonians approved the merger with the Resort Holding Company, which had been formed by Roy Krell in November 1960 as the financial entity for the purchase and development of the island, and the agreement was duly recorded in the Beaufort County Courthouse. The merger agreement between the two corporations offered a frequently used way for corporations to avoid the payment of transfer taxes. The agreement recorded in the courthouse did not detail

the financial arrangements and stated only in the broadest of terms that the two groups merged. The following year Kilgore restructured the corporation under the name Fripp Island Resort.[69]

Fripp Island Bridge

With possession of Fripp Island secured, Kilgore was able to focus on building a bridge. Following the Hilton Head example, he pursued state legislation to establish a toll bridge authority that could raise private funds for the building of the structure. On March 29, 1961, the Beaufort County delegation in the General Assembly in Columbia—Representatives Brantley Harvey Jr. and Reeve Sams and Senator J.M. Waddell Jr.—introduced a bill to authorize the construction and operation of a private toll bridge linking Fripp and Hunting Islands. Mitchell Ott, who had been with Kilgore on his first visit to Fripp and was in the state legislature, probably helped. The bill specified that the governor would appoint three Beaufort County residents empowered to borrow money; issue bonds; and construct, maintain and operate the bridge. The bill faced some opposition, but supporters prevailed and the bill became law.[70]

While working with engineers on preliminary plans for the bridge, Kilgore also needed to secure approximately half a million dollars to pay for construction. In later years Kilgore often told the story of approaching a man for financial backing for the bridge and the man responded, "You want to borrow a half million dollars to build a bridge that goes nowhere." In the end, two bond dealers, one in Charleston and the other in Savannah, handled the sale of bonds, which were free of state taxes. As Eloy Doolan, who worked at that time for the Charleston bond firm, recently recalled, the firm never expected the tolls to raise the kind of revenue needed to pay for the bridge. Thus according to Doolan, they agreed "to underwrite the project if part of the lot sale proceeds—a small percentage—was dedicated to securing the bonds."[71]

With money in hand, construction began in early 1962 on the bridge that was to be one-third of a mile long. But there were obstacles ahead. The first pilings did not have stable footing, thus it was necessary to dynamite them and begin again. A further complication developed when the company building the bridge had financial difficulties and had to stop work. Kilgore had to quickly find a new company to complete the project. During the summer of 1963 Dick and Norine Smoak, who were among the first to buy a lot, described crossing the bridge: "We would drive as far as possible on the new bridge," Norine recalled, "park the car and walk a few yards on row planks fastened to the heavy concrete pillars and cling desperately to a rope railing." Since there was no approach for the bridge on the Fripp Island side, they had to climb down a steep ladder to the ground. The bridge was completed in November 1963.[72]

Kilgore's Vision

When the bridge first opened there was a toll of $2 for each crossing. But by 1965, Kilgore wanted to purchase the bridge in order to ensure the privacy of the island and to reduce the $2 toll, which seemed excessively high for the time. With the transfer of ownership of the bridge to the resort on November 4, 1965, Kilgore instituted bridge passes. For $500, usually paid at the time a lot was purchased, those with bridge passes could cross the bridge indefinitely without paying additional fees.[73]

Developing the Infrastructure

Kilgore planned for the sale of lots to be the financial engine for developing much of the island's infrastructure. Yet before lots could be surveyed and sold, Kilgore had to develop a design for the island. Kilgore had aerial photographs taken, which as he recalled showed the island as "a complete jungle." He went to see Charles Fraser, the expert on Hilton Head, for counsel. "I really admired the work Charles Fraser was doing," Kilgore said, "he was an inspiration and an enormous help in drawing up our

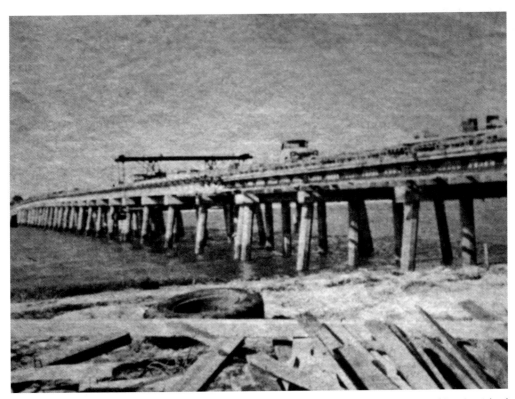

This 1962 photograph of the construction of the one-third-mile-long Fripp Inlet Bridge appeared in Fripp Island Resort's promotional material. *Courtesy of Newman, Saylor & Gregory.*

plans." Using the aerial photo, one of Fraser's employees assisted in conceptualizing the master plan that highlighted sensitivity to the natural environment, used cul-de-sacs to create semi-private neighborhoods, provided numerous access points to the beach and emphasized low-density development. The early layout of roads had about a dozen subdivisions. Between every four to six oceanfront lots there were twenty-foot wide pathways providing access to the beach for all island property owners.[74]

Some of the specifics of Kilgore's first design never came to pass, thwarted by either Mother Nature or lack of financing. The original concept drawing showed a marina situated where the current tennis courts are located. Kilgore had hoped that the tributary from Old House Creek that cut through the marsh in the center of the island could be dredged and widened to provide access to a boating club that would be just eight hundred feet from the ocean and close to the proposed beach club. Even with extensive dredging, navigation was possible only during a few hours around high tide. By 1964, architectural drawings of a proposed Fripp Island motel, ten-story apartment building and convention center with a six-hundred-seat auditorium appeared in the *Beaufort Gazette*. But the master plan for this luxury resort complex proved to be a more ambitious undertaking than was financially possible.[75]

However, the basic plans for Fripp coincided with the county's desire to grow. In 1960, the time Kilgore was launching his vision for Fripp Island, Beaufort County was undertaking a major advertising program to attract more winter and permanent residents to the area. The chamber of commerce, in announcing the new promotional initiative, had boasted, "Beaufort County is now in its best position since World War II to offer prompt service to winter visitors and retiring new residents." The chamber recognized that one of the county's major attractions was its islands and claimed that "there are more than sixty-four major islands in the county and hundreds of smaller ones, giving Beaufort more water-front mileage than any other county in the entire United States." Placing advertisements in major newspapers in Ohio, Pennsylvania and New York, the chamber commended "the equitable climate and a most attractive place to live for those who desire boating, fishing, hunting, and the outdoor life far from the crowded cities and congested areas."[76]

Since Kilgore's goals for Fripp and the county leadership's desire to stimulate growth were compatible, Kilgore had no difficulty in gaining support from the Beaufort delegation to the General Assembly in Columbia to pass a law creating the Fripp Island Public Service District (PSD). Because Fripp was a private island and not an incorporated town, this 1962 legislation—later amended and expanded—gave the PSD the mandate of supplying water to the island. To carry out its charge, the PSD was empowered to determine water rates and to levy taxes on property. A few early wells on Fripp supplied some water, but drinking water had to be transported to the island. Thus there was a pressing need for a freshwater system.[77]

The cost of bringing fresh water to Fripp would be sizeable. Thus the PSD successfully negotiated the issuing of $280,000 worth of bonds from one of the firms that had underwritten the building of the bridge. On August 20, 1965, the first fresh

water was piped to Fripp Island. Kilgore presided over a "turning on ceremony." The water came from a 130-foot well on St. Helena Island, and a pipe brought it the twelve miles to Fripp, where it was stored in a 75,000-gallon elevated water storage tank, the only one of its type in the lower coastal area of South Carolina at that time.[78]

With plans underway for the bridge and water, the Fripp Island Resort prepared the "Declaration of Restrictive Covenants," the legal document filed in the Beaufort County Courthouse that set forth the principles Kilgore believed were important for creating an upscale and attractive resort. Kilgore outlined his development goals as protection, protection, protection: protection of the island's natural beauty; protection of growth to have a sensible mix of commercial, residential and recreational properties; and protection of property values.[79]

Many of the covenants focused on the protection of trees, sand dunes and wildlife. Others established standards for upkeep of lots and dwellings, mandating, for

TAX FREE

This Announcement Appears as a Matter of Record Only, the Securities Having Been Sold.

$280,000

FRIPP ISLAND PUBLIC SERVICE DISTRICT, SOUTH CAROLINA

5%

General Obligation
Water Works System Bonds

VARNEDOE, CHISHOLM & CO., INC.
Savannah, Georgia

FROST, READ & SIMONS
Charleston, South Carolina

The Savannah Morning News, May 24, 1965, carried a notice of Varnedoe, Chisholm & Co., Inc.'s underwriting of the Fripp Island Public Service District's $280,000 bond to pay for supplying fresh water to Fripp Island.

example, that if a lot were unkempt, the resort would clean it and send the owner a bill not exceeding twenty dollars. A number of the covenants addressed building requirements: there were to be only single-family dwellings—none of which were to exceed a two-story height limit—and no temporary structures were to be allowed on any lots. There were to be no businesses except in designated areas and no lots were to have commercial signs. No docks or decks were to be built without the approval of the Fripp Island Resort Architectural Review Board. Finally, the covenants established a permanent fund to be used for landscaping, maintaining of roads and walkways and providing insect and pest control. The covenants specified that each lot owner would contribute fifty dollars annually to this fund. Thus, before any house was built, Kilgore laid down principles—many of which are still in effect—that guided the development of the island.[80]

Before the bridge was completed, Kilgore floated a bulldozer on a barge to Fripp Island to begin building roads and surveying lots. A full-time crew worked on clearing, grading, surveying lots and road construction. Kilgore and his wife, A.J., decided to name the streets after fish. Using a reference book on fish, they selected names of roads. Remora, one of Fripp Island's major thoroughfares, had such a nice sound; however, they experienced some disappointment in learning that it was an unattractive fish.[81]

An obstacle in building the roads and golf course was the presence of numerous wild hogs. Krell estimated the wild hog population on Fripp in 1962 to be in excess of one hundred. Planters from the nineteenth century probably placed domestic pigs on the island to control the poisonous snakes that are the greatest danger to hunters; the hogs returned to the wild and grew tusks. Kilgore recalled that "they would be quite ferocious" and that one hog he saw was probably six hundred pounds.[82]

Krell used the wild hog problem as an occasion to invite area sportsmen and those with an interest in Fripp to a wild hog hunt. In invitations, Krell announced that the group would meet at Russ Point on Hunting Island at 9:00 a.m. on November 30, 1962. Each hunter was to bring his own shotgun, shells and lunch, and the Fripp Island Resort would provide transportation. Jack Pittman, a Greenville businessman who had purchased a lot, attended the hog hunt. He remembered that several black St. Helena shrimpers ferried the hunters over to Fripp in their shrimp boats for what turned out to be a most successful hunt. They shot about one hundred hogs, most of which were given to the shrimpers.[83]

Selling Lots

Once some roads had been built and lots surveyed, the Fripp Island Resort began a major marketing effort to sell lots. Again Kilgore was limited by lack of funds and had to think creatively. He enlisted a fraternity brother, Van Newman, who had an advertising and public relations firm in Columbia, to develop promotional materials

in exchange for credit toward the purchase of land. Newman developed attractive glossy brochures and fliers that captured well the beauty and charm of Fripp. Some included a logo depicting the silhouette of legendary pirate Captain John Fripp in a striking pose. Meanwhile Krell placed newspaper ads, purchased space on billboards and enlisted journalists to write articles. But then as now, many people learned about Fripp from friends and acquaintances.[84]

Archie and Liz Taylor, who bought a lot in 1961, came to Fripp by boat with Charlie New, a friend from Spartanburg who was also one of the directors of the resort. Some buyers were local folks. A few saw the billboards advertising Fripp on the highway to Florida, detoured off to explore and subsequently bought property in the new resort.[85]

A small two-inch ad in Columbia's *State* paper in 1962 caught Bill Winter's eye. Winter, a chemical engineer and administrator at the Savannah River Plant in Aiken, was familiar with Fripp Island. On several occasions he had joined a group of men from Aiken to go on fishing trips there. Armed with fishing gear, beer and camping supplies, they towed a boat to Hunting Island and then went by boat to Fripp, where they would surf fish along the beguiling beach. With these fond memories of Fripp in mind, Winter immediately responded to the ad with a letter of interest. He recalls mailing his letter on a Monday morning after seeing the ad in the Sunday paper. On Wednesday evening he and his wife, Dixie, a schoolteacher, had visitors. Krell and his sales assistant, Marion Westerberry, had come from Columbia to talk Bill and Dixie into buying property on Fripp.[86]

The Winters were definitely interested, so the next step was to visit Fripp. Westerberry was their guide. Dixie remembered taking a boat from Hunting Island and arriving on Fripp to climb "a rickety ladder to a rickety dock" and then being ushered into a topless jeep that "had no springs and didn't go very fast." They then were confronted with ticks, mosquitoes, stifling heat and wild pigs. Dixie's initial impression was that it was an "awful place," but then the most beautiful beach she had ever seen came into view. The fifteen-foot sand dunes and wide beach with shells and birds everywhere all won her over. "That's when I first fell in love with Fripp," Dixie said, "that very first day on that beach."[87]

The early sales pitch included the assurance that the money for the purchase of lots would be placed in an escrow account and returned if the corporation had not signed a contract by December 1962 for the construction of the bridge. The prospectus described plans for water, sewer and electricity. The first lots were sold as part of "package sales" that included several lots as well as shares in the corporation. In 1961 Archie and Liz Taylor purchased one of the first packages for $4,000, for which they received two lots and some stock. Bill Winter recalls that in 1962 he paid $5,000 for two lots and one thousand shares of stock in the Fripp Island Resort. Packages that included oceanfront lots were about $8,000.[88]

Kilgore reported at the annual stockholders meeting in 1964 that land sales for the year had totaled over $600,000. The news in 1964 from neighboring barrier islands was both encouraging and daunting. Hilton Head Island had claimed a spot among

Dun and Bradstreet's list of America's two hundred fastest-growing cities and boasted two of the five accommodations in South Carolina to receive an "outstanding" rating in the 1964 Mobil Travel Guide. In contrast, the reports from Hunting Island were of erosion. Hurricane Dora, which hit the area in September 1964, eroded thirty to sixty feet of beach from Hunting Island and seriously damaged the road to the beach. While there had been some early reports of high waters threatening the Fripp Island Bridge, Kilgore quickly reported "Fripp Island passed this hurricane test completely without damage in any way."[89]

Shortly after completion of the bridge, construction began on the Fripp Island Administration Building, the first building to be erected on Fripp and the one that would serve as the focal point for sales. Located near the bridge, the innovative building had fifty-one exterior panels of sand-sculptured relief, featuring abstract designs of nautical objects such as ships and sea horses. The undulating profile of the roofline recalled the rhythmic waves of the surf. The moat that partially surrounded the building flowed inside, terminating in the lobby in a sunken fish pool that contained a model of the island. As the first building in South Carolina to use sand-sculptured panels, the resort's headquarters building was indeed innovative; however, it did not prove durable, for it stood for only a decade.[90]

The Golf Course

A key component of Kilgore's vision for Fripp Island was a first-class golf course. He envisioned it as the centerpiece of a country club. Again limited by funding, Kilgore's plan was to create a club that would then have responsibility for the care of the golf course. On December 7, 1962, bylaws were adopted for the Fripp Island Country Club, a nonprofit corporation, with membership limited to property owners and stockholders of the Fripp Island Resort. Under the leadership of the resort, the new corporation was capitalized for $350,000. This represented 350 charter memberships at $1,000 each. In 1963 the resort deeded to the country club the golf course but retained the land around the fairways from which they hoped to realize $3 million for the sale of four hundred lots. George Cobb, a nationally renowned golf course architect, designed the course with lagoons and traps to add to the beauty of the scenic location. It had over a mile of oceanfront and three-fourths of a mile fronting on the Fripp Inlet. Some of the course was built on what was marsh that flooded at high tide. The dredging of lagoons provided dirt to fill in the marshland and to supply an overflow area for storm water.[91]

On September 26, 1964, the first nine holes of the course opened for play and by Thanksgiving weekend, all eighteen holes were ready. At first it was simply called the Fripp Island Golf Course but in 1981 the name changed to Ocean Point Golf Links. From the beginning, the financial operation of the golf course proved to be a critical problem. Kilgore's plan for the club to operate the course was not

Kilgore's Vision

A 1960s postcard of Fripp's first golf course, known today as the Ocean Point Golf Links, featured lagoons and tropical foliage. The inscription on the back stated: "Warm winds from the Gulf Stream caress Fripp Island and make it a golfer's paradise in all seasons." *Courtesy of Ernest Ferguson, Photo Arts, Inc.*

viable. Construction loans needed to be repaid and the income from greens fees was insufficient for funding the required maintenance. But Kilgore proceeded with the construction of a golf clubhouse. Built in 1965 on a vantage point on the northeastern tip of the island, the contemporary clubhouse had an open patio connecting the pro shop and locker rooms with a snack bar. Patio seats offered a panoramic view. However, the future of this course with spectacular views was in financial jeopardy.[92]

A Polynesian Theme

Kilgore chose for the island a Polynesian motif as a unifying design concept. This theme captured his vision of a tropical island with an exotic flair. It connoted, he thought, an enchanting and isolated place for getting away from the rush and stress of modern American life. From the palm frond thatched hut that served as the security gate at the entrance to the Fripp Island Bridge to the decor of the soon-to-be constructed inn, Kilgore drew on Polynesian culture for the design of this new resort.[93]

The decal used in the 1960s by the Fripp Island Resort to identify cars of property owners featured a man paddling a Polynesian outrigger canoe. The La Tai Inn, constructed in 1967, had a large model of this logo strategically placed on the lawn near the entrance. *Courtesy of Dick Anderson.*

During the 1960s a dozen or more property owners chose to build houses of this French Polynesian design, which combined the French mansard roof with an exotic flair of the South Pacific. Many of these homes have been remodeled in recent years to eliminate the distinctive roof line; however, at least a half dozen remain in their original form. *Courtesy of author.*

Kilgore's Vision

Americans in the mid-twentieth century had a special fascination with the South Sea Islands. The selection of a Polynesian theme was in keeping with a national trend that had its roots in the 1930s with the Trader Vic restaurants and then flourished in the 1950s and 1960s. The proliferation of Polynesian restaurants and motels was fueled by memories of servicemen who had served in the South Pacific during World War II, the popularity of Thor Heyerdahl's 1951 book *Kon-Tiki*, the 1958 hit movie *South Pacific*, James A. Michener's 1959 best-selling book *Hawaii* and Hawaii becoming the fiftieth state in 1959. As the suburbs and their proclivity for uniformity expanded, there was a special appeal for exotic restaurants and resorts that offered a temporary escape.

For Kilgore the Polynesian motif also proved to be an economical way for the Fripp Island Resort to achieve the desired ambience of a distant land. Using the existing plant life of the island, the resort built palm frond cabanas that dotted the beachfront and golf course to offer a shady resting place. A number of the early houses had Polynesian or Oriental features. One of the most popular styles was a modified Lowcountry cottage built of cedar to blend into the natural landscape. Like Hawaiian cottages, these houses had a pronounced overhanging roof to offer protection from the heat of the sun, and some had supporting beams that extended beyond the eaves in a stylized form that resembled the outrigging of Polynesian canoes.[94]

La Tai Inn

Kilgore recognized that the island needed an inn, a place for lodging with a fine restaurant. However, he did not have the capital required for such an undertaking. Thus he brought together ten investors and created a separate corporation, Resort Lodging Incorporated. He promised to donate the land in return for the new corporation building and operating the inn. In addition to himself, the investors included Ray Berry, Bill Turbeville and Van Newman, three of his Lambda Chi Alpha fraternity brothers, as well as Charlie Spencer, a Rock Hill attorney, and Jim Rentz, a Beaufort contractor who built many of the early houses on Fripp.[95]

Before construction could begin on the inn, the ground had to be elevated. To oversee this endeavor Kilgore hired Bob Sutton, a Georgia native who for many years had been superintendent and engineer for a large Great Lakes dredging company. Sutton combined the tasks of dredging the tidal creek and providing fill for the inn's construction. A large pipe across Tarpon Boulevard carried the dredged sand to the intended site for the inn. Kilgore had hoped to locate the marina on the backside of the inn, but after much dredging the water at low tide was still too shallow for a marina. Yet the land on which the inn was to be built had been significantly raised. Construction began in 1967 on a million-dollar motor inn with sixty rooms for overnight guests. The grand opening took place on March 15, 1968.[96]

Fripp Island

Kilgore gave the inn the name La Tai Inn, which he said meant "sand and sea" in Polynesian. The early promotional fliers advertised it as a luxury inn with a heated swimming pool, excellent fishing, an uncrowded beach, charter boats, bicycle and horse trails, golf and tennis on an "enchanted island." The inn had a sloping shingle roof, pale yellow exterior walls and bold orange trim, all inspired by South Pacific architecture. At the entrance stood a large bright orange sign depicting a man paddling a Polynesian outrigger canoe, which was the early logo of the Fripp Island Resort. The lobby boasted a stunning chandelier and a handsome curved stairway that led to an upstairs cocktail lounge with spectacular views of the expansive beach. The entire inn was decorated with Polynesian artifacts—tapa wall hangings, masks, models of early sailing vessels and tiki lanterns—that helped to create an exotic ambience.[97]

Conclusion

With the opening of a luxury inn on the island, Kilgore had brought to fruition the most essential aspects of his dream. It was a remarkable array of accomplishments.

A picture from the late 1960s shows the curving staircase and chandelier in the lobby of the La Tai Inn. Renovations in the 1970s to convert the inn into the beach club involved the removal of both the staircase and chandelier. *Courtesy of Jack Kilgore.*

He had put together a team that had bought the island, built a bridge, supplied water and electricity, carved roads and lots out of a dense jungle, constructed a golf course and now had a luxury inn to accommodate guests who, besides enjoying the island, might be prospective buyers. Kilgore reported in December 1967 that of the 1,500 surveyed lots on Fripp, 525 had been sold and about 40 homes had been built, many of which were available for rental through the resort.[98]

The end of 1968 launched the resort. The stage was set for the beginning of a community on Fripp Island. But there were clouds on the horizon. The national economy was sputtering and Kilgore was still strapped for cash for operating expenses and development projects. Within a few years some homeowners were feeling disgruntled by what they perceived to be the developer's unkept promises.

Chapter 4
A Community Takes Shape

A community with seventy-six houses existed on Fripp Island by the end of the 1960s. Most were second homes or rental properties. "Settlers," as the year-round residents referred to themselves, lived in about twenty of the houses. A mixture of young families associated with the Fripp Island Resort and older couples planning for or starting their retirement years formed the nucleus of this settlement. Isolation from traffic, stores and services combined with a shared appreciation of the alluring beauty of the island helped to create a close-knit community. Yet like small college towns that experience "town-gown" tensions, Fripp Island would eventually experience friction over the diverging views of the resort managers and residents.[99]

The Early Settlers

Jack Kilgore, the president of the Fripp Island Resort; his wife, A.J.; and their four sons; along with Roy Krell, the resort's chief financial officer; his wife, Mary; and their two daughters were the first people to live on Fripp Island. Shortly afterward arrived the families of Ben Eidson, the resort's office manager; Shirley and Bob Sutton, the island engineer and jack-of-all-trades; and Demos Jones, the golf pro. In 1967, with plans underway for opening an inn, a general manager and a director of public relations moved with their families to Fripp. Considering the few residents during the first few years, there was a surprisingly large number of children.[100]

These families faced a dramatic change in lifestyle when they moved to the island. A.J. Kilgore transitioned from the social whirl of Columbia, where she was president of the Junior Woman's Club, to the relative seclusion of Fripp. She had to get used to the absence of friends and many conveniences and to the half-hour drive to buy

One of a number of palm frond cabanas on the beach that provided shade. Roy and Mary Krell called this one their "air-conditioned office." It is where Mary often assisted Roy by providing refreshments for prospective buyers. *Courtesy of Mary Krell Avinger.*

Palm frond cabana on Fripp beach. *Courtesy of Jack Kilgore.*

A Community Takes Shape

groceries. Additionally, wild animals lived on the island: boars, alligators and big snakes. There were no streetlights and at night it was very dark with lots of new sounds, particularly the loud chorus of katydids.

Both A.J. Kilgore and Mary Krell stood ready on very short notice to entertain and feed prospective buyers. Sometimes Mary would take pimento cheese sandwiches and iced tea down to the palm frond cabana on the beach for visitors touring the island. When Jack called A.J. about some particularly "hot prospects," A.J. would rush to buy fish from the Gay Fish Company on St. Helena Island while her sons built a fire on the beach. A.J. would fry fish and hush puppies in her large iron skillet, and the tailgate of their Bronco would serve as a small bar. The sun would be setting and the smell of sizzling fish would permeate the beach just as Jack would arrive with his client.[101]

Between the ages of two and fifteen, the Kilgore boys relished opportunities for exploration of the mostly deserted barrier island. Glen Kilgore, who was eight when his family moved to Fripp, recently reminisced about growing up on the island. Imbedded in his memory was discovering marsh mud with thousands of fiddler crabs dashing about. After more than thirty years, Glen can still close his eyes and smell the mud, remembering how it felt squishing through his fingers and toes. There were frequent mud fights and the boys would emerge "looking like creatures from the proverbial black lagoon."[102]

The shift in lifestyle was also pronounced for Demos Jones. In reflecting on his decision to become a golf pro, he said that after ten years at the bank, he needed "to get out in the sunshine." Having been the state amateur golf champion in 1961, he had over the years considered becoming a professional golfer. Jones had been a fraternity brother at the University of South Carolina with Kilgore and was familiar with the island. "I haven't regretted for the first minute," Jones said, "trading that busy and cluttered desk top for a smooth grass surface of a putting green."[103]

Bob Sutton's family was one of the most social on the island. They regularly fried the fish caught that day and everyone was welcome, whether resident or visitor. The houseboat that Bob built and docked near the location of the present marina had an upper deck that could accommodate thirty-five people. George Douglass, an avid fisherman, and his wife would bring homemade mayonnaise and freshly baked bread to make their own version of po' boy sandwiches. Kilgore quickly recognized that visitors were attracted to the fun and warmth they found at the Sutton gatherings and often brought potential buyers to enjoy the feast of fresh fried fish.[104]

Chuck and Margaret Owens were one of the first full-time families not associated with the resort. They moved to Fripp in 1965 after Chuck became the first headmaster of Beaufort Academy. They reported that friends frequently asked them what island life was like. Having moved to Fripp from Atlanta, they said that they relished living in "a sportsman's paradise," where there was a golf course and "the finest surf and deep-sea fishing are available at your doorstep." Thus they happily traded the "traffic congestion, smog, and many problems associated with city life," for nature

and a more relaxed life on Fripp. They found enormous pleasure "in watching the ever changing face of the ocean as it responds to the wind and tide." In writing about life on Fripp, Chuck Owens concluded, "As the full moon rises majestically out of the ocean to bathe our island in its light, Margaret and I are again resolved that we could never exchange this beauty and serenity for all the glamour and excitement of the neon-lighted panorama of Peachtree Street."[105]

Retirees soon became the core of Fripp's population. Typical of this group were Kay and Ken Engler, who moved to Fripp from Short Hills, New Jersey, where Ken had been in the building supply business. Kay, a member of the Hammond Map Company family, became a social ringleader who organized parties at the drop of a hat. When new people moved to Fripp, Kay would round up the residents for a get-acquainted cocktail party.[106]

Two other early settlers who contributed greatly to the Fripp community were Dick and Norine Smoak, who in 1966 built the island's sixteenth house and the first house on the south end of the island. The following year Dick retired from his position at the Pentagon and began selling lots on Fripp. With his gracious, outgoing personality, Dick made friends with all he met and sold over seventy-five lots in five years. Norine, a nature enthusiast, referred to herself as "a one person chamber of commerce" and when asked what she did, she replied, "I watch birds, clouds in the sky, count pelicans, walk on the beach, grow a few flowers, enjoy friends and read and read." A life that she described as "not exciting but very satisfying."[107]

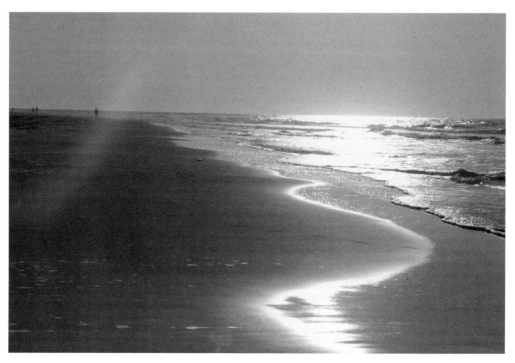

Photograph of Fripp Island on a moonlit evening. *Courtesy of Julie Hodgson.*

Among the first part-time residents were Bill and Dixie Winter. When they built the seventh house on the island in 1965, both were still working in Aiken, Bill at the Savannah River Plant as an engineer and administrator and Dixie as a teacher. They came to Fripp for weekends, and Dixie and their daughters came for the summer. Bill recalls that for the first few years they did not have a telephone at their Fripp house. When they would arrive on Friday evening, there would be a note tucked in their door telling them where the party would be that night.[108]

In a few cases, the husband commuted to work while the wife established a full-time residence on Fripp. This was the case with Gini and Griff Reese. When they moved to Fripp from New York in 1968, Gini retired from teaching music but Griff continued as a pilot for Pan American airline. Since he had the long Asian routes, he had extended layovers on Fripp between flights. Golf, fishing and the natural beauty of the island attracted them to Fripp. As often as three times a week, they would feast in the evening on seafood that they had caught that day.[109]

Many early property owners were as enthusiastic about the island as Kilgore and Krell and helped spread the word. From his first visit to Fripp in 1965, Ron Yaw, director and executive vice-president of the Blodgett Memorial Hospital in Grand Rapids, Michigan, envisioned retiring to Fripp permanently. In the intervening years he used the Fripp house as a family retreat and rented it at other times through the Fripp Island Resort. As president of the American College of Hospital Administrators, he had contact with many health professionals whom he told about Fripp. During a lunch conversation at a hospital management conference in San Francisco, Yaw glowingly described the island to Bill Robinson and George Allen, two executives with the Hospital Association of New York State. They both subsequently visited Fripp and bought property. The Robinsons eventually retired on the island. Yaw also recruited future residents Zack Thomas, CEO of Charlotte Memorial Hospital, and Ray Brown, director of the graduate program in hospital management at Duke University. This pattern of business associates, friends and family extolling the virtues of a special place called Fripp Island began early and continues to this day.[110]

Although the first two houses on Fripp, those of the resort management, appeared more suited to a suburban neighborhood than a barrier island, most of the early residences blended with the environment and reflected Lowcountry styles. Jim Rentz, president of Beaufort's Coastal Contractors, opened an office in 1966 on Fripp and built reasonably priced custom homes as well as houses from set plans drawn by Charlie Johnson, a local architect. Several of these featured modified Lowcountry designs with some Polynesian features, such as the clipped gables resembling a ship's prow and extended supporting beams reminiscent of outrigger canoes. The owners of many of these houses included those seeking a weekend and summer vacation place as well as prospective retirees planning ahead for a future home.[111]

One of the unique early homes belonged to Ron and Elrose Yaw. Built in 1967 by Jim Rentz's Coastal Contractors, this beachfront home called "Sea Dawn" was a gray-stained octagonal structure with surrounding decks that blended with the sand dunes. A

One of the early cottages on Fripp built in the Polynesian style. *Courtesy of Julie Hodgson.*

large living and dining area featured a handsome fireplace with a sunken conversation pit, which Yaw referred to as the "Martini Pit." In 1968 John and Barbara Miller, part-timers from Chicago and Colorado, where they had a Hereford ranch, built a large home with columns that quickly became dubbed "Tara." The Millers were known for their elegant Christmas parties where they served smoked pheasant.[112]

Many of the employees of the resort did not live on Fripp but nevertheless became an integral part of the island community. Dixie Winter especially recalled James Atkins, a black man who worked at the inn and was greatly respected on the island. Atkins "wore many hats," Winter said; "if you needed a ride to the airport he could be chauffeur; if the yard man was sick, he could cut the grass." When Atkins had a heart attack, the Fripp community collected money to assist with his expenses. As Winter tells the story, Fripp retiree John Seymore took the card and money to the hospital. When Seymore arrived at Atkins's room, the nurse looked at him sternly and said, "He's allowed to see members of the family only." Then according to Winter, Seymore looked at the nurse and said firmly, "Well, he's my brother," so they let him in.[113]

Shared Concerns

Concerns about basic services brought Fripp residents together. The need for a fire department was foremost. Using Fripp Island Public Service District (PSD)

A Community Takes Shape

This detailed view of a Polynesian-style cottage highlights the roof shaped as a ship's prow and the extended supporting beams with trim reminiscent of an outrigger canoe. *Courtesy of author.*

property tax dollars supplemented by the contributions of over thirty residents who contributed $200 each, Fripp was able to purchase a second-hand pump engine for $18,000 in 1968 from another town in South Carolina. A three-sided shed with a palm frond roof sheltered the red fire engine, which had "Fripp Island Fire Department" lettered in gold on the doors. It was not until March 1971, under the leadership of Ken Engler, that volunteers began to hold weekly fire drills. The volunteers had many humorous experiences, such as having to use a hair dryer to dry out the plugs of the fire engine.[114]

Residents also united around a desire to have worship services on Fripp. The first plans for the layout of the Fripp Resort, conceived in 1960, had a plot of land designated as a church conference center. While this structure never materialized, the commitment to a religious presence on Fripp remained. Bill Turbeville, owner of a large insurance agency in Columbia and a fraternity brother of Kilgore's, built a vacation home on Fripp in 1967. That year he coordinated an Easter sunrise service held in a home overlooking the ocean. Subsequently A.J. Kilgore spearheaded the effort to have regular church services. During the summer of 1969, there were weekly mid-week vespers services at La Tai Inn with ministers from churches in Beaufort conducting the services. This stimulated a campaign

The store, an early Fripp landmark, was located near the entrance of the island near what is today the parking lot for Spring Tide Village. Often called "Mobley's Mall," it had a convenience store, gas station and liquor store. In 1974 the store and gas station were moved to the marina. *Courtesy of Rita Waller.*

A Community Takes Shape

to raise money for a chapel. However, after this initial experiment with religious services and after raising a few thousand dollars, there was a lapse before a resurgence of interest in 1973.[115]

Besides the inn, there were two places where residents gathered to visit. One was at the corporate headquarters where they went to pick up mail. Before the arrival of individual mailboxes, all mail was arranged in alphabetical order around the edge of the sunken fish pool in the lobby. The other popular spot for congregating was Mobley's Mall. During the early years several different men operated the store, but because Mr. Mobley had the job for the longest period, the store came to be called Mobley's Mall. It provided snacks for construction workers and some limited staples, such as bread, soft drinks, Alka-Seltzer and cigarettes. A small section—partitioned off by lock and key—served as the liquor store and perhaps did the most business. In front of the store was a gas pump. Mobley, who was quite a character, would sit in his rocker, chew tobacco and tell about the entire island's latest developments and gossip. Folks would gather at the store around 3:30 or 4:00 p.m. to pick up the latest news. Dixie Winter recalled, "It was earth-shattering news what kind of fish were running." Mobley was an ardent Clemson supporter while Kilgore pulled for the University of South Carolina. There was a lively tradition between them that when the two teams played each other the flag of the winning team could fly over Mobley's Mall.[116]

Fishing

Fishing was a passion with many early residents. George Douglass, an insurance executive from Connecticut who had retired and moved to Fripp in 1969, headed up the effort to build, at residents' expense, a floating dock on Old House Creek at the end of Bonita Road. The frequent use of the dock highlighted the need for a small service building nearby to provide space for storage of boating equipment, toilet facilities and sale of bait, supplies and soft drinks. On April 22, 1970, George Douglass, on behalf of himself and Bob Sutton, wrote to Jack Kilgore asking the Fripp Island Resort "to lease us a small area near the head of the dock—for a nominal yearly sum." Douglass made it clear that the residents would pay for the structure, follow the island architecture and keep the area clean. In a handshake agreement, Kilgore gave permission for the small marina building in the spring of 1970.[117]

In an oversized green-bound record book titled "Log: Old House Creek Marina," Sutton kept a daily account of activity at the marina. From the first entry on May 17, 1970, until the last one on April 23, 1971, this log provides a rich history of a vibrant community of fishermen. Each entry included a list of boats that went to and from the dock that day, notations on the weather plus sundry other bits of information. During the first two months, the log gave progress reports on the construction of

Photograph taken in 1969 shows a bountiful catch hanging from the makeshift posts on the dock at the Old House Creek Marina. *Courtesy of Shirley Sutton.*

the marina building. For example, the May 27 entry noted, "Finish roof and eaves on bait house." The primary work crew included George Douglass, Bob and Shirley Sutton, their son Bobby, John Miller and Bill Brazell, who operated the dredge for the building of the Fripp canal and lagoons. Dan Sawyer, a retired architect from South Hampton, Massachusetts, salvaged a nineteenth-century arched window to give the building a little class. Finally on June 13, 1970, the log announced "Open House!" and twenty-seven people signed the guest list.[118]

During 1970, on most summer days half a dozen boats would leave from the dock, primarily on fishing trips. And the fishing was superb. In addition to crabs and shrimp, they caught all kinds of fish, from trout and black tip shark to Spanish mackerel and sheepheads. Most of the regular fishermen lived on Fripp, including Ben Eidson; Ed Gidley, a retired New Jersey lawyer for the Pullman Company; John Broz, a former owner of an export business in Cincinnati; and Maury Eastin, a consultant to the Environmental Protection Agency. Of the local Beaufort residents, Henry Chambers, who had been one of the original directors of the Fripp Island Resort in 1960 and later became mayor of Beaufort, and Dean Poucher, the head of the local chamber of commerce, were two of the regulars. Occasionally a chartered boat from Hilton Head docked overnight.[119]

Besides fishing, there was partying at the marina. On August 9, 1970, the log recorded: "Shrimp Boil at Sutton's Houseboat, 18 Fripp Islanders enjoying shrimp and crabs, salad, red rice, chips. Storm came up again and we closed and departed." The party on Saturday, November 28, set a new record for numbers and duration. Preparations began on Friday and a clean-up crew of ten worked on Sunday. The feast featured oysters and the roasting of two wild pigs shot on Fripp. Over one hundred people signed the guest list in the log.[120]

Entries in the log came to an abrupt end in April 1971 with two final postings: "As of today Friday, April 23rd, Marina is under new management. The Past Management will not be responsible from this date," and the next day "Last Entry—Lock being changed on doors." In recalling these events, George Douglass, who had spearheaded the marina initiative and had put a considerable amount of his own money into the project, was very distressed that Jack Kilgore had decided after one year to "cancel the lease on the marina property." Kilgore maintained that from the beginning he had stated that the lease could be canceled at any time. However, when pressed by Douglass, Kilgore did agree to pay the cost of the materials used in constructing the bait house. Effective April 23, 1971, the marina became a part of the Fripp Island Resort operation, and anyone desiring to use the marina had to become a member of the resort's Fripp Island Yacht Club and pay ten dollars annual dues. The resort placed a gate with a lock across Bonito Road leading to the marina. Although it usually remained open, it stood as a painful reminder of what some regarded as a high-handed maneuver. Unfortunately, this was not to be the only issue on which the early residents and the resort management would tangle.[121]

Festivities at La Tai Inn

Fripp's luxury motor lodge, the La Tai Inn, held its grand opening in mid-March 1968, with a weekend filled with special events. The schedule featured something for everyone. There was a performance by an equestrian team, a demonstration by the Marine Sport Parachute Club, entertainment by Tahitian dancers, exotic Polynesian foods, a swing band and "Champagne and Lace," a midnight lingerie fashion show.[122]

A pool surrounded by a palm tree patio and a grass lawn reaching the foot of the large sand dunes that graced the entire beach provided a superb setting. The focal point of La Tai Inn was the restaurant and dance floor. The restaurant combined the fascinatingly strange aspects of Polynesia with the hospitality of the Carolina Sea Islands. The menu featured local seafood prepared by Pierre Rosier, an internationally acclaimed French chef. Dressed in white chef's attire, he oversaw the preparation of gourmet dishes, oyster pie being a favorite. On weekends, there were festive formal dances. Women in long dresses and men in suits or sometimes tuxedos danced to popular swing music. A number of Fripp's early residents were

The grand opening for the new million-dollar La Tai Inn took place during the weekend of March 15–17, 1968. Resort management encouraged guests to wear "Polynesian Dress" for the special dedication of the new facility on Friday evening. *Courtesy of the Fripp Island Property Owners Association.*

A Community Takes Shape

The Fripp Island Resort featured in its promotional fliers La Tai Inn's Polynesian décor, excellent food and elegant dining. *Courtesy of Jack Kilgore.*

regular readers of *Vogue* and *Women's Wear Daily* and wore the latest fashions for their evenings at the inn. In the event that any gentleman forgot his coat or tie, the inn kept a supply that could be provided quickly.[123]

On the upper level of La Tai Inn there was a bar featuring live music. Billie Mustin, a popular pianist and vocalist who performed in Columbia and New York, was among the featured artists. Her sister Helen Fant, who owned a house on Fripp, recently recalled an occasion when Billie was performing for a full house at the La Tai Inn and suddenly someone shouted that a sea turtle was on the beach laying eggs. The audience hastily departed, and Billie noted that it was the first time she had ever been "upstaged by a turtle."[124]

La Tai Inn became the center for resort functions as well as a gathering place for island residents. Resort Lodging Incorporated, a separate corporation, operated the inn. However, Jack Kilgore was its president, and there was considerable overlap between the board of the resort and that of the inn. As a full-service upscale operation with sixty rooms and a dining room that served three meals a day, the inn employed eighty people during busy seasons to work at the front desk, in the kitchen and dining room and on cleaning crews.[125]

With a reputation for fine dining and large luxury bedrooms, many with ocean views, the La Tai Inn developed a program to attract both families and small groups. During its very first summer, the hotel established a children's program and ran a stable to provide guests with horses to ride. Emmy Sullivan, who moved to Fripp with her family when she was a teenager, worked at the stables and fondly remembers leading guests on rides along the beach and through inland trails. The stable workers had their favorite secluded places, easily accessible by horse, where there were always lovely views and cool sea breezes, even in the hot summer. A successful marketing effort brought a wide variety of groups to the La Tai Inn. Among the early groups that held meetings at the inn were the South Carolina Salt Water Sports Fishing Association, the South Carolina Industrial Developers Association, the Beaufort County Development Commission and the South Carolina Associated Press News Council.[126]

Capitalizing on the mild climate, the resort management targeted its publicity efforts on Canadian and Northern markets. The La Tai Inn staff invited a special group of Canadian guests for a three-day round of activities in February 1968. The following year the staff of the Fripp Island Resort and the La Tai Inn initiated what they hoped would become an annual event of sending employees to major northeastern cities to make contacts with travel agents, writers and others who could steer visitors to Fripp Island.[127]

La Tai Inn wasn't only a place for overnight guests; it also housed special celebrations as well as music and art. There were Halloween masquerade parties and New Year's Eve celebrations. Septima Bowers, the head of public relations for the Fripp resort, oversaw many of these special events and adopted the practice of placing on her mailings to Fripp Island friends and owners not only the date but also the temperature.

A Community Takes Shape

During the late '60s and early '70s, the Fripp Island stables, located on land that became Periwinkle Court, offered the La Tai Inn guests and property owners the opportunity to ride horses along the beach or inland trails. *Courtesy of Dora Edwards.*

Horseback riding on Fripp. *Courtesy of Lou Cashdollar.*

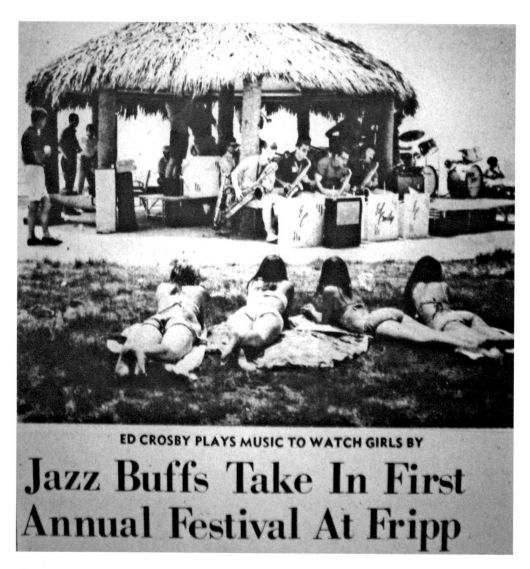

The June 25, 1969 *Beaufort Gazette* and accompanying photograph reported on Fripp Island's first jazz festival where Ed Crosby's fourteen-piece orchestra played jazz and swing tunes for a large crowd of enthusiastic spectators. *Courtesy of the* Beaufort Gazette.

In early 1969 Bowers, always seeking ways to promote the island, facilitated the establishment of the Fripp Island Art Association, which sponsored the first annual jazz festival in June. "Jazz buffs from far and near," the *Beaufort Gazette* reported, "gathered on the oceanfront lawn of La Tai Inn Saturday to enjoy the music of some of the south's top artists." Larry Conger's Two Rivers Jazz Group, which specialized in Dixieland rhythms, and Ed Crosby's fourteen-piece orchestra set up under the palm-frond cabanas on the beach and played to an estimated crowd of six hundred. During the following three years, the annual Fripp Island Jazz Festival continued to draw large amounts of people.[128]

For the promotion of the visual arts, the Fripp Island Art Association hosted special exhibits and shows at La Tai Inn. The first exhibit in February 1969 featured a one-woman show by Ann Karesh of Charleston. During Easter weekend of 1969, the association sponsored an invitational show of South Carolina artists to compete for $600 in prize money; Donald Crawford of the Columbia Museum of Art served as one of the judges.[129]

Declining State of the Golf Course

La Tai Inn also hosted golf tournaments. On July 24, 1968, Fripp Island held the First Annual Ladies Champagne Golf Tournament with many players from nearby states. Among the winners was Fripp Island's own Barbara Turbeville. Other golfing events included an exhibition match by Bobby Cole, a South African pro, and a visit of eighty-five women golfers from the Savannah Women's Golf Association.[130]

However, the golf course quickly began to deteriorate. While the course had a spectacular setting, the exposure to high winds and salt water combined with poor soil made it an expensive course to maintain. How to pay for the golf course on Fripp became a major source of tension between residents and resort management. In 1962, even before the bridge was built, the resort had created the Fripp Island Country Club and initially sold charter membership certificates for around $1,200 with the promise of unlimited play for years to come without dues. From the beginning many club members had realized the resort's sales pitch was unrealistic. In 1963 the resort turned over the deed, the debts and the operation of the golf course to the Fripp Island Country Club. When the club had difficulty running the golf course, the members voted during the 1965 annual meeting to lease the club to the resort. But the resort also had difficulty maintaining the course.[131]

The departure in 1967 of Roy Krell, who had been the island's chief financial officer since 1960, may well have been related to divergent views over issues related to the golf course. Krell had assisted in establishing the Fripp Island Country Club and served as its first president. While Kilgore had enlisted Krell's financial expertise in developing the island and the two men had worked well together in the early stages, there was considerable conflict concerning style of management, priorities

and the future direction of the island. This led to such a rift that Krell resigned and moved to the Santee area, where he worked on development of a new resort.[132]

By 1970 the Fripp Island Golf Course was in bad shape. The water supply furnished by wells on St. Helena Island provided only a fraction of what the golf course needed to maintain its greens and fairways. To make matters worse, the clubhouse built in 1965 burned down in less than thirty minutes on March 6, 1970, in gale force winds. There was no way to control the blaze.[133]

An impasse developed toward the end of 1970 when the Fripp Island Resort and the La Tai Inn failed to make their agreed contributions for the running of the Fripp Island Country Club. In the winter months of 1969 the La Tai Inn had offered guests "unlimited complimentary golf on an eighteen-hole championship course, three free golf balls, and free golf clinics." In return for being able to offer this and other attractive packages, the Fripp Island Country Club expected La

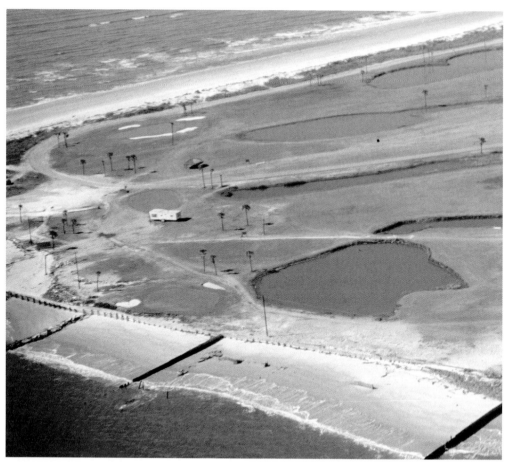

A 1971 aerial view of Fripp's first golf course shows the setting along the Fripp Inlet where there were sand dunes and a broad beach. By the time this picture was taken, the clubhouse built in 1965 had been destroyed by fire and a trailer served as its replacement. *Courtesy of Ernest Ferguson, Photo Arts, Inc.*

A Community Takes Shape

Tai Inn to make monthly contributions to the general operating fund. However, the money was not forthcoming. Furthermore, the Fripp Island Resort, which featured the golf course in marketing the island, was $70,000 behind in its payments to the club.[134]

Brantley Harvey Sr., the president of the Fripp Island Country Club, detailed the financial dilemma in a memo on December 18, 1970, to all certificate holders of the Fripp Island Country Club. Harvey noted that without the contributions from the resort and the inn, the club was unable to make its October mortgage payment. When the bank was about to foreclose on the golf course, fifteen members of the club put up $5,000 each to raise the necessary money to buy the mortgage from First Federal of Savannah. Harvey concluded his memo by stating: "All of the people who put up the money did so hoping that the Fripp Island Resort and La Tai Inn will realize that the membership certificate holders cannot run a golf course for their benefit without substantial help from them."[135]

However, the resort and inn did not make their promised contributions and the situation did not improve. A property owner from Greensboro, North Carolina, named C.D. Warnick voiced a frequently heard sentiment when he stated that the golf course was in a "very bad state of repair." Besides having rough greens and unkempt fairways, many Fripp property owners considered the house trailer, which after the fire served as a pro shop, an eyesore. J.R. Bergevin, the general manager of the inn, agreed. On February 23, 1971, he notified the board that a North Carolina business group had just cancelled its convention at the inn. This action, Bergevin explained, "was due entirely to the state of the Fripp Island Golf Course." The following month Bergevin again wrote to the board detailing how poor conditions on the golf course were having a negative impact on the inn's occupancy rate.[136]

The Fripp Island Country Club instituted a dues structure in 1971 in an effort to raise needed operating funds, but the amount of money required far exceeded the capacity of the club members. Because the resort had indicated that it would not make any payment to the club, the members concluded, "the club should enjoin resort and realty from advertising that an eighteen-hole golf course is available to perspective lot purchasers." Additionally they decided to advise the resort and realty company that any future owners of lots could not enjoy the privileges of the club unless they become club members. The rift between the golfers and the resort management had widened. The club members' determination to force Jack Kilgore and the resort to help support the golf course was, however, to no avail. Kilgore had his own serious financial problems.[137]

Kilgore's solution to the poor state of the Fripp golf course was to put together a new group of investors in the fall of 1971 to purchase the Fripp Plantation on Seaside Road on St. Helena Island, where he hoped to build a new golf course. He envisioned the old plantation house as a pro shop and restaurant. With a plentiful water supply and better soil conditions than Fripp Island for growing grass, he saw the land on St. Helena as the perfect place for a golf course.[138]

Fripp Island Home Owners Association

The resort's lack of funds exacerbated the relationship between property owners and the resort on significant issues besides golf. The increasing level of frustration with the resort over poor roads, absence of security guards on the bridge, failure to adhere to the covenants and the lack of a sewer system—all breaches of the resort's initial promises—led to the founding of the Fripp Island Home Owners Association in the fall of 1969.

The key founders of the association were George Douglass, Bill Huyler, Dick Smoak and Doug Lawrence, all of whom had considerable administrative experience. Douglass was a vice-president with Traveler's Life Insurance; Huyler, a former top executive with Germaine Monteil Cosmetics; Smoak, a career army officer; and Lawrence, a banker. Meeting in the study at Douglass's house, the men mapped out plans for the new organization. The initial meeting of the Fripp Island Home Owners Association was held at the La Tai Inn on November 8, 1969. The new organization's membership included resort managers. The stated objectives were to provide a forum for discussion of mutual concerns and to establish a liaison for cooperation between the resort and residents. Douglass and the other organizers intended for those who owned houses to be the key constituency with an associate membership category for those who owned lots. The annual dues for both categories were five dollars.[139]

One of the first problems the Fripp Island Home Owners Association addressed was the lack of a twenty-four-hour security guard on the Fripp Island Bridge. On March 9, 1970, George Douglass wrote to Jack Kilgore noting the recent burglaries, a store robbery, stolen equipment at the marina and the appearance of unauthorized solicitors and strange vehicles on the island. Douglass reminded Kilgore that when he and other homeowners acquired property on Fripp Island, they believed Fripp would be maintained as a private island with around-the-clock security. Kilgore responded that as a result of the national financial slump, which had caused a decline in sales of lots on Fripp, it was necessary for the resort to "make certain reductions in our overhead and our present guard duty at the bridge is one category that is being reduced." Thus while the Home Owners Association began to explore other strategies for reestablishing bridge security, many residents felt betrayed and discouraged by resort management policies.[140]

The resort's handling of the annual fifty-dollar assessment of all lots also disturbed property owners. At its December 1970 meeting, the organization passed a motion calling for the appointment of a committee to check the records of the Fripp Island Resort. These records dealt with the annual assessment that according to the covenants was to be used exclusively for street repairs, landscaping, beautification and insect control. The poor condition of the roads, unsightly litter and proliferation of mosquitoes had precipitated the motion for this report. After some negotiations the resort management cooperated with the fact-finding initiative. A committee

A Community Takes Shape

An early Fripp Island brochure featured the Polynesian style guardhouse built soon after the construction of the Fripp Island Bridge in 1963. Unlike the current guardhouse, this one was located on the Hunting Island side of the bridge. *Courtesy of Jack Kilgore.*

composed of Bill Winter, Gini Reese and Bill Huyler issued a report on May 2, 1971, stating that Kilgore did not dispute any of the information in the report. Perhaps most disturbing, the committee found that no formal escrow account had ever been established and that often there had been no detailed accounting of expenditures. Additionally the committee learned that capital improvements—such as the construction of groins and the sea wall at the North Point and the construction of the bridge over the canal—had been charged to this account. They also discovered that only about half of the property owners had actually paid the annual assessment. The report included a series of recommendations that would regularize the account. Kilgore maintained repeatedly that Fripp's Public Service District (PSD), which state law required to provide water and fire protection, should also be responsible for roads and bridge security. Without adequate funds, the resort was seeking in the 1970s to shift responsibilities for services it had assured purchasers in the 1960s it would provide.[141]

While the resort seemed eager to turn over the upkeep of expensive services to the PSD, it seemed unwilling to assist the PSD in finding needed office space. When Beaufortonian Henry Chambers had been chairman of the PSD, he supplied office facilities free of charge in Beaufort. However, once the chairmanship shifted to a Fripp Island resident, the PSD operated out of homes. As the work expanded this proved untenable. The PSD needed a central office. In November 1971, Jim Rentz of Coastal Contractors offered the use of his Fripp Island office to the PSD. However, Kilgore blocked the offer and "insisted that Mr. Rentz live up to a verbal agreement that the office would be used only by Coastal Contractors." The residents considered Kilgore's denial of the offer of office space a disturbing form of "harassment." This episode was just another example of the ill will that was festering between the residential community and the resort management.[142]

With services declining and the relationship with the resort continuing to deteriorate, Bill Huyler, who became president of the Home Owners Association in 1971, decided that the association must incorporate. He felt that this step was needed in the event that the Home Owners Association had to step in to make contracts and employ staff to assume services on which the resort was defaulting.[143]

By February 1972, the residents' grievances against the resort had mounted to such an extent that a delegation from the Home Owners Association consulted a lawyer to consider legal action. In a meeting with Beaufort attorney G.G. Dowling, the group reviewed what they described as "a number of areas of misrepresentation by the developers of Fripp Island to purchasers of property" and explored how best "to recover damages and to prevent the continuation of these practices." In addition to the lack of support for the golf course, no twenty-four-hour watch on the bridge and the misuse of the fifty-dollar annual assessment, the group identified a number of other pressing issues. Foremost among them was what the residents understood as a disregard by the management of the commitment in the restrictive covenants to allow only single-family dwellings on Fripp Island. The residents strongly opposed the building of the Captain John Fripp Villa condominiums.

Additionally, they were distressed that the resort management had never fulfilled its promise to build a sewer system. At Dowling's request, the Fripp Island Home Owners Association identified thirteen specific instances of misrepresentation and documented these with references to the "Restrictive Covenants" and the resort's booklet, titled "Basic Data."[144]

The Need for a Sewer System

In 1963, before the bridge or any home had been built, the South Carolina State Board of Health notified Kilgore of the need to build a sewage disposal facility on Fripp Island. However, when there were no plans for a sewage facility by 1972, the Fripp Island Home Owners Association and the PSD retained attorney William Bethea, who brought this issue to the state agency's attention. A final blow to the resort's financial viability came on March 1, 1972, when the South Carolina State Board of Health brought a petition before Judge Green in the Civil and Criminal Court of Beaufort against the Fripp Island Resort. In this suit, the Board of Health requested a temporary injunction to prohibit the resort from "selling any lots or parcels of land in Beaufort County, until such time as a feasibility study on the method of waste disposal is submitted to and approved by the State Board of Health." Bethea, speaking on behalf of the homeowners and the PSD, said that his clients "are interested only in seeing that some concrete steps are taken toward the realization of a sewer system." The state health agency stressed that there were already over 120 septic tanks on the island and there was a major concern that "the lot sizes are too small to safely sustain a septic system."[145]

The resort received a reprieve a few months after the filing of the State Board of Health's case when Judge Rhodes lifted the injunction on the sale of property on grounds that Judge Green lacked the jurisdiction to rule in the sewer case. With the case thrown out, the resort was no longer prohibited from selling lots. However, the restriction on permits for septic tanks remained, and Kilgore knew there was a need for a sewer system. The resort developers contracted with a Columbia firm to prepare a feasibility study for constructing a sewage treatment plan for the island. However, the question remained: how could the resort pay for it? Griff Reese observed that the sewer issue was "the straw that broke the camel's back for Kilgore."[146]

Kilgore Decides to Sell

Kilgore didn't have money to undertake the sewer construction. Additionally, he still had the problem of finding funds for security and for maintenance of the golf course. Kilgore attributed his problems to the faltering economy. Following a mild

Fripp Island

The opportunity for families to enjoy the surf has always attracted people to Fripp Island, where the gently sloping beach and temperate water remains appealing to all generations. *Courtesy of The Fripp Group, Inc.*

A Community Takes Shape

recession in 1969–70, wages, prices and interest rates spiraled upward. The result across the country was limited growth, a stagnant national economy and increased unemployment. Yet, despite this adverse national economic climate, growth on Hilton Head Island continued at an exponential rate with the passage of a $1.5 million bond issue to build a sewage treatment plant and expectation in 1972 for $50 million in new construction.[147]

Not all of the Fripp Resort's difficulties were due to the economy. Fripp was falling behind in the competition for investors as South Carolina gained newer, larger and more easily accessible beach resorts. Hilton Head Island, which had acquired an airport in 1968, was rapidly expanding with the establishment of several major new communities. Just north of Charleston on Isle of Palms, developers started building Wild Dunes in 1968, a large upscale resort. And south of Charleston, Kiawah Island was drawing acclaim as a premier resort. Not only were these islands easier to reach, but they also had the advantages of finer golf courses and more diverse restaurants and shops. For a few short years La Tai Inn benefited from having one of the best restaurants in the area. In fact, the late 1960s was the golden era for the inn. However, as the novelty of the new resort on Fripp diminished and the quality of the golf course declined, the competition increased and took its toll.

In 1960 Kilgore had a vision for a resort on Fripp Island. Twelve years later, there were accomplishments but also serious difficulties. The slumping national economy and rival resorts certainly contributed to Kilgore's financial problems. Among those who were close observers of the early years on Fripp, there was a frequently expressed view that Jack Kilgore, a likeable young man, was "in over his head" in trying to establish a new multimillion dollar enterprise. Furthermore, many on Fripp understood Kilgore's frustration as retired CEOs and top executives scrutinized his every move. Nevertheless, Kilgore's management decisions had the unintended consequence of galvanizing the property owners into an activist community.[148]

Kilgore reflected in 2004 about his years on Fripp. The one thing he said that he would definitely have done differently was he would "have kept the building part" instead of letting a private contractor reap those profits. He still has the carousel with the worn slides that he used as he traveled making promotional talks. "The photos of the beach and the tropical vegetation," he said, "sold the island." When he began the development of the island, he said he "had no idea the amount of money that was needed." He would make money but he "had to just keep plowing more money back into the island." Despite all the challenges, he remembers his Fripp years as exhilarating and retains a great fondness for the island.[149]

Fripp hit a low point in 1972. There were approximately 120 houses, most occupied sporadically. The large majority of people who purchased lots had not built. The community on Fripp was too small to sustain the level of services and amenities necessary to attract investors. In the summer of 1972 when a consortium of South Carolina savings and loans expressed interest in purchasing the resort, Kilgore jumped at the opportunity.[150]

Fripp Island

In the decade following Kilgore's departure, the resort rebounded with the building of more houses and the infusion of needed capital from the consortium of savings and loans. Two auspicious developments promised a brighter future for Fripp: one was the determination of the new owners to bring the highly fragmented operation of separate ownership of the golf course, inn and resort all together under one management; the other was the growth of the year-round community, which by 1976 numbered almost one hundred people.[151]

Chapter 5
Coming Together

On November 10, 1972, a coalition of South Carolina savings and loans purchased Fripp Island's amenities and undeveloped land. The terms of the sale as well as their vision for the future ushered in a period of expansion as well as improved cooperation between the resort and the homeowners. In 1970 only a dozen houses had full-time residents. By 1976 there were almost 50 houses with permanent residents and that number rose to 134 houses with full-time residents by the end of 1979. The increased population on the island provided the critical mass needed for protecting the natural beauty of the island and building a vigorous community. The adoption by the new management of the marketing slogan, "Fripp Island: Another World, Not Another Resort," signaled the corporation's effort to steer a course that emphasized both fine facilities and the natural environment, policies that resonated with the homeowners.[152]

Savings and Loan Coalition

Charlie Spencer, a Rock Hill attorney, played a pivotal role in brokering the transfer of ownership from Jack Kilgore, the original developer, to a coalition of savings and loans. Spencer built one of the first houses on Fripp and subsequently became a member of the board that owned and managed the inn. His son, Chuck Spencer, who was only a teenager at the time, recently recalled his father saying that "Fripp had become stagnant, the golf course had withered away, the stockholders were fed up and something had to be done to prevent foreclosure." Thus Charlie Spencer discussed with his close friend John Hardin the possibility of a coalition of S&Ls acquiring Fripp. Having planted the seed that led to the purchase, Spencer's law firm handled the eventual transaction.[153]

Fripp Island

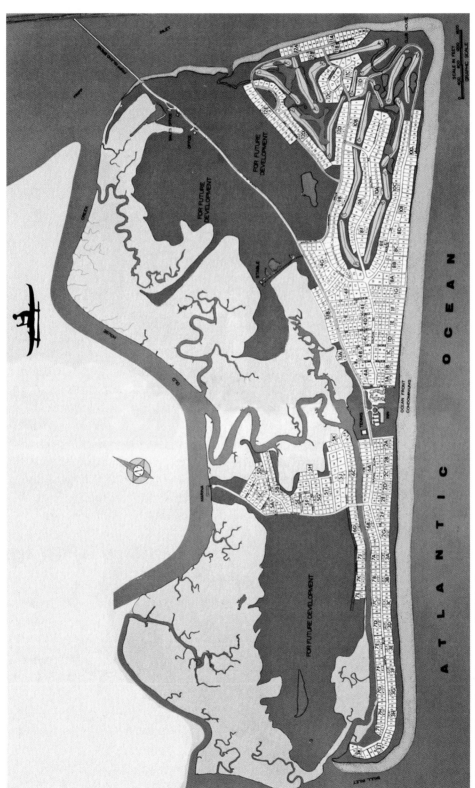

1972 map of Fripp Island. *Courtesy of Bill Merritt.*

Hardin, who headed a Rock Hill savings and loan, subsequently talked to Jack Lawrence, the chief officer of a savings and loan in Greenwood. Both owned oceanfront homes on Fripp and both were seeking promising investment opportunities for their financial institutions. Coastal investment sounded particularly appealing to Lawrence, who was familiar with the sizeable investment of Jim Self, the president of Greenwood Mills, in Hilton Head's Sea Pines Plantation, where the primary road is Greenwood Drive.[154]

In reminiscing about the purchase, Hardin noted that in 1972 almost all of the holdings of South Carolina S&Ls were in residential mortgages, which were limited by state usury laws to a maximum interest rate of 8 percent. With national rates well exceeding this level, these institutions needed to explore ways to diversify their investment portfolios. Toward the end of the 1960s, the regulations of the Federal Home Loan Bank Board included a new provision allowing these lending institutions to form coalitions to buy and develop commercial properties.[155]

Bill Bowen, who in 1970 had bought one of the first Captain John Fripp Villas, also facilitated the purchase. As the executive director of the South Carolina Savings and Loans League, he had been instrumental in establishing the Service Corporation of South Carolina, with assets of $1.3 billion, and positioning the forty-five participating S&L members to take advantage of new investment opportunities. Early in 1972 Hardin and Lawrence proposed the purchase of Fripp at a meeting in Columbia of the Service Corporation of South Carolina. The consensus among the savings and loan leaders was that Fripp Island was a beautiful island with great potential and that since the current owner had financial difficulties, the island could probably be purchased at an advantageous price.[156]

Although neither Hardin nor Lawrence had any resort management experience, they knew that if they were to invest in Fripp Island Resort, they wanted to own all the various interests on the island: the bridge, the inn, the resort facilities, the golf course and all undeveloped land. They also felt it imperative to buy all of Jack Kilgore's interests, including his home and the Fripp Plantation on St. Helena, where work on a golf course had begun but had never been finished.[157]

The rationale for the sale was offered to stockholders of the Fripp Island Resort in an unsigned memorandum. The document asserted that because of the ongoing conflicts between the three separate corporations—the resort, the inn and the golf club—development on the island was at a "virtual stalemate." Additionally, the golf course was in "extremely poor condition" and had no clubhouse, but the resort did not have sufficient capital to purchase the property. Thus the memo strongly recommended that the stockholders accept the offer from the coalition of savings and loans. "Our alternative would be running the risk of a possible forced sale of the Island in the near future in which event our assets would probably bring only a fraction of their true value."[158]

On July 26, 1972, the stockholders of Resort Lodging, Inc., which owned the inn, met and agreed to accept the savings and loans' offer of $1.2 million for the land and the buildings. Two days later on July 28, stockholders of the Fripp Island Resort, Inc., met and approved an offer of $850,000 for their entire assets, which included all of the lots that had not been purchased as well as all the undeveloped land, approximately

half of the island. The members of the country club also met that day and agreed to the price of $325,000 for the golf course. The package deal also included the bridge that connected Fripp and Hunting Islands.[159]

For many Fripp Island property owners, the sale price for the country club was a bitter pill to swallow. Some individuals were even ready to go to the bank and make sizeable contributions toward the effort of keeping the golf course in the hands of homeowners. Yet George Douglass, the president of the Home Owners Association, argued that the money that could be raised would be insufficient and that selling the course was the only realistic option. As a private entity, without the support of the resort, the country club had not found a viable way for handling the debt and maintenance of the course. Fripp Island home and lot owners, who had paid $1,000 and $1,500 just a few years earlier for certificates of membership in the Fripp Island Country Club, were dismayed to learn that once all the debts had been paid, the redemption of membership certificates realized only about $200. However, as one resident pointed out, they had paid no dues and thus had three years of unlimited golf at no extra charge.[160]

Although the Service Corporation of South Carolina handled the initial negotiations for the purchase of Fripp Island Resort, it formed a subsidiary called the Fripp Island Development Corporation to purchase and operate the island. Thirteen savings and loans composed the new corporation, and they subsequently elected Jack Lawrence chairman of the board and John Hardin president. The thirteen financial institutions shared in decision making with contributions based on net worth of the individual institutions.[161]

After the various deeds for the purchases had been recorded, the *Beaufort Gazette* estimated the sale price of the entire deal at approximately $3.5 million. John Hardin, as president of the newly formed Fripp Island Development Corporation, asserted at the occasion of the signing of papers: "We want to make Fripp the finest development of its kind, and we have the strength of our member savings and loan associations to help us do it." Hardin emphasized that Fripp could continue to operate as both a resort for vacationers and as a place for year-round leisure and retirement living. Bill Merritt, the president of American Federal Savings and Loan in Greenville, and Bill Smith, president of Standard Savings and Loan in Columbia, subsequently purchased homes on Fripp. Thus of the thirteen lending institutions, four had chief executives who visited the island frequently.[162]

The Fripp Island Development Corporation had purchased a woefully neglected island. Just three months after the deeds had been filed, in a mailing to all members the Fripp Island Home Owners Association reported on positive changes: "Roadsides are being cleaned, brush and weeds cut down, trees pruned and the accumulation of unsightly junk is disappearing." Other welcomed changes were the corporation's employment of uniformed guards on duty at the bridge entrance twenty-four hours a day and the downward adjustment of prices in the island liquor and grocery store to make them competitive with prices in town.[163]

After addressing some of the cosmetic and easily accomplished tasks, the new developers focused on land planning, data gathering and conducting extensive engineering

and architectural studies. Considerable work was needed on the basic infrastructure of halting beach erosion, providing adequate water and building a sewage treatment plant. Expanding the Captain John Fripp Villas, developing new neighborhoods to bring in revenue and building additional recreational facilities were also high priorities.

In presenting their master plan for Fripp Island, the new management made clear they were steering toward a new path. With the stated priorities of preserving the ecology of the island and maintaining a tranquil family-oriented atmosphere, the owners decided to dismantle the inn, which experienced only limited success in attracting conventions. They also planned to convert the sleeping rooms into efficiency suite condominiums. The restaurant and bar portion of the original La Tai Inn, later called the Fripp Island Inn, became the beach club. Families, not conventions, became the focus. The Fripp Island Development Corporation's promotional fliers stated: "Fripp Island is not a commercial resort spa. Rather, it's a private, fully-serviced residential community." The emphasis on "fully-serviced"—which meant attention to appearance, the quality of the recreational facilities and guards on the bridge—reduced much of the tension that had existed between the previous resort owner and the residents.[164]

Combating Erosion

In 1973 the corporate management and the property owners united in a battle against the sea. The new corporation's first major expenditure was building a sea wall along the island's northeast point. Serious erosion had occurred along the shoreline of the Fripp Inlet in the late '60s and early '70s with the disappearance of beach, dunes and lots. The road that had once provided an outer loop around the golf course had fallen into the pounding surf.[165]

The S&Ls consulted with erosion specialist Dr. Per Bruun, an engineer from the Technical University of Norway, who recommended the construction of a two-thousand-foot-long concrete sea wall, reinforced with an embankment of large rocks. The wall bordered the Fripp Inlet shore and then extended as a jetty out into the Atlantic Ocean. The project was completed at the end of 1974 at a cost of $300,000, which in 2005 dollars would be the sizeable investment of $1.2 million. The sea wall's primary purpose was to prevent the water lines along Porpoise Drive from being washed out. Additionally it protected the golf course and one of the most scenic portions of the island.[166]

Efforts at combating beach erosion, however, had been underway for several years prior to the building of the sea wall by Fripp Island Development Corporation. The commissioners for the Public Service District (PSD), who were charged by state law with responsibility for water supply, erosion control and fire protection on Fripp, had devoted considerable attention and money to the threat to the beach. In 1970, the commissioners developed a three-pronged strategy and borrowed $120,000 from

Fripp Island

This aerial photograph from the early 1970s of the south end of the island shows large sand dunes and a broad beach. A few years later, however, erosion began to take its toll, especially at the north and south ends of the island. *Courtesy of Bill Merritt.*

the South Carolina State Sinking Fund to build four two-hundred-foot concrete and timber groins at the southwestern end of the island, install eleven tube groins filled with sand on the island's northeastern end, reconstruct dunes and renourish the beach at the center of the island.[167]

When still faced with increasing erosion the PSD, which operated with tax revenues, faced a critical financial situation. It had two major debts to pay off: one on a $280,000 bond for the construction of the water system and the other a 1970 loan from the State's Sinking Fund to combat erosion. In a November 1971 letter to all Fripp Island taxpayers, the PSD pointed out that the island did not have a sufficient number of water subscribers to absorb the operating costs of pumping and delivering water; this made the mill rate for Fripp taxes the highest in the county. And to make matters worse, the water system needed additional work. By 1975 the PSD reported receiving $45,000 in tax revenue from the county treasurer but $30,000 of that amount went toward servicing debts. Because of these financial constraints, the PSD could assume only a limited role in battling the sea.[168]

Individuals who owned oceanfront property had some success in using palm fronds and snow fencing to trap sand during windy periods. This tactic encouraged the development of sand dunes. However, the progress made in retaining sand seemed to be followed quickly by more erosion. An early winter storm on December 3, 1971, with tides of twelve to thirteen feet—the highest in almost a decade—flooded the eighteenth green and the tenth fairway of what is now know as the Ocean Point course. The groins at either end of the island proved effective, but there was considerable loss of sand at the mid-portions of the beach. With no other funds available, the beachfront property owners consulted Dr. Bruun and following his recommendation built a large artificial dune. Each of the oceanfront property owners agreed in March 1972 to pay $250 and engaged a Savannah company to build up the beach and dunes.[169]

Just two months after this renourishment program, a northeaster hit Fripp. It began on May 10, 1972, and continued for almost three days. The lethal combination of gale winds and extremely high tides destroyed most of the recently built dune, flooding stranded residents on the southern end of the island. However, Bill Huyler, a retired jewelry businessman from New Jersey and the president of the Home Owners Association, reported to the members that because of the protection provided by the artificial dune, no houses were damaged.[170]

In response to new erosion, in November 1975 the S&Ls and the residents joined efforts to build a rock groin on the beach just south of the ninth hole on the golf course. Just three weeks after its completion, the beach in the area had built up by 1.5 feet on the east side of the groin and 1 foot on the west side. The rock groin helped to stabilize the beach but did not prevent high tides from beating at the steps of many beachfront homes. By the early 1980s, this groin disappeared under sand only to reappear along with mesh fabric from the earlier sausage groins in the spring of 2004 when the northeastern end of the Fripp beach again experienced significant erosion.[171]

Despite the cooperative efforts of all concerned, the sea seemed to be winning the erosion battle. Residents remember with horror witnessing vast portions of the seafront lots disappearing over several months or in some instances overnight. The Atlantic had begun to encroach so severely on many oceanfront properties on Fripp that by 1975 Dr. Bruun and the PSD decided that individual property owners would need to install rock revetments to protect their homes. Based on research in Florida, two approaches to beach erosion were feasible: individual rock revetments to be paid for by the owner of the property and publicly funded nourishment to raise the elevation of the beach. By 1975, there was considerable disagreement among Fripp residents about putting more money into beach nourishment. Thus, the PSD adopted the policy of providing design plans for rock revetments with the cost of the installations as the responsibility of individual property owners. In the mid-1970s embankments of large boulders began to appear in front of vulnerable oceanfront homes. Roger Wilson, who had come to Fripp a few years earlier with his father on a contract to dredge lagoons, stayed after his father left and developed his own business of building rock revetments.[172]

On September 6, 1979, when Hurricane David came ashore on Fripp, the rock revetments withstood the test. Three young men who decided not to evacuate provided a firsthand account of two to three feet of water pouring down Marlin Drive, portions of the golf course being virtually afloat and large chunks of sand dunes disappearing. There were some missing shingles, TV aerials downed, porch screens torn and numerous fallen branches littering the roads; however, the *Trawler* reported "little extensive damage."[173]

Improving the Infrastructure and Recreational Facilities

The Fripp Island Development Corporation worked at considerable expense to address the deficiencies of the water supply, the lack of a sewer processing plant and the poor condition of many of the roads. Thus they collaborated with the PSD to realize the long-term solution of connecting to the Jasper-Beaufort County Sewer and Water Authority. To address the immediate difficulty of obtaining septic tank permits, in 1974 the corporation began construction of an odorless and quiet treatment plant located near the golf course irrigation reservoir. The laying of sewer lines for new neighborhoods such as those around Blue Heron Lake and on Sawgrass Bluff facilitated the sale of smaller lots. The S&Ls also paid for the resurfacing of old roads and the building of new ones with costs far exceeding the annual property assessment of fifty dollars on all lots.[174]

Other visible changes on the Fripp landscape were the Fripp Island Development Corporation's restoration of the golf course, improvements at the marina and construction of new recreational facilities—the Olympic-sized pool, bike paths and a racquet club.

Coming Together

With a fine design and superb setting, the Fripp golf course was nevertheless in seriously ill repair at the time the S&Ls took over the resort. From years of neglect, many of the fairways had reverted to pure sand. In 1973 the newly hired grounds crew began replanting the greens and fairways and installing a new automatic irrigation system. By the spring of 1975, the new management advertised five reasons for playing golf on Fripp: "Play is relaxed; there is seldom any waiting to tee off; the course is the best it has ever been; the atmosphere is congenial; and each hole is a challenge." However, a trailer continued to serve as the clubhouse for the course until the construction of a permanent golf and pro shop in 1979.[175]

Bringing the golf course into top-notch condition had not been accomplished, however, without some setbacks along the way. Obtaining an adequate supply of water was a major complication. The first strategy had been to drill a well. The 3,168-foot deep well had been a sizeable expense. The expectations of the well providing a suitable water source proved faulty, and the initial use of the well's hot water, which had a high concentration of boron, almost killed the newly planted grass. Years later John Hardin, president of the Fripp Island Development Corporation, lamented the building of the well: "We were literally pouring money, $250,000 of it, down a hole."

In 1975 the S&L coalition built an Olympic-sized pool next to the beach club. The grand opening took place on July Fourth weekend and included swimming and diving competitions. *Courtesy of Bill Merritt.*

About this time, the corporation had begun to build a sewage treatment plant that eventually provided the recycling of treated water for the golf course.[176]

The neglected marina underwent a major transformation in the 1970s. First, in 1974 the corporation closed Mobley's Mall and relocated the island's convenience store and gas station to the marina. Exxon put in modern equipment and the island horticulturist and his crew landscaped the area, making the marina more serviceable and attractive. The addition of a rustic screened patio provided a gathering place for crabbers, boaters and fishermen. Then in 1977 the S&Ls sold the marina to Pete Sanders, a part-time resident from Barnwell, South Carolina. Sanders built a new launching ramp, extended the docks, built a dry boat storage facility and constructed over the water a large boathouse with a restaurant. During the summers he would find someone to run the restaurant with its stunning views of the sun setting over the marsh and Old House Creek. Recently reminiscing about seventeen years of owning the marina, Sanders said there was not much boating on Fripp and that he "had more money than sense."[177]

New recreational facilities at the beach club included two nine-hole putting greens on the ocean side of the club and an Olympic-sized swimming pool on the Tarpon Boulevard side. The grand opening of the beach club on July 4, 1975, featured a putting contest, an official swim meet and a diving competition. Bob and Barbara Hess, both physical education teachers, were vacationing on Fripp and participated. Bob won

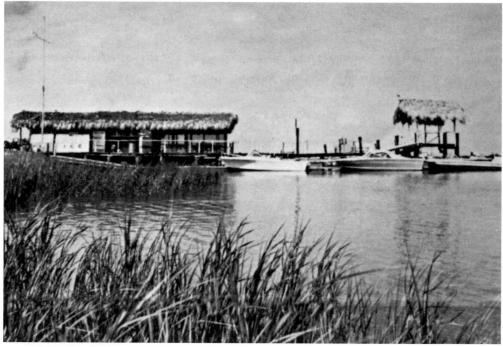

A 1974 view of the Fripp marina shows the initial work of the S&L coalition to expand the docks and build a store and gathering place with a palm frond roof. *Courtesy of Bill Merritt.*

second place in the diving competition for "boys 18 and over," and some twenty years later the couple moved to Fripp. Following the swim meet, the club hosted a pig roast for four hundred people, presented a fireworks display on the beach and held a dance in the newly refurbished bar and lounge on the second floor of the clubhouse.[178]

Combining an opportunity for exercise with a view of lush subtropical vegetation and wildlife, the Fripp Island Development Corporation built bicycle and hiking paths. A special promotional feature was the parcourse, a European fitness sport that was becoming popular at the time in the United States. It consisted of a series of eighteen fitness stations spaced along a jogging path. Designed to accommodate all ages, each station had instructions that described and illustrated three levels of fitness exercises—starting, sporting and championship—and listed a recommended "par" or number of repetitions for each level.[179]

The weekend of March 18, 1978, marked the opening celebration for the new tennis complex, which boasted a clubhouse, pro shop and four additional tennis courts—bringing the total of the soft, fast-dry granular courts to eight. Moreover, the tennis center had all the newest mechanical teaching aids and a nationally prominent tennis pro. Tennis director Butch Trellue had extensive experience, having previously worked with the U.S. Davis Cup Team and served on national tennis committees. The schedule for the grand opening featured competitive matches for members and

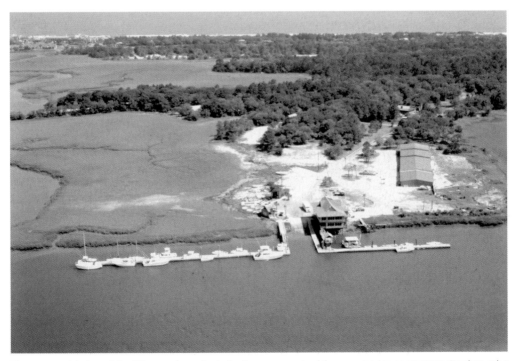

The 1979 aerial view of the Fripp marina reflects the improvements of the new marina owner Pete Sanders, who further expanded the docks and built a large boathouse over the water with a restaurant for dining while watching the sunset. *Courtesy of Ernest Ferguson, Photo Arts, Inc.*

a tournament for visiting tennis professionals. The Wimbledon Room, located above the pro shop, served as a players' lounge. Trellue developed a full tennis program of clinics, stroke-of-the-day drills, private lessons, social round robins and professional exhibition matches. Within months of the opening, the racquet club hosted a number of collegiate and Junior Davis Cup tournaments.[180]

New Residential Communities

The improved recreational facilities were all part of a comprehensive program for attracting prospective property owners. At the heart of the savings and loans' financial plan was the establishment of new residential communities. The sale of lots and houses was the financial engine that was to enable the corporation not only to improve and maintain the island's recreational facilities and services but also to make a profit. During its seven-year ownership of the island, the Fripp Island Development Corporation greatly expanded the oceanfront Captain John Fripp Villa condominiums and established ten new residential communities: the treehouses on Fiddlers Ridge, lakeside homes on Blue Heron Lake, Sawgrass Bluff, High Dunes Lookout, the Tennis Villas, the Fairway Club Villas, Quail Cove, Fiddlers Trace, the Village of Sandown and the Village of Newhaven.

The Bartoli Topsider treehouses, located on a narrow bluff of high land that extends out into undisturbed coastal marshes, commanded some of the most spectacular views on Fripp. Guy Bartoli, a professor of architecture in California, collaborated in the 1960s with Burl Brady, a student of his from North Carolina, to develop the pedestal treehouse concept with its octagonal shape and floor-to-ceiling glass. Brady's father, who had financed the development of a number of recreational mountain communities, had asked his son to design structures that would be economical, easy to build on difficult mountainous terrain, blend into the natural environment with minimal disturbance to trees and vegetation, have many windows for great visibility and could withstand strong winds. In this endeavor, Burl Brady enlisted Bartoli's assistance.[181]

Bartoli and Brady received a patent on their unique pedestal design about 1970, and Brady's father provided the capital for a small prefabrication facility in North Carolina. The houses proved popular and appeared on Hilton Head and other beach and mountain resorts prior to their construction on Fripp. Between 1974 and 1976, the S&Ls built seventeen Bartoli treehouses on Fiddlers Ridge. Their placement on Fripp was in one of the island's most scenic areas where traditional housing was not suitable.[182]

While the Fripp Island Development Corporation made the most of the natural setting of Fiddlers Ridge, it significantly modified existing tidal creeks and natural lagoons on the other side of the island to create Blue Heron Lake and thus to increase the number of waterfront lots. Bulldozers and dredges sculpted the graceful

Coming Together

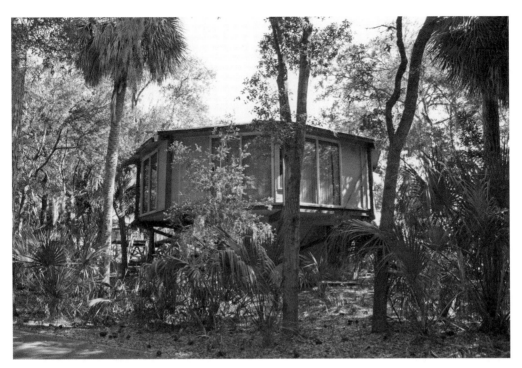

Beginning in 1974 the S&L coalition built a number of Bartoli treehouses along Fiddlers Ridge. These vacation homes built from a "kit" in an octagon shape were nine hundred square feet with a living room, kitchen, two bedrooms and two baths. *Courtesy of Bill Merritt.*

curving shoreline of the tranquil lake. Several high points remain as small, densely wooded islands. By the fall of 1975 portions of the new Blue Heron subdivision had paved roads and water and sewage lines. The expanded lake, surrounded by live oaks, pines and palms and with wax myrtle shrubs hugging the shoreline, is a haven not only for blue herons but also egrets, red-winged blackbirds, chickadees, wrens, kingfishers, painted buntings and many other species of birds. Occasionally osprey and brown pelicans come to fish in the lake.[183]

The Sawgrass Bluff residential neighborhood was an island surrounded by tidal creeks with impressive views of marshes and wildlife. Before the corporation could develop the area it had to provide access by building a causeway for cars and a footbridge across the marsh to connect the bluffs with the main boulevard. On September 1, 1976, the first thirty of ninety-three lots on Sawgrass Bluff went on sale. Perhaps because of its detached location and its own pool, Sawgrass residents became an unusually close-knit group.

In contrast, the Tennis Villas, built in 1978 and bordering the Racquet Club, were at the center of resort activities and seemed to attract more part-time owners. Yet they blended unobtrusively with the environment and had exceptional marsh views. Finally the S&Ls initiated but did not complete the Village of Newhaven, a cluster of condominiums on the northeastern point of Fripp nestled between the

101

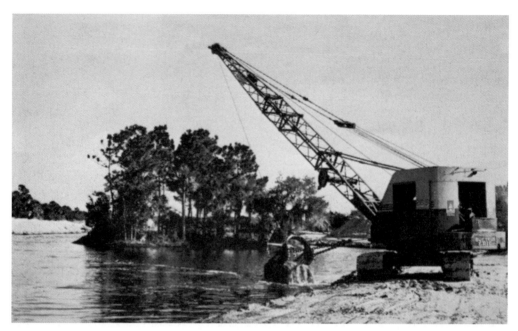

A 1974 photograph of the expansion of a small natural pond to construct Blue Heron Lake. Several portions of elevated ground remain as islands where birds often come to roost. *Courtesy of Bill Merritt.*

Atlantic Ocean and the golf course. The developers intended for the complex to be reminiscent of an English seaside village.[184]

In a number of the new communities, such as Blue Heron Lake, Quail Cove and Fiddlers Trace, the Fripp Island Development Corporation offered several cottage designs and constructed models for viewing. With an innovative housing program called "Back to the Cottage Concept," the corporation made a pitch for designs that made retirement and leisure homeownership affordable. The promotional literature stressed that Fripp Island homeowners had privileges to all island facilities, including beach, golf club, pools, tennis courts and the marina. And the emphasis remained on families. The "Cottage Concept" fliers claimed: "Because Fripp was planned from the first to be a family community, not a bustling resort, the island will always be a place to be relaxed, not frantic."[185]

New Management

The day-to-day management during the Fripp Island Development Corporation's first year was an improvement over that of Kilgore's final year. But from the perspective of the residents there were some lingering issues. The corporation had inherited many problems and its first general manager, Colonel Walter J. Sherman, lacked experience and people skills for the job. Sherman, sometimes compared

Coming Together

One of the homes built as part of the S&L coalition's 1976 "Back to the Cottage Concept." There were several model plans from which to choose and the prices ranged from $39,000 to $69,000. *Courtesy of Julie Hodgson.*

to General William Tecumseh Sherman—to Southerners not a complimentary reference—resigned after less than a year on the job. Following the brief interim appointment of Dick Smoak, a retired military man and popular Fripp Island resident, the corporation made O. Stanley Smith the general manager. Smith had a sterling résumé. He was an educator who had served effectively as the head of a South Carolina program to increase the state's economic and social development and had been named South Carolinian of the Year in 1973. Smith had strong ties to both the Lowcountry and to the Fripp Island Development Corporation. He owned St. Phillips Island, located a few miles from Fripp, and was on the board of Standard Savings and Loan Association in Columbia, one of the financial institutions that made up the Fripp Island Development Corporation.[186]

Under Smith's direction, the corporation built a strong marketing program. Only a few months after his arrival, the corporation abandoned the old logo of a man paddling an outrigger canoe that had been part of Kilgore's use of Polynesian themes and adopted the blue and white stylized sailing ship that suggested both life by the sea and the legendary privateer John Fripp. In 1975 the corporation sent silver and enamel Fripp Island logo pins to all property owners who had paid their annual fifty-dollar assessment with a letter stating that the pin was "designed to be recognized as a mark of distinction." The stylish logo—whether on stunning gold and diamond necklaces, shirts and caps or license plates—remains the symbol for present-day Fripp.[187]

As part of the promotional activities, the Fripp real estate office had an extensive advertising program. A large five-by-twelve-inch ad sporting the Fripp logo appeared

In 1974 the S&L Coalition adopted as the company's logo a stylized shell that represented the ship of privateer Captain John Fripp. For over thirty years the simplicity of the ship logo has remained, in one variation or another, the symbol for Fripp Island. *Courtesy of Dick Anderson.*

in the *Washington Post* on Sunday, June 16, 1974. "Fripp Island is not *too* famous. We love it this way, wouldn't you?" was the message. Another, about the same size, appeared in the *New Yorker* with the headline: "The Yemassee Special. The train that takes you back to a place you've never been." This ad stated that the corporation would provide transportation to and from the Yemassee train station or the Savannah airport and invited people to visit "an island where change hasn't meant commercialism, and tranquility still comes au naturelle."[188]

The ever increasing financial demands of maintaining the infrastructure, amenities and services required the Fripp Island Development Corporation to shift its philosophy of providing all property owners access to all recreational facilities. In the spring of 1975 the corporation established the Fripp Island Beach Club with a dues structure to accommodate residents and nonresidents as well as those interested in social, tennis or golf memberships. Two years later, the corporation introduced an initiation fee. With the addition of new amenities and the passage of four years, there were some adjustments to the dues structure; however, the annual full membership dues for residents remained at $400.[189]

Corporate and Property Owner Relations

In the mid- to late 1970s, the relationship between property owners and the corporation were cooperative and generally without rancor. The Fripp Island Development Corporation made a considerable effort to share information with homeowners. General manager Stan Smith provided detailed accounting of the use of the fifty-dollar annual property assessment stipulated in the 1963 covenants for use in the maintenance of roads and mosquito control. Additionally, the corporation worked with representatives of the Home Owners Association on mutual concerns such as the rental program of homes and villas, security, the golf course and food and beverage services. Smith often talked about achieving a proper balance of vacationers and homeowners on the island. As he would explain, the vacationers' financial support of the amenities was required to supplement the property owners' club memberships. But he also acknowledged the need to control traffic and preserve the island's tranquility.

The residents applauded many of the corporation's activities. They appreciated the footbridge across the marsh to the Sawgrass community and the emphasis on landscaping. Likewise the property owners found the new signs identifying the various neighborhoods tasteful. They delighted in the replica of a pirate ship, called the Fripp Ship, constructed in a new playground at the beach club. The general store, built in 1978 at the entrance to the island, and the golf clubhouse and restaurant at Ocean Point constructed in 1979 all contributed to the quality of life on the island.

Despite a significant list of accomplishments and the improved communication between the corporation and the residents, the Fripp Island Home Owners Association had some grievances about the operation of the island. Bill Huyler, a

former president of the association, stated at the December 5, 1975 semiannual meeting of the Home Owners Association that the corporation was not observing or enforcing some of the restrictive covenants so that a number of violations had occurred that deserved prompt attention.[190]

The situation that triggered this concern revolved around the corporation's control over the architectural review board. Created by Kilgore in the 1960s, this board composed of property owners reviewed and made recommendations about the design and construction of future homes. In 1975 two proposals for prefabricated double-wide houses had come before the architectural review board. In rejecting these proposals, the board determined they were not in keeping with the standards of Fripp housing. However, the corporation overruled their vote. Board member Gini Reese resigned in protest. Longtime property owner Bill Winter recently observed: "The double-wide issue definitely created waves."[191]

At Huyler's urging, the association passed at a meeting on December 7, 1975, a resolution creating a special committee of the Home Owners Association to study the restrictive covenants. Fripp operated at that time under two sets of covenants— the 1963 ones developed by Kilgore and those that the Fripp Island Development Corporation had filed in the county courthouse in 1974—which established standards for dwellings in the newly created neighborhoods.

In a report the following May, the special committee on covenants analyzed the differences between the earlier covenants that applied to the "settled areas" and the 1974 ones that pertained to new areas. The principal difference was that the earlier covenants had specific size and height limits for homes while the 1974 covenants avoided defined limits. The committee felt that the two-story maximum on residential properties should also be required in the new areas. Additionally, the committee questioned whether the standards of the covenants were being enforced, particularly the one regarding no trailers or double-wide homes. Convinced that continued scrutiny of the covenants and their enforcement was desirable and necessary for the welfare of the island, the committee recommended that there be a standing committee on covenants to stay in close communication with the corporation and its architectural review board. The provision in the April 29, 1974 covenants for making changes stated that after twenty-five years and then for successive periods of ten years the covenants would be automatically extended unless a majority of the owners of lots agreed to changes. Thus the homeowners recognized that their first opportunity to make changes would be in 1999.[192]

Both the residents and the corporation envisioned a time when there would be a shift in responsibilities for the maintenance and services on the island from the corporation to the property owners. Concern about the deterioration of services under Kilgore's management had been so great that the association appointed at its April 1972 annual meeting an Island Services Committee to analyze the potential costs of security and road maintenance. Once the Fripp Island Development Corporation took over management of the island from the Fripp Island Resort, services greatly improved. However, at the semiannual meeting of the Fripp Island Home Owners

Association on December 7, 1975, Stan Smith emphasized the need for all property owners to participate in the Home Owners Association to, as he stated it, "prepare for the day when residents take over after the Fripp Island Development Corporation leaves." In looking ahead to the day of "home rule," Smith asked the association to appoint five management coordinators to work with the corporation. In addition to naming management coordinators, the Home Owners Association also appointed at the November 21, 1976 semiannual meeting a "transition committee" to plan for a transfer of responsibilities. Al Schaufelberger, a retired navy captain who had moved to Fripp in 1975, chaired the committee.[193]

The Residential Community Matures

During the 1970s the community of property owners matured. From a few dozen year-round residents at the beginning of the decade, Fripp became a village of 250 people within a ten-year period. The village needed a newspaper. Thus the Home Owners Association began publication in January 1978 of the *Trawler*. The founder and first editor was Edwin Merwin, the president of the Home Owners Association and a retired Bloomingdale's department store executive from New York. Merwin used his cast-iron Smith Corona typewriter to prepare the copy that he then sent to Frank Mundy, a part-time resident who owned a newspaper in Greenwood, South Carolina, and had offered his newspaper's facilities for publishing the homeowners' paper. The *Trawler*, which has continued publication into the twenty-first century, proved from the beginning to be an important vehicle for providing both on- and off-island homeowners with reliable information, a very valuable asset in a community where rumors flourish.[194]

Islanders also launched a number of initiatives to protect the natural environment. The Conservation and Beautification Committee of the Home Owners Association under the leadership of Kay Engler had focused in the Kilgore days on cleaning up trash and debris. When the Fripp Island Development Corporation took over this task, the committee was able to concentrate, as Engler put it, "on conserving all that we have here on this island that is good." The committee decided unanimously to ask for the support of the Home Owners Association and the corporation in petitioning the state legislature to make Fripp Island a bird sanctuary. The association members endorsed this recommendation at the annual meeting on April 29, 1973. Although the association had only specified the desire for a bird sanctuary, somewhere along the way to becoming a law, the protection expanded to include game. At the 1974 annual meeting, Engler reported that according to South Carolina statutes, Fripp Island was now a bird and game sanctuary, subject to the state game laws and under the authority of the game warden. A few years later Dixie Winter, who became a full-time resident in 1977, headed up the establishment of an Audubon Club. A retired teacher, Dixie valued opportunities to learn about wildlife, and Fripp offered a natural laboratory for studying marine life and birds that lived along the shore and marshes.[195]

Interest in wildlife on Fripp extends even to observing crab tracks on a sand dune. Residents and guests find endless possibilities on Fripp for discovering the wonders of nature. *Courtesy of The Fripp Group, Inc.*

Coming Together

Next to birds, the endangered loggerhead sea turtles became the most treasured of the Fripp wildlife. Under Jack Kilgore's leadership, there had been a Fripp Island Sea Turtle Conservation Center that not only helped protect turtles but also collected scientific data. John Mehrtens, the director of the Riverbanks Zoological Park in Columbia, led in the planning and establishment of the Fripp center. Three college students assisted with the project. One of the students, "Satch" Krantz, later became the head of the Columbia Zoo, a position that he still holds. The students monitored the nests for the hatchlings, which they then placed in holding tanks. Once baby turtles became healthy and strong, the staff tagged them and released them a mile or two offshore. With the departure of Jack Kilgore at the end of 1972, the turtle program ended.[196]

A casual conversation in 1978 between Betty Cunningham and Janet Sawyer, two members of the Conservation and Beautification Committee, about the number of loggerhead nests on Fripp led to the establishment of an organized turtle patrol. John Seymour, a former telephone executive and retiree from North Carolina, agreed to head up the turtle patrol that spring. He enlisted seven permanent residents with beachfront houses as volunteers to patrol a specific area each day, to mark nests and, if necessary, relocate nests to a safer site. In 1978 the turtle patrol identified 188 nests on Fripp. The following year, Norine Smoak took over the patrol and reported 150 nests.[197]

The operation of the volunteer fire department, which had its fledgling beginnings in 1969, had by 1978 become a strong force of thirty-six volunteers, three of whom were women. Gina Schaufelberger recently recalled her years of driving the fire engine. The volunteer firefighters faithfully attended bimonthly drills and stood ready at a moment's notice to assume appointed responsibilities. Under the direction of the PSD, Batte Deffenbaugh served as the volunteer fire chief and Griff Reese as volunteer chief engineer. Batte, a former Dupont executive who had been responsible for fire protection at the plant where he worked, and Reese, who began his flying career with Pan American in the 1940s when pilots had considerable oversight over maintenance of their aircraft, contributed hours of labor each week. At the 1976 annual meeting of the Home Owners Association Batte noted that "the response of the volunteer fire department has been good and the equipment is in good condition, enabling the fire department to maintain its good rating." This in turn lowered fire insurance rates of the property owners.[198]

Another group of Fripp volunteers, the Sea Island Rescue Squad, formed in 1977 under the umbrella of the county's emergency response system to ensure that full emergency medical service would be available on the island. This group—not to be confused with Fripp Island Sea Rescue, which formed in 1983 to assist boats in distress—worked with Walter Gay, a resident of St. Helena Island, in lobbying the Beaufort County Council for money for a new ambulance to be stationed permanently on St. Helena Island to provide service to outlying islands. A special fundraising effort on Fripp enabled the Sea Island Rescue Squad to purchase an automatic cardiopulmonary resuscitator, known to the group as "Thumper." After almost twenty-five years of service, the group

dissolved when the Fripp Island firehouse added a full-time emergency medical service unit.[199]

A previously informal gathering of women officially organized in 1974 as the Fripp Island Women's Club. They evolved from the cleanup crew of the Home Owners Association's Conservation and Beautification Committee. They met the first year on the deck of Kay Engler's home. Engler would provide sherry and cookies and each woman would bring a sandwich. One of their first projects was compiling a *Settler's Guide* with information for new property owners. They subsequently prepared a Fripp telephone directory and arranged for the bookmobile from Beaufort to come to Fripp.[200]

The long-range goal of the residents throughout this period was to have a building of their own that could serve as both a place for worship and a meeting place. Efforts toward this end made great strides in the 1970s. Jack Kilgore had promised to deed land for a chapel and the Home Owners Association had a church committee. In 1973, this committee under the chairmanship of Gini Reese discovered that, despite the promise, there was no deed for land on which to build a chapel and thus appealed to the Fripp Island Development Corporation. When Stan Smith became operating manager of the corporation, one his first actions was to donate land for the chapel.[201]

The church committee continued to coordinate arrangements for the vespers services each Wednesday with area ministers presiding. In 1975 the Home Owner's

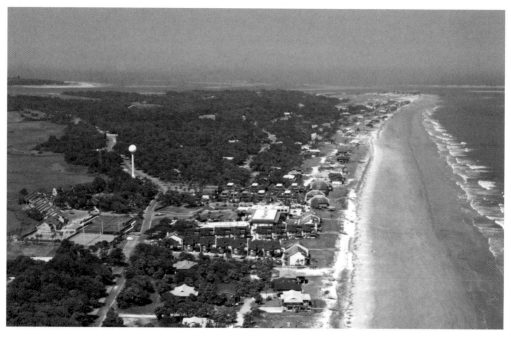

1979 postcard with an aerial view looking northward from the beach club shows the growth of housing with the expansion of the Captain John Fripp Villas along the ocean as well as the new tennis villas bordering the marsh. *Courtesy of Ernest Ferguson, Photo Arts, Inc.*

Coming Together

Association pledged, "We will never cancel our vespers worship" and decided that there needed to be a special nonprofit incorporated organization to build and later manage a chapel. The next year the association endorsed the incorporation of a new organization, the Fripp Island Community Centre, to spearhead this effort. They decided to use the British spelling of "centre" because they foresaw that it would be an exceptional place and felt the name should have a little pizzazz.[202]

At this time the corporation provided space for Wednesday vespers at the beach club. Occasionally the service was held in the bar. Longtime resident Lou Cashdollar, retired chairman of the board of a specialty steel company, recalled that on one occasion a navy chaplain was presiding at vespers, and the lectern was situated with all the bottles and glasses directly behind him. The chaplain began the service by saying, "I don't know what my mother in Ireland would say about my preaching in a barroom." During the winter attendance plummeted and once only two people attended. However, the residents were determined to stand by their 1975 decision for "continuous Wednesday services." In November 1978 Gini Reese organized a choir to sing at vespers. There was a consensus that "the Wednesday evening vespers provide a pleasant, thoughtful and prayerful interlude for residents and visitors alike."[203]

While the corporation was firm in its commitment to allow the beach club to be used for Wednesday evening vespers, the use of a room earlier in the week for choir practice depended on availability. The experience of several weeks with no room for choir practice galvanized the community's resolve to have their own place. Besides the need for a place for vespers, the community had created a plethora of organizations that needed space to meet.[204]

The big push for a chapel and community centre came in 1979 when property owners decided to undertake a building fund campaign co-chaired by Lou Cashdollar and Ron Yaw. Cashdollar contacted nonresident property owners. With the assistance of his wife, Rita, their game room became what Lou called "the three S room," the place where the letters of appeal to eight hundred off-islanders were "stuffed, sealed and sent." This letter raised $14,000. Yaw daily drove his golf cart about the island and focused on the full-time residents, who contributed the major portion of the money. Neighborhood captains solicited funds. Many residents wrote checks for one thousand or more dollars. They were contributing to a building that they knew would become the hub of island activities and would help to bind the community together. The fundraising for the chapel and community centre occurred during the S&Ls' ownership of the resort but the actual construction took place following their departure in 1980.[205]

Conclusion

The S&L era was a time of many positive developments on Fripp: expanded recreational facilities, new neighborhoods and a more mature community. The

developers and the homeowners had similar visions and worked cooperatively to make Fripp Island a special place. One major reason for this relative harmony was the Fripp Island Development Corporation's enormous financial commitment to the island. Their financial reports, however, did not show a profit. The national economy was struggling under the burden of high interest rates. Despite the affection that many of the leaders of the S&Ls had for Fripp Island, it ceased to be a good business investment. John Hardin recalled in a recent conversation, "Whenever I drove across the Fripp Island Bridge, I heard immediately of a need for more money." He began to feel that there was a bottomless pit into which money was going. Finally, federal regulators who inspected the books of savings and loans said that too high a percentage of their holdings were tied up on Fripp Island and recommended they reduce their investment in the island.[206]

In 1979 the Fripp Island Development Corporation began to search for a qualified buyer. As various unconfirmed stories began to circulate on the island about future owners, Edwin Merwin wrote in an editorial in the *Trawler*: "Most island residents and property owners would agree that the Fripp Island Development Corporation under Stan Smith designed and developed the island in a creative, attractive manner with the best interests of both the company and the residents in mind." Merwin acknowledged that there were some disagreements, but he said "there was always the realization that these were family spats, that the goal of all was a finer, better Fripp Island." With rumors circulating about possible owners who did not value a noncommercial tranquil island, Merwin encouraged the corporation to find a buyer who shared their vision for Fripp.[207]

On February 14, 1980, George Magrath, the chairman of the Fripp Island Development Corporation, announced that an agreement had been reached with a new company to purchase the undeveloped land and amenities on Fripp. Once more the residents faced the uncertainties of island life under new management. Yet the property owners stood firm in their attachment to the land and seascapes, the lifestyle and the community of friends that were all vital aspects of living on Fripp. Nonetheless, within a few years the cycle of the resort's fortunes would take a downward swing, one that would challenge the residents to take on greater responsibilities in maintaining and operating the island.

Chapter 6
Residents at a Crossroads

A dizzying pace of change on Fripp marked the 1980s. In a two-year period, ownership of the resort changed hands three times. The residential community, on the other hand, increased in size and confidence and coalesced around the building of a chapel and community centre. As the developers floundered in their ability to provide basic services, the property owners attained new levels of organization and were in a position to take on added responsibilities. The community traded in the Fripp Island Home Owners Association, with its minimal dues and few obligations, for the new Fripp Island Property Owners Association (FIPOA) that undertook significant assignments and considerable financial obligations. In many respects it resembled a small town government, responsible for safety and roads. Yet even after the pivotal agreement in 1983 when the developer deeded, at no cost, the bridges, roads, bike paths and crossovers to the FIPOA, the welfare of the developers and the residents were inextricably entwined as action by one triggered a response from the other.

The Chapel and Community Centre

The first residents on Fripp had dreamed of having their own building to hold religious services, house a library and host various group activities. Early resident Elrose Yaw wrote a poem that captured this longing:

> *Let's build a special church today*
> *Where island folks may come to pray.*
> *Not too large nor yet too small*
> *No fancy carvings there at all*

*But quiet peace you'll find inside
Where warmth and fellowship abide.*

In 1980 the 250 residents who called Fripp Island home decided it was time to build a place to worship and to gather for fellowship. The residents readily agreed that all denominations and religions should be welcome and the name All Faiths Chapel expressed this vision of inclusiveness.[208]

The building fund drive, which began in October 1979, had by March 1980 raised almost $50,000, well over half of the goal. The Fripp Island Community Centre Board, created to build and run the new facility, decided to begin construction. Following an Easter Sunday service with a choir of thirty-two people singing the "Hallelujah Chorus," the assembled congregation proceeded from Tidal Hall at the beach club almost a mile down Tarpon Boulevard to the building site for an official groundbreaking ceremony.[209]

By the fall, the residents reached their goal of $75,000. Jim Rentz of Coastal Contractors offered to construct the chapel at cost. Yet even with this savings, the

The construction of the Fripp Island Community Centre was completed in November 1980 in time for a Thanksgiving Day worship service. The interdenominational Wednesday evening vespers services are an important part of life on the island. *Courtesy of Julie Hodgson.*

original plans had to be trimmed to match the available funds. The board scaled back plans for the community centre wing and decided not to pave the parking lot. Construction began on September 15, 1980, and progressed at full speed on a building that included a chapel, small community room with a kitchen, restrooms and an office. As Dick Anderson, a retired career army officer and one of the key supporters of the undertaking, predicted, the first service was held on Thanksgiving in 1980. The pews had not yet arrived and trim work remained unfinished but that did not dampen the spirits of the Fripp congregation assembled for praise and thanksgiving.[210]

The chapel blended into the wooded setting and exemplified a heightened sense of the cohesion of community. Working on a limited budget with voluntary contributions, the residents managed to equip and furnish the chapel and facility. Captain John Zoller, a chaplain at Parris Island and later the assistant pastor at Beaufort's Carteret Methodist Church, had several years earlier secured for Fripp the cross, candleholders and hymnals that were being phased out on the base. The owners of a Columbia music store, Nick and Jane Peck, donated an organ. Harold Olsen, a retired window designer from a large department store in West Virginia, built the communion table and lectern. Jim Chapman, a retiree from Long Island, designed a stained-glass window free of religious symbols and thus in keeping with the ecumenical spirit of All Faiths Chapel. Visiting ministers were duly impressed with the new facility and several wryly noted it was the first time they had preached in a building with no mortgage. Members of the community centre board, who had initiated the building program, said that what had been accomplished "formed a foundation, upon which could rest limitless possibilities."[211]

The Brandermill Group

The sense of accomplishment that residents felt at having built the chapel and community centre was matched by hope as they learned about the S&Ls' decision to sell the Fripp resort to the Brandermill Group, a development firm with an outstanding record. On February 14, 1980, George Magrath, the chairman of the Fripp Island Development Corporation, announced the agreement with the Brandermill Group. He stressed that the company had a proven financial record and awards from the American Institute of Architects for comprehensive planning and the National Association of Home Builders for "The Best Planned Community in America."[212]

Harry Frampton, president of the Brandermill Group, was a South Carolina native. As a college student, he worked during the summers for Charles Fraser at Sea Pines Plantation on Hilton Head, where his first job was driving a tour bus for prospective buyers. With an instinct for sales, Frampton asked if he could both give the tours and sell real estate. When Fraser agreed, Frampton quickly achieved an

impressive sales record and converted the summer job into a full-time position that gave him the opportunity to learn the development trade from a master. He later recalled Fraser's counsel that the goal of a good developer is to "build a way of life not a subdivision."[213]

Frampton learned from a Greenville friend associated with a savings and loan that the Fripp Island Development Corporation wanted to sell the island. He was interested, visited Fripp and spent a considerable amount of time doing "due diligence" to determine if this would be a wise investment for the Brandermill Group. In a recent interview, Frampton said that after gathering information and evaluating the conditions on Fripp, he came to "the conclusion that the situation was extremely complex and there were too many hidden liabilities." The risk was greater than he could accept. Yet, Frampton saw great potential on Fripp and felt that in a few years he could turn things around. During extended negotiations with the S&L coalition, the Brandermill Group offered to buy Fripp's undeveloped land and amenities for $1 and to assume an $8 million nonrecourse loan. Before the agreement was finalized, the bridge over the Fripp Inlet weakened and required expensive repairs due to shifts in the channel that had undermined the pilings. This was just the kind of hidden liability that Frampton had feared. To persuade the Brandermill Group to take over the island, the S&Ls agreed to continue paying for major repairs and capital improvements.[214]

The May 2, 1980 deed filed in the county courthouse stated that the Fripp Island Company, the designated name of the Brandermill Group for this investment, would assume the principal and accrued interest on the Fripp Island Development Corporation's $8 million mortgage on Fripp Island property. As properties were developed and sold, the Brandermill Group would pay off the loan. When Bill Winter, the president of the Home Owners Association, learned of the agreement, he drove to Virginia to have a firsthand look at one of the Brandermill Group's developments near Petersburg. He was impressed with the high quality of their work, the way they conducted business and their appreciation for the environment.[215]

On assuming the management of Fripp, Frampton sent all property owners a letter that included his vision for Fripp. His statement that "Fripp can avoid the over commercialism that plagues so many resort communities" resonated with property owners. Leonard Wood, who served as the general manager of the Fripp Island Company for the Brandermill Group, placed a high priority on establishing effective communication between the company and the property owners. After meeting several times with groups of residents, he recognized the need for additional parking at the new chapel. One of his first decisions was to deed to the Fripp Island Community Centre an adjacent forty-foot-wide lot. Wood also made a point to thank the homeowners for the thousands of hours of voluntary time contributed to the Fripp community through such endeavors as running the fire department, organizing chapel services, compiling a phone directory and protecting loggerhead turtles.[216]

Residents at a Crossroads

Since 1980, the Fripp Island July Fourth Parade has resembled many small town celebrations where everyone, old and young, takes part. For many years retiree Bob Newman, dressed as Uncle Sam, led the parade while carrying the American flag. *Courtesy of the family of Bob Newman.*

Fripp Island

The first Fripp Island Fourth of July Parade, a tradition started in 1980 that continues to this day, was the result of collaboration between the Fripp Island Company and the property owners. In reminiscing about the first parade, Gary Meyer, who is now a developer, recalled riding in a pickup truck with a group of thirty people, all who had at one time or another graduated from York High School in Elmhurst, Illinois, a Chicago suburb. The McKinley family was the first from Elmhurst to buy on Fripp and soon after Jidge Mearns and her family arrived. By 1980 there were a number of people with Elmhurst ties and annually their scattered families would gather on Fripp for the July Fourth celebration. Jidge's daughter, Marcia Meyer, also then a resident of Fripp, was one of the key organizers of the first parade that included—in addition to the truck of graduates—bikers, floats, the Fripp Island Fire Department and a Marine Corps band. The population on Fripp balloons on July Fourth, the day that each year holds the annual record for the most people on the island.[217]

The Fripp Company's cooperative spirit also led to the donation of a half-acre site at the center of the island for building a necessary new firehouse. This new location was preferable to the former one near the entrance to the island because it would reduce the time necessary to respond to most parts of the island.[218]

Newhaven Village condominiums built on Ocean Point in the late '70s and early '80s are a cluster of villas surrounded by the ocean, the Fripp Inlet and the golf course. A special focal point of Newhaven is an exquisitely landscaped garden, which today continues to be a source of beauty and pleasure. *Courtesy of Julie Hodgson.*

Within months of assuming control of Fripp, the company put together an experienced team of resort managers and adopted an aggressive marketing program that reaped substantial results. August 1980 marked the best month in the history of real estate sales on Fripp, with sales of thirty-four units for a total of $3 million. Many of the sales were the result of opening two new neighborhoods, Fiddlers Point, with views of Old House Creek and the Fripp Inlet, and a Deer Lake community, nestled among winding lagoons and a tropical forest.[219]

The flagship of the company's development projects was an expanded and grander version of the Newhaven condominiums, which the S&Ls had initiated in 1979 but scaled back while looking for a buyer for the resort. In 1981 the Fripp Island Company renamed the project Ocean Point and at the same time renamed the Fripp Island Golf Course the Ocean Point Golf Links. They described the new residential complex as offering oceanfront villas that "will include every luxury found in the most exclusive resorts." In a large glossy brochure, the Fripp Island Company provided an artist's conception of the cluster of villas, pools and gardens.

Despite the considerable talents of a skilled management team, there were soon indications that the Fripp Island Company had financial problems. An August 5, 1981 memo from the president of the Fripp Island Home Owners Association to all Fripp Island property owners announced the bad news: The resort management was dramatically curtailing its security services. The security personnel would only respond to calls from resort-owned properties or resort guests; all other calls would need to be referred to the Beaufort County Sheriff's Department with its closest facility over twenty miles away. This news accelerated the work of the property owners who recognized that the time had come for residents to furnish the services previously provided by resort developers.[220]

On October 13, 1981, the Brandermill Group abruptly terminated its relationship with Fripp Island. The publicly stated reason for the hasty exit after seventeen months was that a sluggish national economy had thwarted development plans. High interest rates, often as much as 16 percent, had discouraged construction throughout the country, and builders reported that many retirees who would like to move to the southeast were unable to sell their current homes. However, in a recent interview Frampton explained that some of the smaller S&Ls in the Fripp Island Development Corporation could no longer afford to invest in Fripp Island, for this was also the time of the national savings and loan crisis. There was disagreement among the coalition of lending institutions about what to do, but they finally decided they needed to sell the island outright and completely divest themselves of any financial relationship with Fripp. They asked the Brandermill Group to purchase Fripp for $8 million. By this time, Frampton was more convinced than ever about hidden liabilities and felt that the price was too high for the risk involved. His only recourse was to leave.[221]

S&Ls Resume Management of Island

Fripp Island's future was again uncertain. The Fripp Island Service Corporation, which represented the coalition of savings and loans that held the mortgage on the resort, reluctantly reassumed control of the island. A few residents proposed the idea of incorporating the island as a municipality run by elected officials and paid for by tax revenue based on property valuation. However, once Fripp owners understood that along with municipal status the island would cease being private, that option faded. The most reasonable solution was for the Public Service District (PSD), which had been established by law in 1962, to continue to manage the water and fire protection and to work toward assuming from the developer at a later time the sewer treatment plant and sewage operation, and for the property owners to take over the services that the developer had been subsidizing.[222]

At a special meeting of over three hundred people in October 1981, the Home Owners Association ceased to exist and the newly formed Fripp Island Property Owners Association (FIPOA) positioned itself to plunge into the work of accepting control of the roads, bridges, bike paths, beach crossovers and security. The man at the helm in setting this new course was William Miltenburg, a retired chief engineer and manager of the RCA Victor Records Division who had moved to Fripp in 1972. He instituted monthly newsletters to keep property owners apprised of the FIPOA's activities and negotiations.[223]

Money was an issue. The fifty-dollar per lot assessment specified in the original covenants had not been sufficient for the resort to provide needed services. More money would be required. "There are no cheap or easy ways," Miltenburg wrote, "to make the transition to property owner rule." The FIPOA shored up arguments for higher assessments by documenting the significantly higher amounts, often tenfold, paid at similar private communities and by noting that, while the assessment on Fripp had stayed level, the value of property in the previous decade had more than doubled or often tripled.[224]

Negotiating an agreement of this scope and complexity was further complicated because the ownership of the island remained in flux. The coalition of savings and loans, upon reacquiring the island from the Brandermill Group, was seeking a new buyer. They indicated that they would like to sell the resort facilities and undeveloped land to the property owners, but the price tag of $12 million put these out of reach. During this period the S&Ls scaled back the resort operation, laid off staff, eliminated some programs such as the landscaping department and phased down the construction and development efforts. They hired John Thigpen, a real estate and financial consultant from Atlanta, to assist in locating a buyer. The end of 1981 and the first part of 1982 were frustrating times for everyone on Fripp. The S&Ls could not find a buyer. A lean staff remained to attempt to operate the resort and property owners' efforts to finalize the transition plan were thwarted by having no one with whom to negotiate.[225]

Residents at a Crossroads

In 1979 the volunteer Fripp Fire Department received a donation of a 1952 open cab Mack fire truck that could produce five hundred gallons of water per minute. It served as a backup engine to the secondhand truck purchased in 1968. *Courtesy of the Fripp Island Fire Department.*

Despite the uncertainty over resort ownership, the work of the PSD, which oversaw the water supply and fire protection, went forward. On March 20, 1982, the PSD dedicated a new firehouse. The new steel structure, paid for by residents' property taxes, could accommodate Fripp's two aging fire engines—a secondhand Howe truck purchased in 1968 and a 1952 Mack truck that was donated in 1979 through arrangements handled by John Krider, a Fripp retiree and a former executive of the Mack Truck Company. During the dedication ceremony, volunteer fire chief Wolfinger, a retired army officer, received the keys to the new firehouse. The fire department volunteers often referred to themselves as the oldest fire department in South Carolina, since the average age of the members was about sixty-five. The Fripp Fire Department operated as a totally volunteer operation until 1986 when the PSD hired its first paid fire chief.[226]

Two developments in this period began to give Fripp a somewhat different look. One was the increasing use of golf carts as the means of transportation. Because the roads on Fripp were privately owned and the speed limit was twenty-five miles an hour, many residents, even those who didn't play golf, began to acquire golf carts and relied on them for getting about the island. Many people enjoyed riding on golf carts, feeling the breeze while experiencing the up close exposure to the natural

121

environment. The second development was the increasing appearance of homes built on pilings to provide greater elevation from the ground. Although the federal flood insurance program had started in 1968, the regulations, which identified flood zone areas and specified that the finished floor should be twelve or more feet above mean sea level, did not come into effect until the early '80s. In some of the older neighborhoods many of the original structures were just a few feet above the ground, whereas the new houses on the vacant lots next to them were considerably taller to accommodate the flood insurance regulations. Many Fripp residents feel this variety of housing contributes to the charm of the island.

Broadus Thomasson

Finally, on May 18, the S&L coalition announced the sale of Fripp Island for an undisclosed sum to Broadus Thomasson, a Rock Hill real estate developer. The June 30, 1982 deed for the sale lists that the conveyance is subject to the obligations secured by a list of six mortgages that totaled a little over $13 million. Broadus Thomasson's real estate background was in multifamily housing, shopping centers and condominiums—not resort or community development. However, he pledged to "keep Fripp above water." Thomasson explained that many people were drawn to Beaufort County because of the reputation of Hilton Head. But because of the overcrowding on Hilton Head, he believed that Fripp would be in a position to attract its overflow. "What we're primarily counting on," he said, "is the opening of the section of Interstate 77 from Rock Hill to Columbia." This he hoped would turn people away from Myrtle Beach and toward Fripp Island.[227]

Just two weeks after assuming ownership of the island, Thomasson laid off sixteen staff members. "There were just so many people here from the prior ownership," Thomasson said, "who were standing around with nothing to do." But from the perspective of the former employees, there were key positions, such as the head of maintenance, that were allowed to remain vacant. Decentralization of resort operations was at the heart of Thomasson's management style. He contracted out the operation of the golf course, the restaurant and the tennis courts, thereby creating a conglomeration of small businesses. Thomasson's promotional material characterized Fripp as "A Sea Island Retreat" with the emphasis on "Unspoiled, Uncrowded, and Uncommercialized."[228]

Despite some reservations about Thomasson's direction, property owners were relieved to finally have someone with whom they could negotiate. The residents had created an ad hoc system of voluntary work and assessments to provide services the resort management no longer performed. In a letter to property owners in December 1982, the officers and directors of the FIPOA stated: "Mr. Thomasson is a businessman with modest development plans—and his plans do not include subsidizing island services for the benefit of the residents." They pointed out that without the voluntary

Residents at a Crossroads

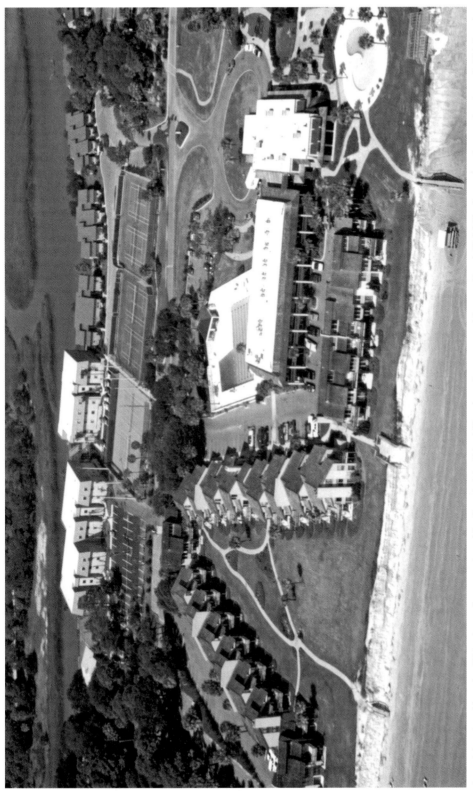

An aerial postcard from the 1980s shows the expansion of the Captain John Fripp Villas along the ocean and the new Beach Club Villas located on the canal and marsh. This location is one of the narrowest on Fripp, known in the days of the hunting preserve as "The Narrows." *Courtesy of Ernest Ferguson, Photo Art, Inc.*

contributions by a number of property owners, there would be no security force. They thus urged all property owners to honor the request for significantly larger contributions and to endorse at a future date the addendum to the covenants increasing the annual assessment. If the property owners failed to honor "fair and reasonable assessments" or refused to endorse the covenant addendum, the directors and officers predicted, "the bright dawn that is just now breaking over Fripp's future could quickly turn to a dismal dusk." Thomasson donated to the FIPOA equipment that had been used in road maintenance and security and almost all the property owners voluntarily contributed the larger assessments required for the maintenance of the island.[229]

1983 Agreement

Meanwhile the FIPOA's transition team put in long hours studying all the options, establishing a budget to pay for the needed services, calculating a fair method for assessing all property owners and preparing an addendum to the covenants to make the new assessments legally binding. It took two years to prepare the pivotal agreement between Thomasson Properties and the FIPOA. While it is dated September 27, 1983, the actual transfer of title, at no monetary consideration, of the roads, bridges, bike paths, exercise trails, beach accesses and all of the common areas from Thomasson to the FIPOA did not occur until April 1984. William Miltenburg wrote to all property owners announcing that the FIPOA now owned some $4.9 million worth of property.[230]

Yet there was need for another essential step: changing the covenants to assure that all present and future owners would be obligated to pay a uniform annual assessment. This step entailed a cumbersome process. Each owner had to sign before witnesses a document verifying the particular lots owned and agreeing to obligations stated in the amended restrictive covenants. The annual assessment was set at a sum of up to $250 for each dwelling unit and $125 for unimproved lots, with a provision for increases no greater than the increase in the consumer price index. There was some expected grumbling about the significant increase in annual assessments. But most property owners realized they had no alternative if they wanted to protect their real estate investments and wished to have the bridges and roads maintained and twenty-four-hour security service.[231]

An Active Residential Community

The residents who had built the chapel continued to find new ways to enrich the community on Fripp and to expand the use of the centre. Besides weekly vespers services, All Faiths Chapel also became the place where island residents gathered to

celebrate weddings and to mourn the deaths of friends. One of the first weddings was that of Patty Smith and Jim Patek, the son of residents John and Doris Patek. Twenty years later the couple and their two sons returned to become permanent residents of Fripp.

The growth of the choir for Wednesday night vespers services prompted a special campaign to purchase a grand piano. The first fundraising effort was a concert followed by dinner on the terrace surrounding the English garden at the Village of Newhaven. Within a matter of months there was sufficient money to purchase a new piano. This in turn led the community centre to sponsor a series of musical events on Sunday afternoons. In 1983 a new organization, the Fripp Island Friends of Music, assumed responsibility for special music. Thus began the tradition of bringing talented musicians to the island for an annual series of concerts.

The Audubon Club, which held its monthly meetings at the centre, not only learned about wildlife but also undertook some innovative projects. They initiated and subsequently received assistance from the telephone and power companies to construct a number of nesting poles for osprey. Watching these large graceful birds nesting on the poles and soaring in the sky remains a treat for Fripp residents and visitors to this day. The Audubon Club also developed an Audubon Trail near the marsh that borders the Fripp Inlet. The club erected signs along the trail and at other scenic spots about the island to alert people to the presence of native birds, fauna and plants.[232]

As anticipated, the centre became the hub for many other island activities such as a weekly Alcoholics Anonymous group, bridge games and dance classes. There were also covered dish suppers and TOPS ("Take Off Pounds Sensibly") exercises. As talented people moved to the island, they organized new groups. For example, soon after Mary Delle Thomas, a retiree from West Virginia, moved to the island, she started a weekly yoga group that she directed for seventeen years and which still continues.[233]

In 1983 under the leadership of Paul Field, who retired to Fripp after a career as a federal bank examiner, a group of men and women formed the Sea Rescue to aid boaters who became stranded on sandbars or had accidents or motor failures. The catalyst for the formation of Sea Rescue was a near tragic event that occurred a few days after Christmas in 1982. Two young men from Columbia and their children got into rough waters in Skull Inlet and their boat capsized. They were only saved because a man on the beach who saw them acted quickly. In the days following this event, Field and others realized the need for a group that could respond quickly to marine emergencies within a ten-mile radius of Fripp. In their first year Sea Rescue, with a mission "to save lives," undertook twenty-five rescues and received special commendation for their work from the coast guard station in Tybee, Georgia. Since 1983, one of their members has always been on duty, ready to respond to dispatches from individuals, the coast guard or county or state officials. In their first years they operated with donated boats and took up collections to pay for gas and supplies. Many a desperate boater is indebted to the dedication and skill of Fripp volunteers

who stand ready to help those in need. The *Trawler* periodically carries accounts of some of their most challenging rescues.[234]

In the mid-'80s a number of residents recognized the need on Fripp for a flagpole to fly the American flag. The Women's Group, under the presidency of Dixie Winter, a retired schoolteacher from Aiken, provided the lion's share of the funding for erecting a flagpole at the entrance of the island. Indicative of the close community on Fripp, the tradition of flying the American flag at half-mast whenever a Fripp Island property owner died soon developed.[235]

Among the organizations led by Fripp volunteers, the PSD continued to play a crucial role in addressing special needs. When high winds and seas threatened Fripp's shores, it was the PSD that responded. In October 1983 a potent northeasterly wind combined with new moon high tides to create a turbulent ocean surge that severely damaged not only the Fripp Inlet shoreline but also washed out a portion of Porpoise Drive, burst the main water lines and for several days interrupted mail delivery and trash removal. Property owners had for some time been aware of the need to stabilize the inlet shoreline, but there was disagreement about who should take the lead and pay for erosion control. Since significant portions of the golf course were in jeopardy, some thought the developer should be responsible. Yet others pointed to the FIPOA because it owned and maintained the roads. However, in the aftermath of the storm it was the PSD that took responsibility.

The PSD had established a policy of not paying for revetments to protect private property, but in this case a key road and main water line were imperiled. Thus the PSD agreed to seek authority from Beaufort County Council to conduct a bond referendum to pay for the Fripp Inlet erosion control project. All property owners would be asked to help foot the bill. The design called for a sloping rock revetment that would rise twelve feet above the mean sea level and would extend for two thousand feet along the Fripp Inlet. Beverly Snow, a civil engineer who had retired to Fripp in 1981, helped spearhead the inlet revetment project. He recently recalled that good communication was the key to the successful referendum. Prior to the public hearing, the PSD commissioners talked to as many people as possible to figure out a cost-sharing scheme that would satisfy the maximum number of persons. They then proposed that the developer and the owners of waterfront property who were directly affected pay for 20 percent of the cost, with the other 80 percent to come from a portion of property taxes levied on all island property owners. The bond passed by a seven to one margin and work began in July 1984.[236]

The work of the FIPOA was also expanding. In 1986 the association secured from Thomasson, at a reduced price, land on which to construct an office building for conducting its ever-increasing responsibilities. In the succeeding years the FIPOA established an emergency road and bridge fund, built crossovers at a number of beach access points, improved the aeration on lagoons and monitored Thomasson's future development plans.

A persistent problem that remained unaddressed was the poor condition of the unpaved portion of Tarpon Boulevard that extended from about a quarter-mile

Residents at a Crossroads

The Fripp Audubon Club was instrumental in having workmen from the telephone and power companies erect several poles on Fripp Island for osprey nests. This one is located on a ridge near the end of Blue Gill Road. *Courtesy of the* Beaufort Gazette.

past Bonito Road to the southern end of the island. The residents of this area had unsuccessfully lobbied all the previous resort owners to pave the road. After the 1983 agreement, FIPOA insisted that their obligations extended only to maintaining the roads in the state they were in at the time of the agreement. The two residents who led the effort to get the rough and dusty dirt road paved were Bill and Ruth Meredith, part-time residents from Atlanta. Augie Gorse, a retired Eastern Airlines captain, recalled that the events that propelled them into action were the large puddles and high standing water that played havoc with Bill's Mercedes, which had a diesel engine that flooded easily when exposed to water. "Bill loved that car," Gorse reminisced, "and didn't want to drive it on such a poor road." Ruth, a forceful person, did much of the organizing and finally the residents decided to voluntarily assess themselves $1,000 per lot to pay for the paving. But two residents held out. Ruth went up to one of them at a social gathering, planted a large kiss on his bald head, said "time to pay up" and he did. The other holdout did not. In December 1986 the south end of Tarpon became a paved road, and the residents received a refund because the cost turned out to be just under $900 a lot.[237]

While Fripp residents devoted hours of volunteer time to various organizations that raised the quality of life on the island, they also had time to play and to enjoy

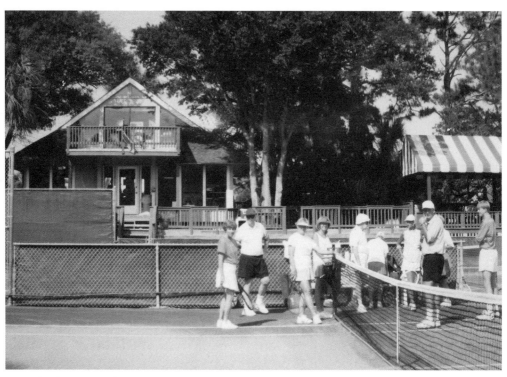

Located in the center of the island, the racquet club has eight clay and two hard courts. Since it was built in 1978, the tennis center has offered clinics, hosted regional tournaments and arranged round robin events. *Courtesy of author.*

fishing and the beach. Joe Oppenheimer, who retired in 1980 from Illinois, where he had been an attorney for a major insurance company, began coordinating in the early 1980s a Friday morning tennis round robin which continued for two decades. Any resident or guest could play with the group and the rotations provided a means for welcoming newcomers. The increased activity at the racquet club under the leadership of Joe Towe, who managed the tennis facility, and his son Joey, the resident pro, led to the extension of the decks to include a covered area with rocking chairs for relaxing after matches and for viewing the Fripp teams and the lively ladder competitions.[238]

The *Trawler* had a regular column called "Fishing and Foraging" that provided information on the oyster and clamming seasons and details on the best spots in the area for catching crabs and various kinds of fish. The turtle patrol that began in the 1970s continued with marked successes. For the 1985 season they reported 176 nests, with 105 having to be moved to safer ground, and estimated over 11,000 hatchlings. Both the turtle program and the Audubon Club alerted residents and visitors of the possibilities for exceptional viewing of the island's wildlife.[239]

Disgruntled Property Owners

While the individual property owners, the FIPOA, the community centre and the PSD were able to tackle many of Fripp's problems, there was little they could do about Thomasson's failure to maintain the golf course. Some residents considered the golf course unplayable and joined the new club on Dataw Island. Fripp golfers were particularly irritated that Thomasson continued to promise that Fripp would have one of the best golf courses in the county while doing little to improve its condition. Knobby Walsh, a retired navy captain, described the improvement as "What was an ill-tended cow pasture has now been upgraded to a fourth-rate golf course." In a letter in the *Trawler* a resident called it "far-and-away the worst-conditioned golf course in Beaufort County." The restaurants and pools didn't rate much better. The 1987 spring luncheon of the Women's Group at the beach club had been a "fiasco" and the women had successfully secured a reduction in price for the disappointing food. Deterioration of amenities prompted some property owners to discuss the possibility of purchasing the golf course and other club facilities.[240]

Many residents were also quite critical of Thomasson's two major building projects—the Beach Club Villas and the North Hampton condominiums. In contrast with the Brandermill Group, whose designs were geared to upscale investors, Thomasson's projects lacked aesthetic appeal and were aimed at those seeking modestly priced vacation homes. With a background in multifamily buildings, Thomasson built high-density box-shaped condominium apartments that he could sell at relatively low prices. The Beach Club Villas possessed lovely views of the marsh and the canal; however, the three-story nondescript buildings

were wedged onto a small plot of land with the entrance dominated by a large asphalt parking lot. The North Hampton condominium complex had two three-story buildings consisting of forty units with elevators and commanding views of the Fripp Inlet and ocean plus a pool. However, the poor construction eventually led the buyers to join together to pursue legal measures that led to the successful correction of structural problems.[241]

There was little doubt among residents that Thomasson had financial problems. In November 1986, he decided that a property auction would be the solution to his difficulties. "What we set out to do," Thomasson said, "was to get rid of slow moving properties and create cash flow." Under a huge green and white tent with an organist playing festive music, several auctioneers kept up a constant chant for three hours barking out in rapid fashion such lines as "If you don't bid soon, you'll be too old to enjoy golf." The auction offered about one hundred properties valued at $6 million. The selection included eighteen efficiency condos, twelve villas, two beach homes, seventy lots and two large undeveloped parcels of land. By predetermined rules, Thomasson did not have to accept a bid. Thus at the end of the day, less than half the properties were actually sold. In assessing the event, the developer commented: "We thought we were going to hit a grand slam home run and we ended up only getting a double with two men on base." The income from the sales did enable Thomasson to reduce his debt by $1.1 million, make sewer payments necessary for selling more lots and create a small pot of cash for operating expenses.[242]

The two parcels of undeveloped land did not sell at the auction. The following year Thomasson entered into a tentative agreement to sell them to Randy Brewer of a development company from Greenville, South Carolina. Before Brewer could proceed with his plan to create the South Pointe Plantation on the southwestern portion of Fripp, he had to get permission from the county to revise the Fripp Island Master Plan and had to secure numerous permits.

When Fripp residents learned about Brewer's plan, they actively opposed it, and in the end achieved a crucial victory for the FIPOA and Fripp Island. Brewer proposed an average of four units per acre for South Pointe Plantation. At stake was whether Fripp would remain uncrowded with a core of year-round residents. Beverly Snow, a member of the FIPOA board at the time, recalled that we "prepared a hard-hitting presentation with charts to argue our case before the Joint Planning Commission." On June 1, 1987, the entire board plus numerous Fripp property owners filled the county chambers to overflowing. By a five-to-four vote, Brewer received approval for 807 plantation units, of which less than half would be single-family homes. The commissioners who voted for Brewer's plan justified their votes by saying that since there was no density agreement for Fripp that the limit of 807 at least put a cap on the number of units that could be built.[243]

This vote, however, did not deter the FIPOA from continuing to oppose plans for the South Pointe Plantation. The development of Fripp Island to this point had been on an average of 2.5 units per acre, a sharp contrast to the 4 units per acre proposed by Brewer. The lower density allowed for the open space and the protection of

A 1986 flier announced a Thomasson Properties auction of a number of condominiums, houses and lots on Fripp Island. *Courtesy of Dick Anderson.*

the natural environment that many believed to be essential to preserving Fripp's unique qualities. Through letters to the *Beaufort Gazette*, TV interviews and countless meetings with county, state and federal officials, the FIPOA pressed its case. A few months after the county hearing, Snow reported that Thomasson's deal with Brewer unraveled. Snow attributed this to negative publicity, an uncertain permitting process and the large expenditures that would be immediately required for providing water and sewage.[244]

The activated FIPOA did not take the abandonment of the South Pointe Plantation as a reason to rest. In their efforts to establish a low-density agreement for Fripp, the association members were assisted by Beaufort County's new zoning policies. The county's Joint Planning Commission established Planned Unit Developments (PUDs) for the county's various island communities. The PUDs were to include a density limit in their master plans. This county policy set in motion a long series of negotiations between the FIPOA and Thomasson that resulted in an agreement signed on December 14, 1988, which specified that the number of units—whether an efficiency condo, a single-family house or a possible hotel room—could total no more than 2,800. Given that the total number of acres on Fripp above mean high water is 1,133, the Fripp Island property owners succeeded in establishing an average of 2.56 units per acre. The property owners had cause to celebrate the fact that they had exerted significant influence over the future development of Fripp.[245]

With difficulties facing Thomasson at every turn, he indicated in 1988 that he would be receptive to the possibility of selling the holdings of the Fripp Island Club. An independent group called the Fripp Island Amenities Acquisition Committee formed to explore the purchase of the golf club, the racquet club and the two swimming pools. After a positive response from a survey of club members, the committee secured an appraisal and made an offer on August 25, 1988, of $2,190,200 for the amenities. The plan was to create equity memberships. There had been several conversations with Thomasson leading up to the offer. When the offer was made, he indicated he would give a response within two weeks. But nothing happened. Thomasson never even acknowledged the offer. On December 1, 1988, Knobby Walsh, who had served as chairman of the Amenities Acquisition Committee, wrote to Thomasson that the negotiations "are terminated and the Committee is disbanded."[246]

By 1989, the relationship between Thomasson and the property owners seemed beyond repair. Yet the president of the FIPOA invited Thomasson to a May board meeting to try to figure out a way to ease the tension. Some sought reconciliation but others emphatically stated, "Broadus Thomasson had never done anything he had promised, that the island was going to hell in a basket and that further cozying up to the developer would lead only to more broken promises." Thomasson further antagonized residents when he invited everyone in Beaufort to come to Fripp for the July Fourth celebration. This completely violated any sense of Fripp being an uncrowded private island. Residents responded by boycotting the resort's annual July

Residents at a Crossroads

Fourth parade. Norine Smoak, a longtime resident, organized a separate parade on the south end of Tarpon Boulevard for the property owners.[247]

Thomasson was weary from the constant problems that beset his operation on Fripp Island. He was looking for a buyer for the resort and undeveloped land. The December 1989 issue of the *Trawler* reported that a tentative agreement had been reached between Thomasson Properties and the Hornsby Company for the sale of Fripp Island. An announcement by Thomasson on March 22, 1990, confirmed the sale.

The news created a celebratory spirit on the island. At the spring luncheon meeting of the Fripp Island Women's Club the "Darling Old Girl Singers," affectionately known as "DOGS," sung a song that expressed the sentiments of many Fripp Island property owners to the tune of "The Caissons Go Rolling Along":[248]

> *Turn about*
> *Let's all shout*
> *Broadus Thomasson is out*
> *And Fripp Island is rolling along*
> *Looky here,*
> *Let's all cheer*
> *Someone new is really here*
> *And Fripp Island is rolling along.*

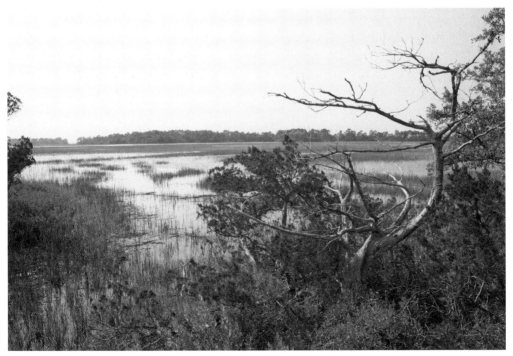

Observing the ebb and flow of the tides in the marsh is as fascinating to watch as it is along the beach. Many Fripp homes have spectacular marsh views. *Courtesy of Julie Hodgson.*

One longtime Fripp resident recently summed up the Thomasson era as the "seediest, neediest, mess you ever saw," but added, "it was our island full of beautiful vistas." Many residents of the 1980s remember it as a time when everyone knew one another and there was a sense of extended family among the residents. Despite the poor condition of the amenities, the residents could still feel the ocean spray, observe the ebb and flow of the tides in the marshes, savor magnificent sunsets, sizzle burgers on their decks and raise their glasses in toasts to the beauty of Fripp Island.

In the 1990s new owners would bring an upscale look and growth to the island. Inevitably more houses and more people would strain the delicate balance that existed between a close-knit residential community and a thriving, expanding resort.

Chapter 7
The Gay Nineties

Fripp of the 1980s—with its scruffy golf course—morphed during the next decade into a stylish resort. For property owners who longed for attractive amenities, their wish came true. In the transition, some losses accompanied gains. The cohesion of the community, relative tranquility and large areas of natural habitat diminished as more part-time residents and tourists arrived to partake of the gaiety of an expanded resort with a Caribbean air. The challenge for residents was to adapt to the changes brought by development while retaining a sense of community that made Fripp special.

A Delicately Negotiated Purchase

It had been clear since the mid-1980s that Broadus Thomasson, who had purchased the Fripp resort in 1982, had neither the resources nor the experience to deal with the island's challenges and opportunities. In response some property owners tried to purchase the amenities in 1988. When that failed, they were eager to facilitate acquisition of the island by a more able and interested owner. In the fall of 1989, developers David Hornsby and Ken Willis explored the possibility of buying the resort. Initial conversations with Thomasson proved promising. When the board of the Fripp Island Property Owners Association (FIPOA) got wind of this development, they sent a delegation to St. Simons for a firsthand look at one of their projects. Impressed, the board arranged a meeting with Hornsby and Willis to hear their preliminary plans for the island. Their goals, they said, were to "puff up" appearances, sell real estate, operate amenities and maintain the residential and family orientation of the island—all objectives that pleased the board.[249]

Both Hornsby and Willis had experience with coastal developments. David Hornsby grew up in the resort business in Georgia where his parents owned and operated a mom and pop motel and restaurant. After receiving a business degree from Georgia Southern University and living for a time on the West Coast, he came back east to work on motel and hotel construction projects. While on St. Simons, Hornsby teamed up on a joint residential venture with Ken Willis, who had real estate experience in Myrtle Beach.[250]

When the two began to look for a new challenge, it was Willis who learned from mutual friends that Thomasson was interested in selling his Fripp holdings. On several occasions in late 1989 and early 1990, Hornsby and Willis thought they had an agreement for the purchase of Fripp. But each time, Thomasson either expressed reservations or new impediments arose that prevented the signing of a contract. As the FIPOA board explained, the complications included tougher government regulations on S&L loans for resort development, a lien by residents of the North Hampton condominiums on the golf course, a matter that Thomasson had not disclosed to the prospective buyers, and delays in raising money for the purchase.[251]

Hornsby and Willis, as well as property owners, became frustrated by the stalemate. With each month amenities fell into greater disrepair; the golf course was routinely called a "poorly tended cow pasture." Both buyers and residents sought

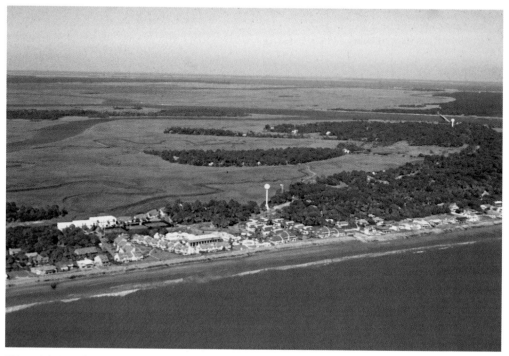

This aerial view of Fripp shows the expanse of the marsh areas. The wooded area in the middle of the picture is the Sawgrass Bluff neighborhood. *Courtesy of Ernest Ferguson, Photo Art, Inc.*

ways to end Thomasson's foot-dragging and to facilitate the sale of the resort. Hornsby and Willis had limited resources of their own and turned to property owners for financial backing. Meanwhile some property owners independently explored new ways for leveraging pressure on Thomasson to sell.[252]

Resident Knobby Walsh, a retired naval captain, gathered some residents who might be interested in investing in Hornsby and Willis's bid to purchase the Fripp resort. Regulations of the Security and Exchange Commission limited the number of investors in this type of undertaking. For this reason Walsh invited only a small group to hear a presentation by Hornsby and Willis. The developers explained that they were looking for ten people willing to invest $50,000 each. Loans would be secured by land that was to become the River Club and interest would be quarterly at an annual rate of 12 percent. The buyers anticipated being able to pay off the loans within a year or two at the most. As discussions with the group became more serious, Bill Shaw, a retired accountant and one of the potential investors, negotiated concessions—dues in the club would be permanently waived and investors would receive shares of stock in the new company. Needed commitments were soon secured. Additionally, an unanticipated source of financial support emerged. Bob Wardle, a part-time resident from the Pittsburgh area, had learned on the golf course about the gathering called by Walsh. Though not officially invited, he sat in on the meeting and subsequently indicated his willingness to become a major investor with Hornsby and Willis.[253]

Meanwhile some members of the Fripp Island Club formed an ad hoc committee to withhold dues. They knew timing was everything. Under Thomasson's management, members paid annual membership dues in March, which was also when Thomasson had a crucial mortgage payment due. Without income from dues he would be unable to meet the loan deadline. To make the strategy of withholding dues effective, the ad hoc committee began work in January to ensure cooperation of a large percentage of both resident and non-resident members. Augie Gorse, a retired Eastern Airlines captain and former executive in the Airline Pilots Association who moved to Fripp in 1972, helped spearhead the effort. The ad hoc committee sent letters to all club members explaining the situation, asking them to withhold payment of their dues and requesting a contribution of $5 for the work of the committee. Some demurred for fear that they would lose their membership in the club and have to repay the initiation fee. But Gorse recalled an overwhelmingly positive response. Many sent much more than the requested $5 and the ad hoc committee ended up with a surplus of $600 that they turned over to the Fripp Island Community Centre.[254]

While Hornsby and Willis's enlistment of local supporters was a rather hush-hush operation, the movement to withhold dues was public. Thomasson was well aware that income he needed for the loan payment probably would not be forthcoming. The final resolution came during a well-attended meeting of the ad hoc committee of club members. Gorse presided. He had heard that afternoon

that Thomasson had agreed to sell, but Gorse did not want to let up the pressure until he was certain papers had been signed. Definitive word came after the meeting began when Bill Shaw came running in the back door and shouted "deal done." The celebration began. The close-knit Fripp community had prevailed to save the island they loved from sinking into perpetual neglect.[255]

On March 20, 1990, Hornsby and Willis purchased Thomasson's holdings on Fripp for $7,537,748. According to the Affidavit of Consideration filed in the Beaufort Courthouse they paid $2.3 million and assumed fifteen mortgages that totaled approximately $5.2 million. Besides the golf course, racquet club, pools, store and restaurants, they acquired eighty-three lots and three parcels of undeveloped land located in Deer Lake, Fiddlers Cove and in the jungle on the southwest end of the island.[256]

Moviemaking on Fripp

One of the first decisions of the new Fripp Company involved Hollywood. In the spring of 1990, Hornsby and Willis agreed to allow Columbia Pictures to film several scenes for the movie *The Prince of Tides*, the first of several moviemaking ventures to capitalize on the island's scenery. Barbara Streisand, the director, and Paul Sylbert, the production designer, spent weeks scouting the Lowcountry for the right location. In describing the decision to choose Fripp, Sylbert said: "We wanted a beach that matched everyone's idea of what a beach should look like. The tides are great, with low tides revealing vast expanses of beach that stretch in all directions. The surf is wonderful too." Cinematographer Stephen Goldblatt was equally enchanted, noting, "Fripp and the surrounding areas offer some of the most extraordinarily beautiful countryside I've seen." The clouds, the tropical storms, the sunlight, the green marshes—all resonated with Goldblatt. The relatively uncrowded beach and lack of traffic were also plusses.[257]

Because the film was based on a Pat Conroy novel that drew heavily on his experiences on Fripp, the decision to film on the island was natural. Conroy explored Fripp as a teenager while a student at Beaufort High School and his mother became a resident of the island in the 1980s. While visiting her home, he wrote significant portions of *The Prince of Tides* and subsequently bought a house on Fripp.

Columbia Pictures spent two weeks on Fripp in July 1990 filming *The Prince of Tides*. The beach house on Red Drum Road belonging to Nancy and Michael Ford served as the home of two of the movie's principal characters, Tom and Sally Wingo, played by Nick Nolte and Blythe Danner. Much of the filming took place inside the house but there were also beach scenes. The opening and closing scenes in the movie featured spectacular aerial views of Fripp's expansive beach and dunes.

The Gay Nineties

The filming of beach scenes for *The Prince of Tides* involved large equipment and a sizeable crew. Fripp residents enjoyed the opportunity for an "insider's view" of the movie industry. *Courtesy of The Fripp Group, Inc.*

Many Fripp property owners can recall stories about the making of *The Prince of Tides*. Miriam Nisbet, whose mother and father owned the beach house next to the one used for the filming, recently recalled that Barbara Streisand took a fancy to their kitchen curtains and asked to borrow them. The Nisbets happily obliged. Streisand considered but then rejected including a dog in one scene. When word of this possibility spread about the island, many dog owners began preparing their dogs for an audition that never came to pass. Stuart Mitchell, who was then general manager of the resort, remembered the filming of a scene involving Nolte and Danner. The two were engaged in a tense conversation on the beach when Nolte ran off into the ocean, wetting the seat of his pants. There were countless retakes of this episode, and Nolte had to change into dry clothes before each new take. As Mitchell recalled, the shooting went into the late hours of the night with Nolte deciding to save time by not going to his trailer to change clothes. Mitchell observed: "It seemed as if every woman on Fripp—up to the age of about eighty—was there."[258]

The filming of *Forrest Gump*, which starred Tom Hanks, Sally Field and Robin Wright and won the Academy Awards for best picture and best director, occurred in the fall of 1993. After hearing colleagues rave about their experience on Fripp working on *The Prince of Tides*, Paramount Pictures selected the island as the setting for the *Forrest Gump* Vietnam scenes. The island offered a large unspoiled tract of land near water and marshes, which Mary Morgan, the locations manager, said looked like rice fields from a distance. In creating eight filming sites, the Paramount crew cleared several acres of underbrush, imported red clay to cover selected patches of ground, positioned tropical plants and built Vietnamese huts in the area now called Ocean Creek. Computer simulations provided mountains in the background.[259]

The battle scene during which Gump carries the wounded soldiers away from the napalm bomb explosion required the services of the Fripp Island Fire Department. Paramount Pictures sent letters to all Fripp homeowners alerting them that they would be hearing "simulated gunfire" and seeing special effects of smoke and fire. After a week of daytime rehearsals, director Robert Zemeckis scheduled night shooting with fire, a filming that could not be easily repeated. Zemeckis feared, as Bill Robinson recently recollected, that the firefighters with three engines and five hoses would want to get very close to the scene in order to be ready instantly to put out the fire. Zemeckis cautioned them not to appear until he yelled, "Cut!" However, in the excitement of the moment, Robinson said Zemeckis failed to give his cue, and there was a slight delay before the fire department went to work. The fire spread to the top of tall pine trees and took several hours to bring under control.[260]

Several Fripp residents had a few seconds of fame by successfully auditioning for minor roles, but most Frippers were content to stand on the sidelines and observe the action. Al Oram, one of the Fripp volunteer firefighters, recalled watching "carpenters erecting sets faster than you could blink." One special

The Gay Nineties

Tom Hanks, the star of *Forrest Gump*, is pictured here with several Fripp Island volunteer firemen who provided backup assistance for the filming of the Vietnam napalm battle scene and the creation of a storm. *Courtesy of the Fripp Island Fire Department.*

effect that was fascinating to watch was the simulation of a storm. Filming at the end of Bonito Road, Paramount Pictures had the assistance of the Fripp Fire Department to shoot water high into the air. Big fans created the effect of gale force winds. The tale of the soybean patch also merited much telling and retelling. Paramount had made arrangements with Davis Dempsey, who had a large strawberry and tomato farm on St. Helena Island, to plant a soybean patch on Fripp that would be mature at the intended time of the filming. Everything was going according to plan. Then the night before the filming, Fripp's deer began to eat the soybean plants down to the nub. Paramount put one of the Hollywood crew on guard duty and he shot a deer with a bow and arrow. Because Fripp is a state designated nature preserve, shooting any wildlife is forbidden. Fripp security banned the California deer watcher from the island.[261]

For Fripp residents the highlight of the filming of *The Jungle Book*, made during June 1994, was seeing exotic animals—elephants, tigers, lions, panthers and monkeys—up close. For scenes that were supposed to take place in India, the Walt Disney Studios used the same jungle settings that had served the prior year as Vietnam. Longtime resident George Douglass considered one of the most unusual experiences he ever had on Fripp hearing a loud, strange sound and looking out his window to see a noisy herd of elephants meandering down his street. While the smaller animals spent the nights in cages on Fripp, the elephants stayed on Hunting Island. Teenager Bryon Stanley, who was on Fripp for a family vacation, played basketball in the late afternoons with a new friend, whom he later was surprised to learn was actor Jason Scott Lee. Lee played the lead role of a boy raised in the jungle by wild animals.[262]

The Fripp Company had hoped to reap a financial windfall from providing lodging and meals for the sizeable movie crews, but that didn't happen. The Hollywood companies brought their own house trailers as well as food. Yet it was still a winning collaboration. The island got considerable publicity as a secluded, lovely place. Property owners enjoyed the excitement and gaiety that Hollywood brought to Fripp and filmmakers appreciated the privacy and natural beauty of the island. Even the actors gave Fripp high marks. Of all the movie stars who came to Fripp, resident June Everett observed, the one who most enjoyed the island and won the hearts of Fripp residents was Tom Hanks. He rented a house on Fripp for his family and mingled easily with the island community.[263]

Fripp Company Adopts a New Vision

Hornsby and Willis also brought a gay spirit to the island as Fripp's property owners experienced a happy honeymoon period with the new management. The company immediately set about upgrading Ocean Point Golf Links, giving the beach club a needed facelift, resurfacing tennis courts and improving the

The Gay Nineties

general appearance of the island. Stylish navy blue awnings decorated decks and entrances to the club and fashionable recliners circled the pool with its sparkling fountain. FIPOA board members reported "a new upbeat spirit has pervaded the Island since our change of development administrations." The theme for the annual Fourth of July parade, "Happy Days Are Here Again," captured the new optimism.[264]

The couple who most believed in the Fripp Company and who supplied needed financial assistance was Bob and Rene Wardle. The two met as high school students in Connecticut. Rene's father, Bill Grinold, was the president of Wallingford Steel in Wallingford, Connecticut. After Bob Wardle worked his way through college at the University of Michigan and received his degree in business, he also pursued a career in the steel business. He became a senior vice-president of Pittsburgh-based Allegheny Ludlum Steel and was instrumental in implementing significant improvements to the steel-making process that subsequently made the company a formidable competitor in specialty steel manufacturing. The couple came as guests to Fripp for the first time in the late 1970s. As Rene reminisced, "we immediately fell in love with Fripp." They soon began bringing their four children for a week each summer. Rene said, "then one week a year became two

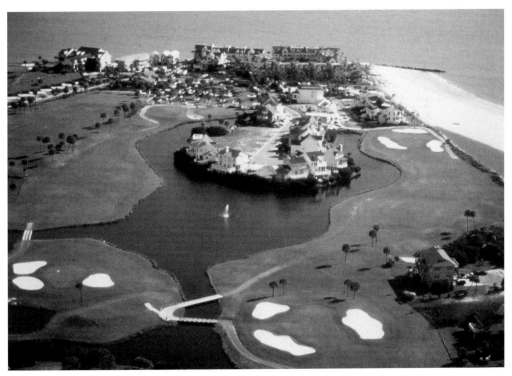

This aerial view from the 1990s shows the transformation of Ocean Point Golf Links from its previous scruffy state to one that is well manicured. Also in view is the new residential community, the Village at Ocean Point, developed by Hornsby and Willis. *Courtesy of The Fripp Group, Inc.*

weeks, and then three weeks." In 1985 they moved into their first house on Fripp and gradually spent more time on Fripp than in Pennsylvania. In the mid-1990s they finally made Fripp their permanent home. Hornsby and Willis valued Bob Wardle's involvement as a stockholder in the company and the advice, friendship and financial support of Bob and Rene Wardle.[265]

Once the Fripp Company stabilized amenities, they turned to their primary agenda, which Hornsby recently described as "developing dirt and selling dirt." Their first residential community was the carefully appointed River Club. Located behind a handsome tabby wall in an area near the entrance to the island, Hornsby and Willis plotted eighteen large lots, many with panoramic views of the Fripp Inlet. Next came Deer Lake, a planned community of sixty-three homes on quarter-acre lots bordering lagoons or tropical oak, pine and palmetto forest. Architect Ed Cheshire designed two cottage-style homes for the Deer Lake community. "We think Deer Lake will have strong appeal," Willis said, "for young families looking for second homes as well as older couples who are planning to retire in five to ten years." For those who wanted ocean views, the Fripp Company opened up a new development at Ocean Point.[266]

Just four months after taking over management of the island, Ken Willis boasted that the real estate arm had set a new Fripp record, which he attributed in part to the property owners, who provided two hundred referrals. The developers also remodeled the beach club to accommodate large meetings as well as small conferences. The objective was to attract groups that would keep the club busy during the entire year. Through special meeting packages, the company offered group prices that included all meals, lodging and conference facilities plus golf carts for easy island transportation. After years in which Fripp did not have the kind of facilities required for drawing groups, the sales staff recognized that it would take time to rebuild Fripp's reputation as a place for group events.[267]

The centerpiece of the Fripp Company's vision for the island focused on converting the undeveloped jungle area of *Forrest Gump* and *The Jungle Book* into a golf course and pool complex with 450 new home sites. The Vietnam War scene in *Forrest Gump* had started the job of clearing the area. The conceptual plan included 193 acres, of which 48 percent would be devoted to the golf course, 39 percent reserved for residential development and the remaining 13 percent would consist of newly constructed lagoons, which were necessary for managing water from storms. Yet before any construction could begin, the company had to secure permits that would allow altering portions of the area's wetlands. Of particular concern was securing authorization for filling in with dirt 5.2 acres of isolated wetlands.[268]

Besides securing building permits, Hornsby and Willis had to figure out the financing for the development of the southwest end of the island. To head up this task, they brought in Danny Robinson, a consultant from Hilton Head. In 1994 Robinson put together a financial package to present to banks and lenders and subsequently joined the company as chief financial officer.

The Gay Nineties

The popular 1990s design of Deer Lake houses had exteriors of stained cedar and tabby that blended into the natural environment and interiors with high ceilings and large windows to provide bright, cheerful rooms. *Courtesy of Julie Hodgson.*

Fripp Island

An aerial view of Ocean Creek Golf Course shows the beauty of the setting with the tropical vegetation and marsh bordering the greens and fairways. *Courtesy of The Fripp Group, Inc.*

The cottages at Veranda Beach, many within easy walking distance of the new Cabana Club, overlook the canal and Skull Inlet. They convey the charm of nineteenth-century houses with big porches and second-story verandas designed to catch breezes. *Courtesy of Julie Hodgson.*

The Gay Nineties

Hornsby and Willis selected Davis Love III, a noted golfer in his own right and son of the noted pro and teacher, to design the Ocean Creek Golf Course. Just thirty years old at the time, Love was eager to undertake the challenge of creating his first course. With support of an able architectural team, Love described his desire for the "course to fit the land" and for it to be "fun for me—and my mom—to play." The beauty of the natural landscape inspired the layout, which design team member Paul Cowley said achieved what every golf course designer hopes for: "variety, mystery, visual drama." The Ocean Creek Golf Course opened in October 1995 to rave reviews. About a thousand residents, guests and representatives of the media gathered for a fun-packed day of bluegrass music, barbeque and a walking and playing tour of the new facility. As part of the festivities the Fripp Company dedicated a plaque to the filming of *The Jungle Book* and a bench to remember *Forrest Gump*.[269]

The same year the Fripp Company offered for sale the first properties in Ocean Creek and began construction of the pool complex at Veranda Beach, a $2 million seaside water wonderland. Along the golf course and marsh, they sold lots for building custom homes. Around Veranda Beach, Hornsby and Willis created a village inspired by Seaside, Florida, a pedestrian-friendly community of wood-frame cottages in the nineteenth-century style with elevated verandas to catch breezes. Built on small lots that required little upkeep, the colorful houses—blue, pink, green or yellow—reflected the pastels of the sea and sunrises.[270]

Hornsby and Willis developed a number of other residential neighborhoods, including Mulberry Place near Fripp Inlet, Fiddlers Cove on Fiddlers Trace and the Marina Village. In 1995 they purchased the marina from Pete Sanders and began planning a new residential community and expanded marina facility. The new village was to include eighteen waterfront homes, a store, pool and renovation of the boathouse restaurant. To provide first-class marina services, the developers built two large boat storage facilities and new dockage spaces.

Upscale amenities along with the new neighborhoods appealed to the second home market and increased the number of nonresident owners and people renting and attending special events. The increased population and the colorful new architecture contributed to an entirely new appearance for Fripp. The change was difficult for some longtime residents who missed the simplicity of the 1980s, when they knew almost everyone on the island.

Resistance to Change

Most people were happy to see the island spruced up with a more than presentable golf course. After a honeymoon period in which the homeowners, relieved at the departure of Thomasson, welcomed Hornsby and Willis with open arms, a chill developed between the residents and developers. Some of the Fripp Company's

new policies elicited strong resistance from property owners. Asked about the relationship with the homeowners in the early 1990s, Hornsby responded: "We had all-out war." There were minor skirmishes over such matters as the colors of the small boutiques surrounding the Olympic-sized pool. Supporters referred to the colors as gay Caribbean hues while critics found the bright colors jarring and inappropriate in a place where covenants prescribed houses to be soft grays and tans that blended into the landscape.[271]

However, the biggest battles were not over colors but centered on three basic issues: the privacy of the island, the emphasis on a resort instead of a residential community and club dues.

From 1963, when the bridge to Fripp opened, there had been an understanding that Fripp was a private island. Property owners felt that this was significantly undermined when the developers established patron club memberships that allowed non-property owners to come on the island and use the amenities without paying the high club dues and initiation fees required of property owners. Many property owners were outraged. The final signal that the small island's privacy was slipping away was the Fripp Company's plans for an expanded conference center with a small hotel. Even the Property Owners Association waded into the fray by passing a resolution opposing the proposed hotel complex.[272]

Closely related to the issue of loss of privacy was the Fripp Company's emphasis on making Fripp a resort destination. Knobby Walsh, who set up the original meeting for potential investors to meet Hornsby and Willis, recalled three years later that the two developers were asked at that time about their vision of the future. "They had no plans to alter the private residential–family orientation of the island," Walsh said, "in fact they thought that was just what they wanted because they planned to make our island their home." Instead of a quiet island where everybody knew each other, tourists often outnumbered homeowners, especially in the summer. Some property owners resented this change.[273]

While improving the golf course and upgrading the amenities were essential for attracting guests to the resort, the Fripp Company also significantly increased the annual club dues that property owners who used the amenities had to pay. Higher dues are rarely popular, but most islanders realized increases were necessary to support higher quality amenities. Yet Fripp club members took exception to some of the new policies in which they had little say or recourse. There was a Club Advisory Board at the time made up of members appointed by the company. As Maude Hornsby, David's wife, recently recalled, the company was in the process of initiating a more representative committee structure. But in 1993, a large number of club members felt neither the advisory committee nor the company was responsive to their concerns. For example, the Fripp Company hiked the annual golf cart trail fees, which allowed members to use their own golf carts on the course, by 23 percent and then ruled that accompanying houseguests could not ride free in a club member's golf cart. In a letter to the *Trawler*, Knobby Walsh captured the sentiments of many club members when

The Gay Nineties

This Fripp Island golf ad appeared in the *Beaufort Gazette* on April 21, 1995, and advertised to the general public "a get-acquainted golf special" at the Ocean Point Golf Links as a spring appetizer for the opening in the fall of the new Davis Love III course.

he wrote: "The 'private' Fripp Island Club is a laugh. It is private only because it serves the Fripp Company's commercial interests. We are not 'members,' we have no say in club operations; all guests from downtown motels enjoy the same privileges as we but without payment of dues, and we must compete with them for access to the amenities." As frustrations mounted, the FIPOA passed a resolution expressing displeasure at the "precipitous increase" in dues.[274]

The feuding reached its boiling point in 1993. Both sides realized it was time to work out what seemed to be irreconcilable positions. After much deliberation, the parties consented to a binding agreement that was filed on April 22, 1994, in the Beaufort County Courthouse. This legal document limited the number of patron memberships, specified a road fee for patron members, established an election process for the Club Advisory Board, set limits on dues increases until additional facilities were added and required establishment of a new dining club membership. Additionally, the company agreed to refrain from advertising Fripp as a public island but gained the right to submit informational articles to the property owners' newsletter.[275]

Neither side felt the agreement was totally satisfactory, but it did calm the waters. One unresolved issue was the desire of the Property Owners Association for a significant role in the decisions of the company-controlled architectural review board. But as Jim Chapman, editor of the *Trawler*, wrote in an editorial, "Real estate development is a risky business." He observed that while there is complaining about the company, most residents are glad that Fripp has a stylish look. "When all is said and done," Chapman concluded, "there is no place like Fripp. With a little give and take from everybody, we can keep it that way."[276]

When development on Ocean Creek began in 1995 on the south end of the island, property owners again expressed misgivings about the emphasis on a resort at the expense of the community and natural environment. Many were sad to see numerous giant oak trees cut down for the golf course and Hidden Lake, a breeding ground for hundreds of alligators, dramatically altered. The most vocal concern focused on development of a water park with three pools, large animal sculptures and lagoon-style pool with carved caves, waterfalls and whirling mist. Some year-round residents also criticized the new neighborhoods at Veranda Beach and Davis Love Drive that were designed primarily for the "second home" market.

To generate needed funds to build the golf course and water complex, the developers created a new category of club membership, Horizon Members. Unless the current club members paid an additional initiation fee, they would be unable to use the new Ocean Creek Golf Course and Cabana Club pool complex. This levy created much grumbling among club members, particularly those who played little or no golf and who would use the pools only a few weeks a year when grandchildren visited. The residents and developer were again at odds. As Jim McElwain, an advisory club member, recalled, "it was a difficult time." Many members—even golfers—felt there was no need for a second golf

The Gay Nineties

The alligator slide and the frog fountain in the one-foot-deep children's pool at the Cabana Club provide hours of enjoyment for young children. *Courtesy of The Fripp Group, Inc.*

course. Yet the resort had decided to build one whether the club members liked it or not. The Club Advisory Board, which had been reconstructed the year before with a new election process, worked persistently to reach a compromise. In the end, Hornsby agreed to significantly lower the Horizon initiation fee from the $2,000-plus amount that had first been announced to closer to $1,000 and stated that if at least 90 percent of the club members became Horizon Members, club dues would not rise for three years. According to McElwain, 95 percent of the club members paid the initiation fee, and Hornsby and Willis kept their word: dues did not go up within the next three years.[277]

As time passed, Hornsby and Willis and the Fripp property owners learned to live together. The company abandoned plans for a hotel, and property owners became aware that with attractive new amenities their property values had increased dramatically. They knew that club dues alone could not pay for upscale amenities. The company's growing rental program and widely advertised promotional golf packages brought in guests who produced much needed revenue for the company during the off-season. Having a Club Advisory Board that was elected instead of appointed by the club and held open instead of closed meetings gave a vehicle for members to express their views

to the company. Yet club members knew that they had little influence over the company, which controlled policies and determined initiation fees, dues and the quality of amenities. The role of the Club Advisory Board in the negotiations over the Horizon Club initiation fee was a rare exception; generally, the purview of the board has been limited to issues such as the hours for the opening and closing of the pools.

Caught in the Politics of Beach Erosion

While property owners and the company were battling out differences, the sea was hammering the Fripp coastline. On barrier islands sand continuously migrates. This dynamic environment means that over time some portions of a beach experience a buildup of sand and then within a short period, a reversal may occur as dunes and sand wash away. On Fripp all homes along the ocean have at one time or another been threatened by encroaching high

Soon after building a beachfront home on the south end of the island, Jon Tabor took this aerial photograph, which unbeknownst to him was to become important evidence in a future lawsuit to gain permission to build a rock revetment. *Courtesy of Mary and Jon Tabor.*

tides. Beginning in the 1970s many beachfront homeowners constructed rock revetments to protect property.

The ability of beachfront property owners to respond to erosion, however, was severely restricted when the South Carolina General Assembly passed the 1988 Beachfront Management Act. Although the stated intention of the legislation was to preserve the state's beaches, the result was to require setbacks from the dunes that prevented some homeowners from building revetments. Additionally, the new law's "no construction zone" included sixty-nine Fripp houses that if severely damaged by a hurricane could not be rebuilt. In response to the 1988 law, a group headed by beachfront resident Austin Beveridge formed the Fripp Island Beach Association to monitor developments and make concerns of Fripp property owners known to state legislators.[278]

In October 1991 erosion on the south end of Fripp began to accelerate at an unprecedented pace. Bill and Barbara Robinson, who were living at that time at the ninth house from the south end of Tarpon, recalled waking up one morning to find forty feet of their lot had disappeared into the ocean. The Robinsons immediately called Jon and Mary Tabor, who owned the house next to them and who lived most of the year in Columbus, Ohio, to alert them to this discomforting new development. The Tabors quickly came to Fripp to see for themselves the vanishing beach, the lost stairs and the battered walkway. Each day Jon Tabor measured the sand and discovered he was steadily losing a few inches each day. Just months earlier, Jon had taken aerial photographs that documented an expansive beach in front of their new home.[279]

By 1991 the Robinsons and Tabors were among only ten oceanfront homes on Fripp without any protective rocks. If the erosion continued at the rate it was going, they would surely lose their homes. Appeals to the South Carolina Coastal Council for permission to safeguard their houses fell on deaf ears. The staff adamantly stated that the Beachfront Management Act prevented their building revetments.[280]

After some evenings of strategizing over drinks, the owners of the ten homes decided to sue the South Carolina Coastal Council. They figured it would cost about $5,000 each, but they felt they didn't have much choice. Manning Smith, who specialized in coastal policies and was a partner in the Beaufort law firm of Davis, Tupper, Griffith and Smith, represented them. After reviewing the situation, he told them "they would have flounder in the living room if they didn't sue."[281]

On March 20, 1992, Judge Thomas Kemmerlin heard the case in the Court of Common Pleas in Beaufort and ruled in favor of the Fripp homeowners. Kemmerlin's seven-page opinion offered not only cogently described findings but also humorous commentary. Kemmerlin concluded that the ten Fripp homeowners faced "permanent loss of their property" and since the revetments that covered 95 percent of the island were working, the "obvious solution…is to allow them to build revetments." This seemed a particularly prudent

course of action, Kemmerlin argued, because other state laws require that if restrictions result in loss of use of land then the state must provide "reasonable compensation." Stressing also that the Coastal Council's mission is to protect coastal areas for the public, Kemmerlin emphasized that Fripp was not a public beach. Concluding that no neighbors or the public would be harmed by the ten landowners' building revetments, Kemmerlin proceeded to ask, "Is this prohibition an unreasonable exercise of police power?" He responded with a resounding "Yes!" After noting that the Coastal Council would not be taking this property to use it as an "observation post" or for "machine gun embankments," he again asked, "What public good?" With whimsical wit he rhetorically pursued the issue by asking, "What members of the public are standing there or sitting in row boats off the beach saying, 'Hooray! The rich Yankees' lots are washing away. Now we can use the lots that have washed away'?"[282]

After losing, the South Carolina Coastal Council wouldn't let the matter rest and appealed the case. For the plaintiffs, however, time was of the essence in preventing further erosion. The usual time for an appeal to work its way through the legal process was a year and a half, enough time for erosion to take the houses. Thus Manning Smith went to work on the legal provisions that would allow the Fripp property owners to build revetments immediately. The following month the Supreme Court of South Carolina unanimously voted to allow permits for the construction of revetments on the ten lots to proceed with the understanding that each party involved would pledge $10,000 that would be used to remove the rocks if the Coastal Council won the appeal.[283]

Manning Smith had assured the Fripp homeowners, many of whom attended the procedural hearing in Columbia before the state supreme court, that the motion to allow immediate construction of the revetments would be approved. He was correct. On April 20, 1992, the supreme court verdict was unanimous in their favor. Smith explained that all seven of the judges had studied at the University of South Carolina Law School under Kemmerlin, who had taught there prior to becoming a judge. They all had enormous respect, Smith said, for the way in which Kemmerlin constructed judicial arguments.[284]

Following the Fripp owners' victory, it became clear that there would be increasing litigation against the Coastal Council. The General Assembly amended the Beachfront Management Act to allow property owners to protect their homes from erosion but retained all the laborious hoops involved in the permitting process. The South Carolina Supreme Court dismissed the Coastal Council's appeal in the Fripp Island case on August 8, 1993. By that time a case before the United States Supreme Court, *Lucas v. South Carolina Coastal Council*, had established that the South Carolina Beachfront Management Act's restrictions on property owners was an unconstitutional "taking" of property without "just compensation."

The Gay Nineties

In all seasons, residents and guests have opportunities for close-up viewing of the great egret. These stately birds with their long necks often stand at the edge of the water waiting patiently for their prey. *Courtesy of The Fripp Group, Inc.*

The Community Thrives

Despite beach erosion and tension with the resort management, the community of Fripp residents thrived. Two organizational structures—Fripp Island's Public Service District (PSD) and Fripp Island Property Owners Association (FIPOA)—performed services equivalent to that of a town government and grew exponentially with the addition of new neighborhoods. In 1995 the PSD expanded its responsibility for erosion, water and fire protection by taking over from the developer the operation of the sewer system, which had been built in the 1970s by the coalition of savings and loans. In 1999 the PSD built a needed new firehouse. Supported by property taxes, the PSD had some full-time staff but depended heavily on a large core of Fripp volunteers who served as firefighters and committee members using their time and expertise to ensure the health of Fripp's infrastructure. Meanwhile the FIPOA cared for the roads, bridges, beach crossovers and bike paths and managed the security force. For many years the FIPOA depended almost totally on volunteers with the aid

155

of a part-time bookkeeper. In 1996 the board hired Kate Hines as a full-time community manager. Residents still did the legwork on numerous tasks, such as overseeing the maintenance of roads, bridges and lagoons as well as putting out the *Trawler*, the property owners' newsletter.

Fripp residents found ways to combine civic responsibilities with fun. Bill Winter fondly recalls that several men built a wooden raft, propelled by a small motor, which they used as a moving laboratory for gathering information about the condition of water in Blue Heron Lake. The annual firemen's memorial golf tournament, which began in the early 1980s and is one of the island's biggest golf events, is an occasion of spirited fun and competition as well as an occasion for remembering deceased members of the island's volunteer fire department.[285]

Besides the PSD and the FIPOA, another key part of the Fripp organizational structure was the community centre, which cared for the spirit of the island by offering opportunities for worship, play and education. In 1990 property owners undertook a major expansion of the ten-year-old centre, the residents' central gathering place. The board of the centre was optimistic about raising needed money because a survey revealed strong support for the project and attendance at chapel was high. There was widespread agreement that while the chapel had adequate space, the kitchen and meeting rooms were too small. A fundraising letter, with follow-up telephone calls, secured pledges for the required $130,000 to build a thirty-by-fifty-foot addition. Construction began in January 1991.[286]

Following extensive research and numerous meetings, the community centre's board determined that because of the increased use of cremation, a memorial garden and columbarium would be a meaningful addition to Fripp Island. The board voted $30,000 to build the facility. In a tranquil natural setting on the south side of the chapel, the columbarium has an attractive brick wall that encloses an area designed to eventually have 512 niches for holding urns with the ashes of deceased persons for whom Fripp was a special place. The Fripp Island Garden Club assisted with the landscaping. On May 12, 1993, as part of the regular Wednesday night vespers services, the Fripp community gathered to dedicate the new memorial park. A month later eighty-one of the first ninety-six niches had been reserved.[287]

The centre continued to be at the core of the island's shared life as established activities grew and new ones were added. One of the first uses of the new space was for the 1991 white elephant sale, a traditional community centre fundraiser held in conjunction with the July Fourth festivities. The sale raised $6,500 that was used to furnish the new addition. The expanded space soon became the venue for even bigger and better community-wide covered-dish dinners, wedding receptions and numerous private parties. Friends of Music, which now had a venue for wine and cheese receptions following their concerts, contributed to the community centre a new $17,000 concert grand piano, which they dedicated to Gini Reese, a founding member of both the chapel choir and Friends of Music. The long-established yoga group had room to grow and became so popular that

The Gay Nineties

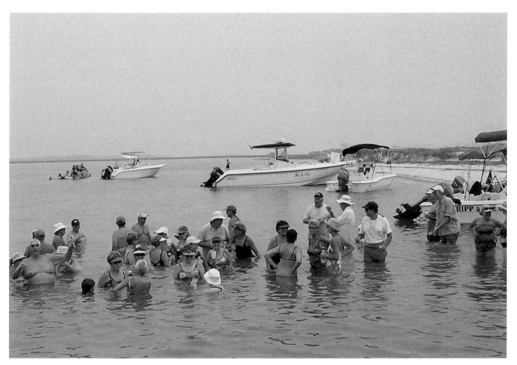

The Fripp Island Yacht Club's annual trip to Bull Point is one of the club's most popular outings. A caravan of boats leaves the Fripp marina, winds along Old House Creek to Fripp Inlet and then takes the Story River past Pritchards and Capers Islands to arrive at Bull Point, a small uninhabited island. *Courtesy of Susan Briggs.*

by 1996, leader Mary Delle Thomas had to request that interested persons put their names on a waiting list. The Fripp Island Women's Club, founded in the 1970s, met regularly at the centre for educational programs and socializing. [288]

Beginning in the mid-1990s, the men on Fripp decided to have monthly gatherings. They named their group ROMEOs, which stands for Retired Old Men Eating Out. ROMEOs prided itself on being an informal group with no bylaws, no officers, no dues and no program. They would meet for lunch and a social time of exchanging the latest island news and telling jokes. Originally they ate at the marina restaurant and then at the beach club, but in 2001 moved to the centre where they took turns preparing tasty lunches for the gathering of approximately sixty men. [289]

Several Fripp groups devoted themselves to care of wildlife and the environment. A cadre of people led by Betty Sobol continued to walk the beach early in the mornings during the spring and summer to ensure protection of loggerhead turtle nests. The Audubon Club sponsored monthly programs, some being field trips on a range of nature-related topics. In 1997 a group of residents formed the Fripp Island Land Acquisition Group to provide a vehicle for acquiring lands through donations to be used exclusively for the protection of scenic views as well as animal and plant habitat. There was increasing concern that the natural

157

environment that had attracted many to Fripp was being lost. The following year they acquired their first property, a lot on the corner of Tarpon Boulevard and Remora Drive, which was given by the family of John Watson, a longtime active member of the Fripp community.[290]

Cultural activities in the 1990s also thrived. The number of book clubs, which generally met in homes, increased. There was also a growing interest in art. A group of island artists would gather weekly in the community room of the firehouse to paint, share ideas and critique each other's work.

Golf and tennis remained major leisure activities on Fripp. Throughout the year, the calendar was full of tournaments for residents, exhibition games, exchanges with nearby communities and regional and national events. The annual collegiate golf tournament drew teams from the eastern half of the country. One of the golfing highlights was Member-Guest Day, a time that combined socializing and golf.

During the 1990s an upgraded marina and increased storage space attracted a growing number of boaters to Fripp, but there was no organized boating group. Ralph Goodison, a Pennsylvania retiree from Merck and an experienced navigator, decided to change that. In 1997 he spearheaded the founding of the Fripp Island Yacht Club, which quickly grew to be one of the largest clubs on the island. Annual dues were only twenty-five dollars a family. Ownership of a boat was not necessary but enjoyment of the water was. The goals of the new group were to promote boating safety, to have fun and to bring together under one tent Fripp's diverse groups of golfers, tennis players and bridge enthusiasts. Significantly less than half of the members of the yacht club own boats, but there are enough to provide transportation to destinations such as Bull Point, where a picnic outing takes place each year. Many people on Fripp would never have the opportunity to visit Bull Point, which is accessible only by boat, were it not for the yacht club. Neither would Fripp residents have a chance to attend a formal dinner dance if the yacht club had not instituted its annual winter Commodore's Ball. The first of these gala events was held in 1998, and since then the ball has been one of the island's major social events. While promoting an opportunity for all islanders to get together and have fun, the yacht club's mission has also included teaching navigation skills and placing buoys in adjacent creeks to assist boaters.[291]

Perhaps the true spirit of community on Fripp was demonstrated most vividly in the days following March 12, 1997, when the Fripp Bridge had to be closed for the first time in its history. During routine maintenance one section of the bridge settled about one foot. For five days while crews worked diligently to repair the bridge, volunteers ran a boat shuttle service from Paradise Pier on Hunting Island to the Fripp marina. Personal as well as business plans had to be significantly altered. Those who had been off the island at the time of the mid-morning collapse had to leave their cars on Hunting Island but willingly let their vehicles be used by other residents to provide rides to Beaufort. Since people couldn't easily leave the island, the residents shifted into a more relaxed mode. Those with larger

stocks of food shared with those with less. Peg Gorham noted that she almost hated to see the bridge repaired for such a strong bond had developed among the residents as they helped one another. The Fripp community proved it could indeed thrive in the face of adversity.[292]

Hornsby and Willis Era Comes to An End

In November 1999 Hornsby and Willis celebrated their tenth anniversary on Fripp and reflected on the past decade. They said they had a vision in 1990 of Fripp's undiscovered potential. The Fripp Company subsequently spent more than $17 million to enhance the island's infrastructure, amenities and corporate facilities. Hornsby emphasized that their accomplishments were the result of having a team that worked well together. Hornsby provided the development leadership and Willis concentrated on real estate sales. Each bought homes on Fripp and their wives took on major responsibilities in the company. Maude Hornsby focused on the services provided by the club, while Jeanie Willis worked to develop the retail side of the business. Other major players were the two general managers. Stuart Mitchell handled the day-to-day operations and served as a liaison with the property owners. With a winning smile, he always had time to talk to property owners. Cameron Haught was the general manager in charge of the rental program and the person responsible for instituting Camp Fripp, a children's day camp.[293]

The Fripp Company dramatically changed the physical appearance of the island. As promised, they "puffed up" things to give a well-kept and stylish look.

Dwellings on Fripp Island: 1963–2005

Year	Dwellings
1963	0
1972	120
1980	498
1990	960
2000	1,385
2005	1,535

Note: Dwellings include houses and condominiums.

And they brightened the landscape with stores and houses of Caribbean colors. The development of the south end of the island with a second golf course, a Disneyesque pool complex and several new neighborhoods significantly increased both the number of recreational opportunities as well as the number of homes. Their development of the Marina Village created not only a new neighborhood but also enhanced boating opportunities on Fripp.

The change that residents appreciated the most was the growing value of their property. A typical beach house that sold for $300,000 in 1990 was going for $800,000 by 2000. Many factors contributed to this escalation in prices but few would deny that Hornsby and Willis's contributions to the island were a factor. The economic climate driven by the rising stock market combined with the demographics of the aging baby boomers interested in purchasing a second home fueled the vacation housing market. Hornsby and Willis were keenly aware of the potential of this market and had built accordingly. A *USA Today* article that featured Fripp ran under the headline of "New wealth brings surge in two-home families" and emphasized that people no longer had to wait for retirement to have a place to escape the cold or the hectic pace of city life.[294]

The growth of the second home market on Fripp had a major impact on the demographics of the island. Although the number of houses was increasing, the percentage of full-time residents was decreasing. When Hornsby and Willis took over the Fripp Company in 1990 there were 960 dwellings, including houses and condominiums, and by 2001 the number was 1,435, almost a 50 percent increase. Yet in 1992 there had been about 600 year-round residents and almost ten years later in 2000 there were still only 600 permanent residents. Yet this number provided a supply of people to lead Fripp's organizations. The full-time residents, however, had to get used to seeing many unfamiliar faces on the island as the numbers of tourists and part-timers grew.[295]

While Hornsby and Willis focused their energies on Fripp during the early '90s, they soon began to divide their time between several other business ventures. In 1993 they began developing real estate on Harbor Island. Later they acquired some undeveloped real estate and the golf course on Cat Island and renamed the course the South Carolina National Golf Club. Another Beaufort area project was the development of the remaining real estate at Pleasant Point Plantation. In 1997 they acquired the University Club in Columbia and began developing the real estate that surrounded the golf course. Once the land available to Hornsby and Willis for development on Fripp had been sold, it was time to move on.

As early as 1994 resident George Douglass pointed out that the Fripp Company had "accumulated a huge overhead and enormous debt." The 1998 death of Bob Wardle, who had been not only a friend but also a chief investor, undoubtedly contributed to their decision to sell the company. After Bob died, there were negotiations between the Wardle family and Hornsby and Willis to deal with the ever-rising debt that had never been given priority. As part of an agreement reached in February 1999, two large parcels of undeveloped land

that abutted the Ocean Creek Golf Course were conveyed to the Wardle family to reduce a portion of the debt. Since the company did not own any other large parcels of undeveloped real estate, Hornsby and Willis could no longer depend on real estate profits to cover the year-in and year-out losses for operations.[296]

When talk of the Fripp Company selling the island surfaced in 2000 and became a reality in 2001, the cycle of uncertainty for the property owners began anew. What would be the agenda of the new owners and how would their policies impact life on Fripp? As in the past, the residents owned the large majority of the land on Fripp and had developed the organizational structures to support a strong and vibrant community, but had no control over the amenities.

The 1990s brought increasing numbers of homes, a strengthened community and an enhancement of the Fripp resort and its amenities. Although some property owners were unhappy with the changes, the majority came to appreciate the transformation. The end of the decade signaled not only the end of the Hornsby–Willis era but also an end of major residential development by the Fripp Company. There were only two parcels of undeveloped land left. These were located along the Ocean Creek Golf Course and were owned not by the resort but by the Wardle family. The next owner of the resort would not be able to "develop dirt and sell dirt" as the others had done.

Epilogue

The *Beaufort Gazette* and *Trawler* carried headlines in 2001 citing the $50 million price tag that the Hotel Corporation of America paid Hornsby and Willis for the resort. However, according to Danny Robinson, the chief financial officer for the Fripp Company, the total consideration for the sale was in the neighborhood of $36 million. Robinson added that part of the $36 million included a considerable sum still owed to the Wardle family and sizeable vendor obligations. Contracts signed on January 22, 2001, and recorded in the county courthouse transferred ownership of the resort. However, the Hotel Corporation of America did not really purchase the resort as the news accounts indicated. Instead, a number of limited liability companies established by Steve Bauer and Gary Keller, the principals of the Hotel Corporation of America, purchased the Fripp Company.[297]

The new group operated under the name of Fripp Island Resort and their principal executive on the island was Steve Bauer. Little is known about Bauer aside from the fact that he came from Atlanta and had some previous experience in the motel industry. His usual dress of very casual beach attire was off-putting to many property owners who expected more from the CEO of a multimillion-dollar business. One of the first opportunities that many on the island had to meet him was at a large community meeting on March 8, 2001. In answer to the question of who owned Fripp, Bauer responded that Proof of the Pudding, an Atlanta food and beverage service, held 10 percent, and he and Gary Keller, of the Hotel Corporation of America, each had a 45 percent interest.

The Fripp Island Resort partners faced serious challenges in their first year of operation. Just months after acquiring the island, Keller, who had provided most of the capital for the purchase, became seriously ill and was never able to assume his anticipated leadership role. In addition, the national economy was suffering from a downward turn in the stock market. Moreover, the entire national tourism industry experienced setbacks in the aftermath of the 9/11 terrorist attacks. Obviously Steve

Epilogue

Bauer faced many difficulties over which he had no control. Yet his confrontational style of management and lack of sensitivity to the Fripp community set the stage for many problems of his own making. One of Bauer's first initiatives, which met with strong skepticism from property owners, was a decision to have a "cashless" island. This meant all purchases at the golf and racquet clubs, stores and restaurants were charged to a club membership card or a guest amenity card. The desire to ensure that all those who used the amenities paid for them was understandable, yet guests as well as residents found the system burdensome. After a year Bauer abandoned the experiment. But conversation at islander gatherings continued to focus on serious concerns about Bauer's management of the resort. To Bauer's credit, he focused his efforts on needed cost controls but often at the expense of maintenance of the amenities.

Purchase and Sale of Fripp Island Amenities
and Undeveloped Land: 1960–2005

	
1961	Jack Kilgore and investors buy undeveloped island from 16 Beaufortonians for over $500,000
1972	Coalition of S&Ls buys for $3.5 million
1980	Brandermill Group assumes mortgages totaling $8 million
1981	Coalition of S&Ls reassumes mortgages
1982	Thomasson Properties buys for $13 million
1990	Hornsby and Willis buy for $7.6 million
2001	Steve Bauer, Gary Keller and others buy for approximately $36 million
2003	Wardle family gains controlling interest
2005	Wardle family acquires Bauer's interest in the island

Epilogue

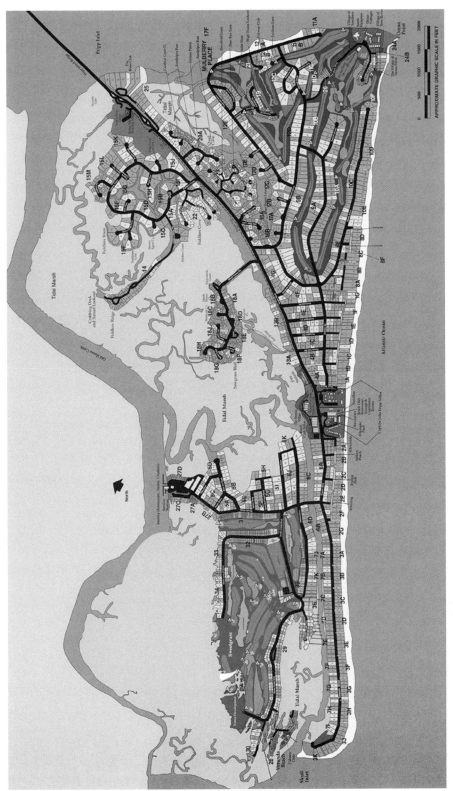

2005 map of Fripp Island. *Courtesy of The Fripp Group, Inc.*

Epilogue

With the development and widespread use of the Internet, those dissatisfied with the high fees and uneven service of the resort's rental program had another option. Those who had houses to rent and those seeking a place to vacation began using *Vacation Rentals by Owner*, a quickly expanding website to market and rent properties.

Unlike the past, when the resort managed the large majority of houses and condos, the Internet allowed individual owners to bypass the services of the resort. In a short time, the listings for Fripp on the Internet amounted to almost half of the island's total rental units.

Bauer's policies seemed calculated to disadvantage club members and owners who rented their homes themselves and did not use the resort rental service. He particularly went after non-club members. He announced that residents selling their property could not assure new buyers of membership in the club unless the sellers were members or had purchased a $5,000 certificate.

Because the board of the FIPOA believed these matters were the purview of club members and not the property owners association, a new group called Property Owners United (POU) emerged to challenge the Fripp Resort's policies. The POU set up a website and appealed to disgruntled club members to contribute to a legal fund. In October 2002, the POU, representing 330 club members, sued four of the resort's companies over allegations of questionable management practices, unreasonable fees, failure to properly maintain the amenities and services and monopolistic practices. Judge Thomas Kemmerlin of Beaufort County heard the case and following his urging the two sides arrived at a negotiated settlement. The terms of the agreement reduced the bedroom fees for use of the amenities for those who chose not to rent their properties through the resort, discontinued the $5,000 certificate program and removed Bauer from daily management operations.[298]

Despite this agreement, Bauer continued to alienate many property owners, club members and guests. His relationship with the real estate arm of the resort reached a boiling point, and all the agents walked out in 2002 with most joining together to form a new company, Island Realty. Thus, the resort had to build from scratch a new real estate operation. For numerous reasons, Bauer experienced serious cash flow problems and often delayed payment of bills, which had serious repercussions. Several Beaufort merchants would only deliver to Fripp on a cash-on-delivery basis, and delinquent tax lists in the *Beaufort Gazette* often listed the resort. The *Beaufort Gazette* carried a front-page story on October 23, 2002, with the headline "IRS files lien on Fripp Island Co." This was not only bad press for the resort but also resulted in heavy fines.

The Fripp resort's desperate financial situation finally led to the sale of some corporate assets. On January 31, 2003, The Fripp Group, Inc., a separate business venture on the island, gained controlling interest in over seven acres of property that included the Spring Tide Village complex with the welcome center and general store, the corporate office building and miscellaneous support facilities located behind the corporate office. The transaction also ceded to The Fripp Group control of the Fripp Island Real Estate Company and Channel 7, the island television station. Although

Epilogue

Bauer got needed cash from the deal, he put the resort in the position of having to rent a considerable amount of essential space from The Fripp Group. Subsequently, however, The Fripp Group had its own difficulties. When Mary Smith, the operator of the island's general store, TT Bones, retired after fifteen years, the store remained empty for nineteen months before reopening in May 2006 under the name Spring Tide Market.[299]

Bauer's ability to put together new deals to bail the resort out of financial problems finally ran its course. Although a sizeable group of club members organized in an attempt to purchase the golf courses and the racquet club, nothing came of the effort because the resort insisted on a price greater than what members considered reasonable. Because the corporation owned almost no undeveloped land, a major source of income was club dues. But it was hard to justify dues increases when pools and other facilities were not in first-rate condition. In October 2003, the Wardle family, which had been deferring interest payments and loaning additional money to the company, gained a controlling interest and fired Steve Bauer a year later. The Fripp property owners gave a sigh of relief. Bauer was finally out of management. In October 2005, the company acquired Bauer's interest in the business. The future of Fripp appeared considerably brighter.[300]

Optimism returned to Fripp under the new leadership of the sons of Rene and Bob Wardle. Bill Wardle, who became the chief executive officer, had shut down his law practice in 1997 and returned to school for an MBA to hone his business skills, knowing that it would be useful in dealing with future issues at Fripp. Bob Wardle, a structural engineer and owner of a concrete restoration business near Philadelphia, has been overseeing the construction and remodeling projects of the company. Doug Wardle, who is the owner of a California restaurant and has a degree in food service and hotel administration, is the chief operating officer. Doug agonized about whether to take direct responsibility for the operations of the company, but with the support of his wife, he told his mother that he had decided to commute from California as often as necessary in order to protect the investment of the family on Fripp Island. His only stipulation was that Stuart Mitchell return to the company and assume responsibility for daily operations. Rene, who has a great attachment to the island, gave her blessing to her sons' new commitments. Under the Wardles' leadership, the company settled accounts with vendors, gave attention to repairing pools, improved the golf courses and provided friendly service.[301]

The new confidence in the future of Fripp combined with the national enthusiasm for real estate investment made 2005 a banner year for sale of homes on Fripp. Prices soared. Some longtime residents who had contributed much to the island took advantage of the escalating real estate prices, sold their homes and moved closer to family and medical care. Newcomers arrived, quickly assimilated and assumed leadership roles. The numerous committees of the FIPOA, the Audubon Club, the community centre, golf and tennis groups, Friends of Music, Women's Club, men's lunch group and the Yacht Club offered ample means for new part-time and full-time residents to become a part of the island community.

Epilogue

Side by side with the turmoil of the Bauer years, the Fripp community successfully addressed several pending issues. The FIPOA expanded its building and made changes to its organizational structure to respond to the growth and shifts in the Fripp population. The adoption of new bylaws by a 92 percent majority of property owners in effect changed the FIPOA from a council to a city manager form of government. At the same time the bylaws provided that the board of directors would be composed of five nonresidents and five residents. Additionally the FIPOA reached a solution to the thorny issue of how to cull the large herd of deer on Fripp. On the recommendation of the FIPOA and funded solely by donations, the Humane Society of the United States has begun a deer fertility control program on Fripp. And finally, the PSD solved the environmental conundrum of relying on septic tanks for the earliest homes built on Fripp. In 2005 the PSD began installing a new sewer system for the 750 homes and lots that were without sewage service. This will enable the PSD to provide collection and treatment of all wastewater generated on the island.

Another new initiative was the joint effort of the Women's Club and the FIPOA in rebuilding Davis Love Park. The new shrimp trawler and lighthouse play stations became popular activities for little folks, and big folks enjoyed playing basketball and volleyball. Nancy Purdon, a resident with a great love of literature, formed a short story group in which members meet monthly in homes to hear readings and engage

The newly renovated Davis Love Park opened on Thanksgiving weekend in 2004. The shrimp boat that is part of the new playground equipment has quickly become a favorite with the younger set. *Courtesy of author.*

Epilogue

in discussion. Under the leadership of Dick Briggs, a retiree from Tennessee, Fripp Island gained a certified bridge club where residents can accumulate master points without leaving the island. More than ever in its history, the hub of island life rested at the community centre where there was once again talk of the need to expand the building. Turnout for Wednesday night vespers, which had begun on a regular basis in 1975, remained strong. The dynamic twenty-five-voice choir enhanced vespers services and in February 2006 gave a special concert for an overflowing and enthusiastic audience. On Easter Sunday in 2006, all parts of the Fripp community joined together to plan and publicize a sunrise service. Since the chapel had been in recent years unable to accommodate the crowd, the resort made the large oceanfront tent available. The community centre planned the service and the FIPOA helped to alert people of the time and place. Resident Jerry Hammet, a retired Presbyterian minister, preached. Over four hundred people attended, the chapel choir sang and the sun rose gloriously over the ocean at midpoint in the service.

Despite increasing development on the island, the slogan "Seaside Simplicity" used by Hornsby and Willis continues to express the essence of Fripp for most of the year. From mid-June to mid-August the island is filled to capacity. However, when schools resume, the crowds thin out. A peaceful quiet returns to the island and residents reclaim it for themselves. Compared with the size of Hilton Head with its gridlock traffic jams and neighborhoods where people don't know each other, Fripp

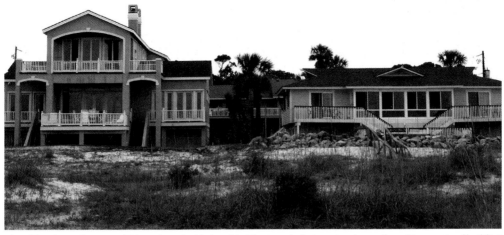

The old and new houses of Fripp often sit side by side. The twenty-first century has ushered in a surge of building of large handsome homes. *Courtesy of Julie Hodgson.*

Epilogue

Island offers tranquility combined with small-town friendliness. Additionally, it has two beautiful golf courses as well as an excellent tennis facility.

By the end of 2005, there were 1,535 dwellings, including 340 condos, on Fripp. Houses are rapidly being constructed on the 543 vacant lots that dot the island. While the majority of houses on Fripp are still relatively modest beach cottages, many new homes are large with stylish architectural features. Nonresidents, many of who spend a considerable amount of time on Fripp and have become part of the island community, own the large majority of houses. The approximately 500 year-round residents provide the core of volunteers for the fire department and leadership for the community centre and numerous other island organizations.

In the years since 1963 when Jack Kilgore built the bridge to Fripp, there have been seven owners of the amenities and undeveloped land. Yet the two constants in the island's history have been the beauty of its natural setting and its residents who share their time and talents to create a special community. As a small island with a gently sloping white sandy beach, live oaks, palms, pines, vast marshes with meandering tidal creeks, an abundance of wildlife and a dedicated population, Fripp captivates both residents and visitors.

Notes

Chapter 1

1. Edith M. Dabbs, *Sea Island Diary: A History of St. Helena Island* (Spartanburg, SC: The Reprint Company, 1983), 71; Lawrence S. Rowland, Alexander Moore and George C. Rogers Jr., *The History of Beaufort County, South Carolina, Volume I: 1514–1861* (Columbia: University of South Carolina Press, 1996), 2.
2. Rowland et al., *Beaufort County,* 8–9.
3. Dabbs, *Sea Island Diary,* 32, 71; Rowland et al., *Beaufort County,* 18.
4. Manuscript, Fripp File, South Caroliniana Library, University of South Carolina, 9; Caroline T. Moore, "Abstracts of the Wills of the State of South Carolina, 1740–1747" (Charleston: self-published, 1964), 30.
5. A.S. Salley Jr., "Stock Marks," *South Carolina Historical and Genealogical Magazine,* 1912, v. 13, 128, 228; Charles H. Lesser, *South Carolina Begins: The Records of A Proprietary Colony, 1663–1721* (Columbia: South Carolina Department of Archives and History, 1995), 425; Colonial Land Grants (Copy Series), vol. 38, 106, 301, South Carolina Department of Archives and History.
6. Manuscript, Fripp File.
7. Colonial Plats (Copy Series), vol. 3, 256, South Carolina Department of Archives and History; Memorial Book, Original Series IV, vol. 38, 106, 301, South Carolina Department of Archives and History.
8. Bonnie Burgess Neely, "Tracing Tidal Tributaries Through Time" (self-published, 1999), R2.
9. Ibid. (R3–R6 and marginal additions and corrections on F10 made by Allison A. Darby and Elizabeth S. Darby on August 26, 1999, with the permission of author.)
10. Ibid., R5–R6; Theodore Rosengarten, *Tombee: Portrait of A Cotton Planter with the Plantation Journal of Thomas B. Chaplin 1822–1890* (New York: McGraw-Hill Book Company, 1987), 687, Appendices; Manuscript, Fripp File, 9.
11. *Beaufort Gazette,* March 2, 1982.
12. Walter Edgar, *South Carolina: A History* (Columbia: University of South Carolina Press, 1998), 102–3.

13. Ibid.; Nell S. Graydon, *Tales of Beaufort* (Beaufort, SC: Beaufort Book Shop, 1963) 105–6.
14. Norman C. Pendered, *Blackbeard: The Fiercest Pirate of All* (Manteo, NC: Times Printing Co., 1975); Nell S. Graydon, *South Carolina Ghost Tales* (Beaufort, SC: Beaufort Book Shop, Inc., 1969), 38.
15. "Here Lies Count Pulaski's Body–Maybe," *Savannah News-Press*, February 2, 1975.
16. Ibid.; *Fripp Island Treasure Chest*, newsletter by the Fripp Island Resort, January 1967, 9.
17. Rosengarten, *Tombee*, 687; Guion Griffis Johnson, *A Social History of the Sea Islands* (Chapel Hill: University of North Carolina Press, 1930), 106; Dabbs, *Sea Island Diary*, 90.
18. Rowland et al., *Beaufort County*, 183; Virginia Wood, *Live Oaking* (Boston: Northeastern University Press, 1981), 73.
19. Dabbs, *Sea Island Diary*, 87–88; Rosengarten, *Tombee*, Appendices, Fripp Family Chart.
20. Rosengarten, *Tombee*, 127–131.
21. Ibid., 337.
22. Ibid., 370.
23. Ibid., 480.
24. Willie Lee Rose, *Rehearsal For Reconstruction: The Port Royal Experiment* (New York: Oxford University Press, 1964), 105.
25. Gerhard Spieler, "Fripp Island: A Brief History," *Beaufort Gazette*, December 10, 1979.
26. Johnson, *A Social History of the Sea Islands*, 191–95.

Chapter 2

27. Deed Book 24, September 21, 1903, 624, Beaufort County Courthouse, SC; Kenneth T. Jackson, ed., *The Encyclopedia of New York City* (New Haven: Yale University Press, 1995), 709; *New York Times*, June 25, 1919.
28. *Beaufort Gazette*, December 10, 1903; *Beaufort Gazette*, December 31, 1903.
29. Deed Book 48, March 28, 1933, 264–5, Beaufort County Courthouse, SC.
30. *Beaufort Gazette*, February 18, 1996.
31. Ibid.
32. Ibid.
33. Deed Book 48, 264–5.
34. Interview with Julian Levin, February 23, 2003; Interview with Pierre McGowan, April 26, 2006.
35. Pierre McGowan, *The Gullah Mailman* (Raleigh, NC: Pentland Press, 2000), xiv–xvi.
36. Ibid., 18–20.
37. J.E. McTeer, *Adventures In the Woods and Waters of the Lowcountry* (Beaufort, SC: Beaufort Book Company, 1972), 24–27.
38. Ibid., 84–9.
39. Interview with Ned Brown, June 27, 2002.
40. Deed Book 53, March 16, 1937, Beaufort County Courthouse, 120.
41. Interview with Pierre McGowan, Beaufort, July 6, 2003.
42. Eleanor C. Bishop, *Prints In the Sand: The U.S. Coast Guard Beach Patrol During World War II* (Missoula, MT: Pictorial Histories Publishing Co., 1989), ix–x, 11–12.
43. Brown interview; Interview with Jack Woods, July 17, 2002.
44. Woods interview; Bishop, *Prints in the Sand*, 10, 16, 22.
45. Bishop, *Prints in the Sand*, 16; *Hoof Prints*, United States Coast Guard Mounted Bach Patrol, Sixth Naval District, July 1, 1943 (South Carolina Room of Beaufort County Library).

46. Woods interview; *Hoof Prints*.
47. Woods interview; Bishop, *Prints in the Sand*, 73–5.
48. McGowan, *The Gullah Mailman*, 87.
49. *Beaufort Gazette*, May 21, 2002.
50. Ibid.
51. Nancy Ricker Rhett, *Beaufort and the Lowcountry* (Beaufort, SC: Rhett Gallery Publishing, 2003), 58–60.
52. Telephone interview with Robert Graves, April 28, 2006.
53. Deed Book 79, September 9, 1954, 115, Beaufort County Courthouse.
54. Deed Book 86, September 3, 1957, 362–3, Beaufort County Courthouse.
55. *Beaufort Gazette*, May 21, 2002.

Chapter 3

56. Interview with Jack Kilgore, June 21, 2004; John W. Watson, "Fripp Island," *Sandlapper*, July 1968, 45–8; "Fripp Island," *Charleston News and Courier*, August 6, 1968.
57. "Kilgore Buys Island," *Charleston News and Courier*, December 31, 1967.
58. Ibid.; *State* (Columbia, SC), February 12, 1967; Interview with Betty McCrary, August 7, 2003.
59. *Washington Post*, February 6, 2005; Edgar, *A History of South Carolina*, 579–80; Michael N. Danielson, *Profits and Politics in Paradise* (Columbia: University of South Carolina Press, 1995), 22–5.
60. Danielson, *Profits and Politics*, 15–16.
61. Kilgore interview; Woods interview.
62. First Security Investment Corporations, *Minutes of the Board of Directors*, n.d.; Kilgore interview; Fripp Island Resort, Incorporated, *Prospectus*, February 5, 1962.
63. *Charleston News and Courier*, December 31, 1976; Fripp Island Resort, *Prospectus*.
64. Deed Book 79, September 9, 1954, 115, Beaufort County Courthouse; Deed Book 86, September 3, 1957, 362–3, Beaufort County Courthouse; Kilgore interview; *Beaufort Magazine*, Spring 1993, 20–23.
65. *Beaufort Gazette*, October 13, 1960; Interview with Dubose Edmonds, August 15, 2005.
66. *Beaufort Gazette*, September 29, 1960.
67. *Beaufort Gazette*, November 23, 1960.
68. Deed Book 103, 51, Beaufort County Courthouse.
69. Fripp Island Resort, *Prospectus*; Interview with Van Newman, June 16, 2005; *Beaufort Gazette*, March 30, 1961; Deed Book 109, March 27, 1961, 103½, Beaufort County Courthouse.
70. *Beaufort Gazette*, March 30, 1961.
71. Eloy Doolan, memorandum to author, March 6, 2004; *State*, February 12, 1967.
72. Interview with Jack Pittman, February 28, 2006; Norine Smoak, audiotape presentation to Fripp Island Women's Group, n.d.
73. *Beaufort Gazette*, November 4, 1965.
74. *Charleston News and Courier*, August 6, 1967; *Beaufort Magazine*, Spring 1993; Kilgore interview.
75. *Beaufort Gazette*, October 13, 1960; *Beaufort Gazette*, July 16, 1964.
76. *Beaufort Gazette*, December 8, 1960.
77. South Carolina Statutes at Large, Local and Temporary Laws, 1962, No. 1042.
78. Doolan memorandum; *Beaufort Gazette*, August 24, 1965.
79. "Declaration of Restrictive Covenants," September 13, 1961, Deed Book 108, 138, Beaufort County Courthouse; Fripp Island Resort, "Fripp Island Basic Data," n.d.

80. Ibid.
81. *Charleston News and Courier*, August 6, 1967; Kilgore interview.
82. Roy Krell to Fripp Island sportsmen, n.d.
83. Ibid.; Pittman interview.
84. Newman interview.
85. Interview with Archie and Liz Taylor, January 1, 2003.
86. Interviews with Bill Winter, July 14, 2002, July 16, 2002, October 15, 2004, and February 6, 2006.
87. Dixie Winter, video presentation to the Fripp Island Ladies Club, n.d.
88. Fripp Island Resort, *Prospectus*; Winter interview; Taylor interview.
89. *Beaufort Gazette*, June 11, 1964; *Beaufort Gazette*, August 6, 1964; *Beaufort Gazette*, September 17, 1964; *Beaufort Gazette*, September 24, 1964.
90. *Beaufort Gazette*, January 16, 1964; *Beaufort Gazette*, June 18, 1964.
91. Roy Krell, memorandum, n.d.; Interview with Grace Fox, November 13, 2003; Woods interview.
92. *Beaufort Gazette*, August 20, 1964; *Beaufort Gazette*, February 4, 1965.
93. Kilgore interview; Fripp Island Resort, early promotional brochures, n.d.
94. *Sandlapper*, July 1968, 45–48.
95. Newman interview.
96. Ibid.; Kilgore interview; Interview with Shirley Sutton, February 13, 2006.
97. *Sandlapper*, July 1968, 45–48.
98. *Charleston News and Courier*, August 6, 1967; *Charleston News and Courier*, December 31, 1967.

Chapter 4

99. George Douglass to Fripp Island Home Owners, November 28, 1969.
100. *State*, February 12, 1967.
101. *Beaufort Lowcountry Magazine*, January–February 1999, 11–12.
102. Ibid.
103. *State*, February 12, 1967.
104. Interview with Shirley Sutton, February 6, 2006.
105. *Fripp Island Treasure Chest*, January 1967, 8.
106. Winter interview.
107. Smoak audiotape.
108. Winter interview.
109. Interviews with Gini and Griff Reese, July 21, 2002, and August 4, 2004.
110. *Fripp Island Treasure Chest*, April 1967, 8; Interview with Bill and Barbara Robinson, October 22, 2003.
111. Robinson interview.
112. *State*, June 1, 1967; Winter interview; Interview with David Reese, January 2, 2004.
113. Winter video.
114. Fripp Island Home Owner's Association, Minutes, May 2, 1971; Winter interview; Interviews with George Douglass, May 6, 2001, June 18, 2001, and July 3, 2001.
115. *Trawler*, March 1980; Fripp Island Home Owner's Association, Minutes, April 25, 1970, and May 29, 1972; Interview with Barbara Turbeville, May 25, 2004.
116. Winter video; Smoak audiotape.
117. Douglass interview.

118. "Log: Old House Creek Marina," 8–20; Douglass interview; Winter interview; David Reese interview.
119. "Log," 115.
120. Ibid., 48, 103–6.
121. Ibid.; Douglass interview; Jack Kilgore to George Douglass, April 19, 1971; David Reese interview.
122. *Beaufort Gazette*, March 14, 1968; William Ross, general manager of La Tai Inn, to Fripp Islanders, February 26, 1968.
123. Gini and Griff Reese interview.
124. Interview with George and Helen Fant, September 19, 2003.
125. *Trawler*, January 1978, 4.
126. Interview with Emmy Sullivan, May 6, 2006; *Beaufort Gazette*, February 15, 1968; *Beaufort Gazette*, May 23, 1968.
127. *Beaufort Gazette*, February 22, 1968; *Fripp Island Outrigger*, March 1970, 4.
128. *Beaufort Gazette*, May 22, 1969; *Beaufort Gazette*, June 5, 1969; *Beaufort Gazette*, May 25, 1972.
129. Septima Bowers to Fripp Islanders, February 21, 1969.
130. *Fripp Island*, Summer 1968, 3, 7.
131. Fox interview.
132. Interview with Jack Pittman, February 28, 2006.
133. Fripp Island Country Club Board of Directors, Minutes, December 19, 1969; W. Brantley Harvey Sr. memorandum to Fripp Island Country Club certificate holders, December 18, 1970.
134. *Our Jack Frost Special Package To You*, La Tai Inn flier, circa January 1969; Harvey memo.
135. Ibid.
136. C.D. Warnick to George M. Douglass, March 1, 1971; J.R. Bergevin to Resort Lodging, Inc., board members, February 23, 1971; J.R. Bergevin memorandum to board members of Resort Lodging, Inc., March 16, 1971.
137. Golf Club Committee Report to the Fripp Island Home Owners Association, March 15, 1971.
138. Jack Kilgore to Fripp Islanders, December 22, 1971.
139. George Douglass to Fripp Island Home Owners Association, November 28, 1969; Douglass interview.
140. George Douglass to Jack Kilgore, March 9, 1970; Jack Kilgore to George Douglass, May 28, 1970; Edwin L. Gidley to Jack Kilgore, June 8, 1970.
141. Report of Committee on Assessment Account of Fripp Island Home Owners Association, May 2, 1971.
142. PSD to Fripp Island taxpayers, November 15, 1971; Fripp Island Home Owners Association to G.G. Dowling, February 18, 1972.
143. George Douglass to W.L. Bethea Jr., December 21, 1971.
144. Fripp Island Home Owners Association to G.G. Dowling, February 18, 1972.
145. *South Carolina State Board of Health, Petitioner, v. Fripp Island Resort, Inc. and Fripp Plantation, Inc.*, Civil and Criminal Court of Beaufort County, March 1, 1972; *Beaufort Gazette*, March 9, 1972.
146. Fripp Island Home Owners Association, Minutes, April 29, 1972; Gini and Griff Reese interview.
147. *Beaufort Gazette*, July 20, 1972; *Beaufort Gazette*, August 10, 1972.
148. Douglass interview; Gini and Griff Reese interview.

149. Kilgore interview.
150. Memorandum to members of the Fripp Island Home Owners Association, August 5, 1972.
151. Fripp Island Home Owners Association and the Fripp Island Women's Group, *Fripp Island Settler's Guide*, May 1976.

Chapter 5

152. George Douglass to members of Home Owners Association with attachments, November 28, 1969; *Fripp Island Settler's Guide*, May 1976; Fripp Island Home Owners Association and Fripp Island Women's Group, *Fripp Island Residents: Address and Telephone Directory*, 1980.
153. Interview with Chuck Spencer, April 7, 2005.
154. Interview with Preston Nesbit, May 29, 2004; Danielson, *Profits and Politics in Paradise*, 47.
155. Interview with John Hardin and Bill Merritt, October 24, 2003.
156. Interview with Bill and Catherine Merritt, June 15, 2004.
157. Harden and Merritt interview.
158. Unsigned memorandum to stockholders of Fripp Island Resort, Inc., June 30, 1972.
159. *Beaufort Gazette*, November 16, 1972; Memorandum to members of Fripp Island Home Owners Association, Inc., August 5, 1972.
160. Interview with Archie and Liz Taylor, January 1, 2003; Douglass interview; Reese interview.
161. Hardin and Merritt interview.
162. *Beaufort Gazette*, November 16, 1972; Merritt interview.
163. Fripp Island Home Owners Association to its members, February 10, 1973.
164. Fripp Island Development Corporation, *Fripp Island: Another World, Not Another Resort*, n.d.
165. Fripp Island Home Owners Association memorandum, March 4, 1970; Fripp Island Home Owners Association, Report, December 5, 1970.
166. *Fripp Island Privateer*, October 1974.
167. Fripp Island Home Owners Association memorandum, March 4, 1970; FIHOA, Report, December 5, 1970.
168. PSD memorandum to all Fripp Island taxpayers, November 1971; PSD letter to all Fripp Island taxpayers, November 15, 1971; *Fripp Island Privateer*, May 1975.
169. *Beaufort Gazette*, March 23, 1972.
170. W.D. Huyler memorandum to Fripp Island Home Owners Association, May 20, 1972.
171. Fripp Island Public Services Department (PSD) Report, July 1, 1974, to December 31, 1975.
172. Ibid.
173. *Trawler*, September 1979.
174. *Privateer*, October 1974; *Privateer*, May 1975.
175. *Privateer*, April 1975.
176. *Privateer*, October 1974; Hardin and Merritt interview.
177. Ibid.; *Privateer*, Fall 1977; Telephone interview with Pete Sanders, May 10, 2006.
178. *Privateer*, July 1975.
179. *Privateer*, Fall 1977.
180. *Privateer*, Winter 1977; *Privateer*, Spring 1978.
181. Sheldon Storer, president of Topsider Homes, e-mail communication with author, November 25, 2003.
182. Ibid.

183. *Privateer*, October 1974.
184. *Privateer*, September 1976; *Privateer*, Holiday Issue, 1978.
185. *Privateer*, May 1976, 5; *Privateer*, December 1976, 6; Fripp Island Development Corporation, *Fripp Island Presents "Back to the Cottage Concept,"* n.d.
186. Fripp Island Home Owners Association reports, November 8, 1973, and February 1975; Bill and Catherine Merritt interview.
187. *Privateer*, February 1975.
188. *Washington Post*, June 16, 1974; *The New Yorker*, circa mid-1970s.
189. *Privateer*, May 1975, 1, 6; Barbara Farmer, membership administrator of the Fripp Island Beach Club, to all property owners, November 30, 1976.
190. Fripp Island Home Owners Association, Minutes, December 7, 1975.
191. Reese interview; Winter interview.
192. Fripp Island Development Corporation, "1974 Single Family Covenants," January 29, 1974; Report of Special Committee on Covenants of Fripp Island Home Owners Association, May 2, 1976.
193. *Privateer*, December 1975; Fripp Island Home Owners Association, Minutes, November 21, 1976.
194. Edwin Merwin Jr., e-mail to author, July 11, 2005; *Trawler*, January 1978.
195. Minutes of annual Fripp Island Home Owners Association meetings, April 29, 1973, and April 28, 1974; Reese interview.
196. *Beaufort Gazette*, March 30, 1972.
197. *Trawler*, November 1978; *Trawler*, September 1979.
198. Fripp Island Home Owners Association, Minutes, May 2, 1971 and May 2, 1976; conservation with Gina Schaufelberger, November 12, 2005.
199. *Trawler*, April 1978.
200. *Privateer*, December 1975.
201. Gini and Griff Reese interview; Interview with Lou Cashdollar, October 11, 2004.
202. *Trawler*, July 1998; Jean Pearne and others, eds., *A History of the Fripp Island Community Centre, Inc.* (Fripp Island, SC: Fripp Island Community Centre, 1981).
203. *Trawler*, November 1978.
204. Gini and Griff Reese interview.
205. *Trawler*, July 1998; Cashdollar interview.
206. Hardin and Merritt interview.
207. *Trawler*, September 1979.

Chapter 6

208. *Trawler*, March 1980; *A History of the Community Center*.
209. Ibid.; *Trawler*, July 1998; *Trawler*, September 1998.
210. *Trawler*, July 1998, 5.
211. *Trawler*, September 1998, 1, 5; Interview with Al Schaufelberger, February 12, 2005; Interview with Dick Anderson, October 28, 2004; *A History of Fripp Island Community Centre*.
212. Harry Frampton to Fripp Island Property Owners, February 19, 1980.
213. "Harry Frampton III—Managing Partner of East West Partnership in Beaver Creek, Colorado," *Florence Morning News*, October 8, 2004.

214. Telephone interview with Harry Frampton, April 22, 2005.
215. Deed Book 300, May 2, 1980, 814–821, Beaufort County Courthouse; Winter interview; Hardin and Merritt interview.
216. Winter interview; *Trawler*, September 1998, 5; Leonard Wood to Fripp Island Property Owners, n.d.
217. Telephone conversation with Gary Meyer, May 1, 2006; Telephone conversation with Jidge Mearns, May 16, 2006.
218. *Trawler*, June 1980; *Trawler*, September 1980.
219. *Trawler*, January 1981.
220. Fripp Island Property Owners Association (FIPOA), "Newsletter," August 5, 1981.
221. Frampton interview; W.H. Miltenburg to members of the Fripp Island Property Owners Association, October 15, 1981; *Beaufort Gazette*, October 21, 1981.
222. FIPOA, "Newsletter," December 29, 1981.
223. *Trawler*, November 1981, 1.
224. FIPOA, "Newsletter," September 18, 1981.
225. *Savannah Morning News*, May 18, 1982.
226. *Trawler*, April 1982; *Trawler*, June 1983; *Beaufort Gazette*, February 5, 1985.
227. *Beaufort Gazette*, May 18, 1982; Deed Book 350, 678–695, June 30, 1982, Beaufort County Courthouse; *Beaufort Gazette*, June 1982.
228. *Beaufort Gazette*, June 1982.
229. FIPOA Board of Directors to property owners, December 1, 1982.
230. William H. Miltenburg to FIPOA members, April 16, 1984.
231. *Trawler*, July 1984.
232. Winter interview.
233. *Trawler*, November 1978.
234. *Trawler*, January 1984; *Trawler*, November 1984; Telephone conversation with Paul Field, May 14, 2006.
235. Fripp Island Women's Group, "President's report," 1985–86.
236. Beverly Snow, "A Project to Save An Island From Devastation by the Sea," unpublished manuscript, n.d.
237. *Trawler*, December 1986; Robinson interview; Interview with Augie Gorse, March 7, 2006.
238. *Trawler*, September 1985.
239. *Trawler*, December 1985.
240. *Trawler*, September 1987; *Trawler*, July 1989; Robinson interview; Fripp Island Women's Group, Minutes, May 20, 1987.
241. *Trawler*, July 1989.
242. *Trawler*, December 1986.
243. Beverly Snow, "Presentation to FIPOA Board," July 23, 1992.
244. Ibid.
245. "Agreement between Thomasson Properties and the Fripp Island Property Owners' Association," December 14, 1988, Beaufort County Courthouse.
246. *Trawler*, September 1988; *Trawler*, March 1989.
247. *Trawler*, June 1989; Interview with Augie Gorse, July 12, 2005.
248. 1989–1990 records of the Fripp Island Ladies Club.

Chapter 7

249. *Trawler*, December 1989; Robinson interview; *Trawler*, March 1993.
250. Interview with David Hornsby, October 3, 2005.
251. Ibid.; *Trawler*, March 1990.
252. Gorse interview; Robinson interview.
253. Ibid.
254. Gorse interview.
255. Ibid.
256. *Beaufort Gazette*, March 22,1990; Affidavit of Consideration between Thomasson Brothers and The Fripp Company, March 20, 1990, Beaufort County Courthouse.
257. *The Fripp Island Tides*, Fall 1990, 1.
258. Interview with Miriam and Preston Nesbit, May 29, 2004; Robinson interview; Ginni Kozak, *Lights, Camera...Beaufort: Hollywood Comes to the Lowcountry* (Beaufort: Portsmouth House Press, Third Edition, 2004), 10.
259. *Trawler*, December 1993.
260. Robinson interview; Mary Morgan, locations manager for Paramount Pictures, to Fripp Island residents, September 18, 1993.
261. *Trawler*, December 1993; Interview with Ralph and Pat Goodison, January 20, 2006; Winter interview.
262. Douglass interview; Kozek, *Lights, Camera*, 19; Conversation with Sandra Thacker, February 1, 2006.
263. Hornsby interview; Interview with June Everett, February 1, 2006; *Trawler*, December 1993.
264. *Trawler*, June 1990; *Trawler*, December 1990.
265. Interview with Bill Wardle, May 16, 2006; *Trawler*, September 2003; *Trawler*, May 1998; Cashdollar interview.
266. Hornsby interview; *Trawler*, December 1990; *Trawler*, March 1992.
267. *The Fripp Island Tides*, Fall 1990; *Trawler*, March 1991; *Trawler*, June 1992.
268. Environmental Services, Inc., "Ocean Creek Plantation: Narrative for 404 Application," January 17, 1994.
269. *Trawler*, June 1994; *Trawler*, December 1995; "An Ocean Creek Love Story," *The Fripp Island Tides*, n.d., 2.
270. Hornsby interview; *Beach Bound*, Summer–Fall 1997.
271. Hornsby interview.
272. Minutes of FIPOA Board, January 11, 1994.
273. *Trawler*, March 1993.
274. Ibid.
275. FIPOA Minutes, January 11, 1994; *Trawler*, March 1994; FIPOA and The Fripp Company 1994 Agreement, April 22, 1994, Beaufort County Courthouse.
276. *Trawler*, March 1993.
277. Ibid.; *Trawler*, June 1995; The Fripp Company, Cabana Club promotional fliers, n.d.; Telephone interview with Jim McElwain, May 23, 2006; Telephone conversation with Maude Hornsby, May 23, 2006.
278. *Beaufort Gazette*, April 28, 1989; *Beaufort Gazette*, May 17, 1989; *Trawler*, December 1989.
279. Interview with Jon and Mary Tabor, December 3, 2005; Robinson interview.

280. Ibid.
281. Ibid.
282. *Berry-Leithouser, et al. Plaintiffs v. South Carolina Coastal Council*, 92-CP-07-105, March 20, 1992. One of the ten houses involved in this case was owned by Robert Berry and Connie Leithouser.
283. Tabor interview; Robinson interview.
284. Ibid.
285. Winter interview.
286. Everett interview; Robinson interview; *Trawler*, March 1991.
287. *Trawler*, June 1991; *Trawler*, June 1993; *Trawler*, January 1999.
288. *Trawler*, September 1991; *Trawler*, September 1996.
289. *Trawler*, September 1997; *Trawler*, March 2003.
290. *Trawler*, November 1998.
291. Goodison interview.
292. *Beaufort Gazette*, March 14, 1997; Interview with Peg Gorham, February 16, 2006.
293. Hornsby interview; Fripp Island Resort, "Resort Review," November 1999.
294. "New wealth brings surge in two-home families," *USA Today*, February 11, 2000.
295. *Fripp Island Directory*, January 1992; *Fripp Island Phone Directory*, December 2000; statistics on the number of dwellings provided by the FIPOA.
296. George Douglass to John Quigley, February 8, 1994; Wardle interview.

Epilogue

297. *Beaufort Gazette*, January 23, 2001; *Trawler*, March 2001; Interview with Danny Robinson, May 16, 2006.
298. *Beaufort Gazette*, October 19, 2002; *Beaufort Gazette*, November 8, 2002; *Beaufort Gazette*, January 18, 2003.
299. Fripp Island Real Estate, "About Us," http://www.discoverfripp.com/about.html.
300. *Beaufort Gazette*, October 19, 2003.
301. Wardle interview.

Index

A

Administration Building 56
advertising campaign 54, 55, 81, 93, 103, 122
agreement of 1988 124
alligators 150
All Faiths Chapel 71, 110, 111, 113, 114,
 115, 116, 124, 156, 169
Anderson, Dick 115
architectural review board 54, 106, 150
artists 158
assessments 82, 84, 96, 103, 105, 120, 124
Atkins, James 68
auction, property 130
Audubon Club 107, 125, 157
Audubon Trail 125

B

Bartoli, Guy 100
Battle of Port Royal 25
Bauer, Steve 163, 164, 166, 167
Beachfront Management Act 153, 154
beach club 93, 98, 111, 129, 142
Beach Club Villas 129
beach crossovers 52, 120, 126
Beaufort, South Carolina 15, 16, 17, 23, 25, 30
Beaufort Bridge 29, 33
Beaufort Chamber of Commerce 52
Beaufort Gazette 30, 31, 48, 49, 52, 92, 163, 166

Benett, Richard 16
Bergevin, J.R. 81
Berry, Ray 46, 47, 49, 59
Bethea, William 85
bicycle paths 96, 99, 113, 120, 124, 155
birds 101, 107
bird and game sanctuary 107
Blackbeard 20, 21, 22
Blue Heron Lake 100, 102, 156
bond referendum 126
book clubs 158
Bowen, Bill 91
Bowers, Septima 76
Brady, Burl 100
Brandermill Group 115, 116, 119, 129
Brazell, Bill 73
Brewer, Randy 130, 132
bridge pass 51
Briggs, Dick 169
Brown, Ned 38, 39
Brown, Ray 67
Broz, John 73
Bruun, Dr. Per 93, 95, 96

C

Cabana Club 150
Campbell, Elizabeth 48
Camp Fripp 159
Canadian guests 76

Index

Captain John Fripp Villas 25, 84, 91, 93, 100
Caribbean look 135, 148, 160
Cashdollar, Rita and Lou 111
cashless amenity program 164
cattle mark 16
Chambers, Henry 73, 84
chapel 113
Chaplin, Thomas B. 23, 25
Chapman, Jim 115, 150
Charles Town 20
Charles Towne 15, 16
Cheshire, Ed 144
choir 111, 114, 169
Civil War 22
Club Advisory Board 148, 150, 151
club dues 81, 105, 148, 150, 151, 167
Coast Guard 39, 125
　barracks 39, 41
　dog patrol 39, 41
Cobb, George 56
Coffin, Ebenezer 23
Columbia Pictures 138
Commodore's Ball 158
Community Centre 111, 114, 125, 137, 156, 170
　building fund 111
　expansion 156, 169
Conroy, Pat 138
cottage concept 102
cotton 15, 22, 23
covenants 53, 82, 84, 106, 120, 124
Cowan, John 16
Cowley, Paul 147

D

Danner, Blythe 138
Darling Old Girl Singers 133
Davis Love Park 168
deer 23, 30, 36, 37, 168
Deer Lake 119, 144
Deffenbaugh, Batte 109
Dempsey, Davis 142
density agreement 130, 132
Doolan, Eloy 50
Dorman, William 33, 36, 38
double-wide houses 106
Douglass, George 65, 71, 73, 82, 92, 142, 160

Dowling, G.G. 43, 48, 84, 85
dredging 52, 59
Duncan, Alderman 46, 47

E

Easter Sunday 114, 169
Eastin, Maury 73
Edisto Island 16
Edmonds, Dubose 48
Eidson, Ben 63
elephants 142
Emancipation Proclamation 25
emergency road and bridge fund 126
England 15, 17
Engler, Kay and Ken 66, 70, 107, 110
erosion 93, 95, 153
Everett, June 142

F

Fairway Club Villas 100
Fant, Helen 76
Federal Home Bank Board 91
ffrips Island 16
Fiddlers Cove 147
Fiddlers Point 119
Fiddlers Ridge 100
Fiddlers Trace 100, 102, 147
Field, Paul 125
Field, Sally 140
firehouse 70, 118, 121, 155
First Security Investment Corporation 47, 49
fishing 23, 25, 32, 37, 41, 43, 45, 55, 65, 71, 73, 129
flagpole 126
flood insurance 122
Ford, Nancy and Michael 138
Forrest Gump 140, 147
　Vietnam 140
Frampton, Harry 115, 116, 119
France 15, 17
Fraser, Charles 46, 51, 115
Fripp, Captain John 17, 23, 25, 55
Fripp, Edgar 33
Fripp, John 16, 17
Fripp, Sarah Harriet Reynolds Prentiss 17, 27, 30
Fripp, William 17, 23, 27, 30
Fripp's Inlet 17

182

Index

Fripp Company 142, 143, 144, 147, 148, 159, 160, 161, 163
 special meeting packages 144
Fripp Group, Inc. 167
Fripp Inlet 13, 51
Fripp Island Amenities Acquisition Committee 132
Fripp Island Art Association 79
Fripp Island Bridge 50, 51, 56, 57, 82, 92
 collapse 158
Fripp Island Club 105, 137, 148, 150, 152, 167
Fripp Island Company 116, 119, 138
Fripp Island Corporation 43, 44, 49
Fripp Island Country Club 56, 79, 80, 81, 92
Fripp Island demographics 63, 87, 88, 89, 107, 160, 170
Fripp Island Development Corporation 92, 93, 95, 96, 97, 98, 99, 100, 101, 102, 103, 105, 106, 107, 110, 111, 112, 115, 116, 119
Fripp Island Fire Department 70, 109, 118, 140
 fire chief 121
Fripp Island Friends of Music 125, 156
Fripp Island Garden Club 156
Fripp Island Home Owners Association 82, 84, 85, 92, 105, 107, 113, 116, 120
 church committee 110
 conservation and beautification committee 107
 transition committee 107
Fripp Island Inn 93
Fripp Island Land Acquisition Group 157
Fripp Island Property Owners Association 113, 120, 124, 126, 130, 132, 135, 143, 148, 150, 155, 166, 168
Fripp Island Public Service District 52, 68, 84, 85, 93, 95, 96, 109, 120, 121, 126, 155, 168
Fripp Island Resort 50, 54, 55, 56, 59, 60, 63, 67, 70, 71, 73, 76, 80, 81, 82, 87, 91, 92, 106, 163
Fripp Island Service Corporation 120
Fripp Island Women's Club 110, 129, 133, 157, 168
Fripp Island Yacht Club 73, 158
Fripp Plantation 81, 91

G

gas station 71, 98
German spies 39
Gidley, Ed 73
golf carts 121
golf clubhouse 57, 80, 97
golf courses
 Dataw Island 129
 Fripp Plantation 81
 Ocean Creek 144, 147, 150
 Ocean Point (formerly Fripp Island Golf Course) 56, 80, 81, 85, 91, 92, 93, 95, 97, 129, 136, 142
Goodison, Ralph 158
Gorham, Peg 159
Gorse, Augie 128, 137
grand piano 125, 156
Graves, Robert 43
Green, Judge 85
Green and Schumpert 43
Grinold, Bill 143
groins 95

H

Hammet, Jerry 169
Hanks, Tom 140, 142
Harbor Island 160
Harbor River Bridge 38
Hardin, John 89, 91, 92, 97, 112
Harvey, Brantley, Jr. 50
Harvey, Brantley, Sr. 43, 48, 81
Haskell, Adam and Natalie 33
Haught, Cameron 159
Hess, Bob and Barbara 98
Hidden Lake 150
High Dunes Lookout 100
Hilton Head Bridge 46
Hilton Head Island 13, 15, 46, 50, 51, 55, 87, 122, 169
Hines, Kate 156
hogs 43, 54
Horizon Club Membership 150, 151
Hornsby, David 133, 135, 137, 138, 142, 144, 147, 148, 151, 159, 160, 163, 169
Hornsby, Maude 148, 159
hotel, proposed 148, 151
Hotel Corporation of America 163
Humane Society of the United States 168

183

Index

hunting 15, 22, 23, 25, 30, 36, 37, 38
 preserve 30
Hunting Island 13, 55
Hunting Islands 17, 23, 25, 27
Hunting Island State Park 38, 39, 41
hurricanes
 David 96
 Dora 56
Huyler, Bill 82, 84, 95, 105

I

Internet's impact 166
IRS 166
Island Realty 166

J

jazz festival 79
Johnson, Charlie 67
Johnson Creek Bridge 38
Jones, Demos 63, 65
July Fourth Parade 118, 133
Jungle Book 142, 147

K

Keller, Gary 163
Kemmerlin, Judge Thomas 153, 154, 166
Kiawah Island 87
Kilgore, A.J. 45, 54, 63, 65, 70
Kilgore, Glen 65
Kilgore, Jack 44, 45, 46, 47, 48, 49, 50, 51, 52, 53, 54, 55, 56, 57, 60, 61, 63, 65, 67, 71, 73, 76, 81, 82, 84, 85, 87, 91, 106, 107, 109, 110
Kinghorn, Mills 31, 32
King Charles II 15, 17
Krell, Mary 63, 65
Krell, Roy 48, 49, 54, 55, 63, 67, 79
Krider, John 121

L

Lady's Island 16
Lambda Chi Alpha Fraternity 46, 59
Lawrence, Doug 82
Lawrence, Jack 91, 92
La Tai Inn 59, 70, 74, 76, 79, 80, 81, 87, 93
Lee, Jason Scott 142
legends 17, 20, 22
Levin, Julian 33

Litomisky, Charles 22
live oak trees 23
logo 55
 Polynesian outrigger canoe 60, 103
 Privateer Captain John Fripp 20
 ship 103, 104
Lords Proprietors 16
lots 48, 54, 55, 96, 100, 138, 168, 170
Love, Davis, III 147
Lowcountry 13, 16, 33
Lucas v. South Carolina Coastal Council 154
lumbering 23, 38, 43, 44

M

Magrath, George 112, 115
Marina Log 71, 73
Marina Village 160
McElwain, Jim 150
McGowan, Pierre 33, 36, 38, 41
McGowan, Sam 33, 36, 38
McLeod, Claude 43
McLeod, R.L. and Sons 38, 43
McLeod, William Hardee 41, 44
McLoughlin, Cornelia 30, 33
McLoughlin, James 30
McTeer, J.E. 36, 37, 38, 39, 41, 43, 48
Mearns, Jidge 118
Mehrtens, John 109
Meredith, Bill and Ruth 128
Merritt, Bill 92
Merritt, Bob Shafter 48
Merwin, Edwin 107, 112
Meyer, Gary and Marcia 118
Miller, John and Barbara 68, 73
Miltenburg, William 120, 124
Mitchell, Stuart 140, 159
Mobley's Mall 71, 98
mosquitoes 33, 36, 43, 48, 82
motorboats 30
Mulberry Place 147
Mundy, Frank 107
Mustin, Billie 76

N

Narrows, The 36, 37, 123
national economy 87, 112
Native Americans 15
New, Charlie 55

Newhaven condominiums 100, 101, 119, 125
Newman, Van 54, 59
Nisbet, Miriam 140
Nolte, Nick 138, 140
non-club members 166
nonresident owners 147, 168
North Hampton condominiums 129, 136

O

Old House 33, 36, 43
Old House Creek 71
Old House Creek Marina 71, 73, 98
Olsen, Harold 115
Olympic-sized pool 96, 98
Oppenheimer, Joe 129
Oram, Al 140
osprey nesting poles 125
Ott, Mitchell 45, 50
Owens, Chuck and Margaret 65, 66

P

Paramount Pictures 140, 142
parcourse 99
Patek, Jim and Patty 125
Patek, John and Doris 125
Peck, Nick and Jane 115
Pittman, Jack 54
Planned Unit Developments 132
plantation owners 22, 23, 25, 27
Pollitzer, Jack 41, 43
Polynesian theme 57, 59, 60, 74
Port Royal Island 16
Poucher, Dean 73
Prentiss, Jeffrey Otis 17
Prentiss Island 17
Prince of Tides 138
Prioleau, Eula 30
Prioleau, Juliana Mathilda 27
Pritchards Island 15, 32
Proof of the Pudding 163
Property Owners United 166
property taxes 52
property values 124, 151, 160, 167
Pulaski, Casimir 22
purchase of Fripp Island 30, 33, 38, 49
purchase of undeveloped land and amenities
 92, 122, 138, 163, 164
Purdon, Nancy 168

Q

Quail Cove 100, 102

R

raccoons 38
racquet club 96, 99, 100, 101, 129
Reese, Gini and Griff 67, 84, 85, 106, 109,
 110, 111, 156
rental program 159, 166
Rentz, Jim 59, 67, 84, 114
Resort Holding Company 49
Resort Lodging Incorporated 59, 76, 91
Revolutionary War 22
Reynolds, William 17
Reynolds Island 17
Rhett, Nancy Ricker 43
Rhodes, Judge 85
Ribaut, Jean 15
River Club 144
roads 52, 54, 82, 101, 120, 121
 paving south Tarpon Boulevard 126
Robinson, Bill and Barbara 67, 140, 153
Robinson, Danny 144, 163
rock revetments 96, 126, 153
Rodgers, E.B. 36
ROMEOs 157
Rose, Willie Lee 25
Rosengarten, Theodore 23
Rosier, Pierre 74

S

Sams, Reeve 50
Sanders, Pete 98, 147
sand dunes 55, 95
Santa Elena 15
savings and loan coalition 88, 89, 92
Sawgrass Bluff 35, 100, 101, 136
Sawyer, Dan 73
Schaufelberger, Al and Gina 107, 109
Seaside, Florida 147
Sea Island Rescue Squad 109
Sea Pines Plantation 46, 91
Sea Rescue 125
Sea Turtle Conservation Center 109
sea wall 93
second home market 147, 150, 160
security guards 57, 82, 84, 85, 92, 119, 120, 124

185

Index

Self, Jim 91
Service Corporation of South Carolina 91, 92
Settler's Guide 110
settlers 63
sewer system 85, 96, 98, 101, 120, 155, 168
Seymore, John 68, 109
Shaw, Bill 137, 138
Sherman, Walter J. 102
Skull Inlet 15, 17, 25, 31, 39, 41, 43
Skull Inlet house 31
slaves 23, 25
Smith, Bill 92
Smith, Manning 153
Smith, Mary 167
Smith, Stan 103, 105, 107, 112
Smoak, Dick and Norine 50, 66, 82, 103, 109, 133
Snow, Beverly 126, 130
Sobol, Betty 157
South Carolina Beachfront Management Act 154
South Carolina Coastal Council 153
South Carolina Savings and Loans League 91
South Carolina State Board of Health 85
South Carolina State Sinking Fund 95
South Pointe Plantation 130
soybean patch 142
Spain 15, 17
Spencer, Charlie 59, 89
Spencer, Chuck 89
Spring Tide Market 167
Spring Tide Village 166
St. Helena Island 13, 15, 16, 17, 22, 23, 25, 27, 33, 53, 81
stables 76
Stanley, Byron 142
Station Creek 31, 37
stills 43
store 71, 92, 98, 105, 147, 167
Streisand, Barbara 138, 140
Sullivan, Emmy 76
Sutton, Bob and Shirley 59, 63, 65, 71, 73

T

Tabor, Jon and Mary 152, 153
Taylor, Archie and Liz 55
tennis 99, 129, 142
Tennis Villas 100, 101
terrorist attacks of 9/11 163
Thigpen, John 120
Thomas, Mary Delle 125, 157
Thomas, Zack 67
Thomasson, Broadus 122, 126, 129, 130, 132, 133, 134, 135, 137, 138, 147
Tidalholm 33
Tidewater 17
toll bridge 51
Tombee 37
Towe, Joe 129
Trask, Harold 43
Trask, John 43, 46, 47
Trawler 107, 112, 129, 150, 163
treehouses 100
Trellue, Butch 99
TT Bones 167
Turbeville, Barbara and Bill 59, 70, 79
turtles 32, 37, 76, 109
turtle patrol 109, 129, 157

U

U.S. Tax Commission 25, 27
undeveloped land, two parcels 130, 160, 161
Union military forces 25

V

Vacation Rentals by Owner 166
Veranda Beach 147, 150
vespers services 70, 110, 111, 125, 169
Village of Sandown 100
volunteer firefighters 70, 109, 121

W

Waddell, J.M., Jr. 50
Wallace, John N. 30
Wallingford Steel 143
Walsh, Knobby 129, 132, 137, 148
Walt Disney Studio 142
Wardle family 160, 161, 167
 Bill 167
 Bob 137, 143, 144, 160
 Bob (son) 167
 Doug 167
 Rene 143, 167
Warnick, C.D. 81
water supply 53, 96
Watson, John 158

Webb, Del 46
wells 52, 97
Westerberry, Marion 55
Wild Dunes 87
Willis, Jeanie 159
Willis, Ken 135, 136, 137, 138, 142, 144, 147, 148, 151, 159, 160, 163, 169
Wilson, Roger 96
Winter, Bill and Dixie 55, 67, 68, 71, 84, 106, 107, 116, 126, 156
Wolfinger, Chief 121
Wood, Leonard 116
Woods, Jack 39, 47
Works Progress Administration 38
World War II 39
Wright, Robin 140

Y

Yaw, Elrose and Ron 67, 111, 113
yoga group 125, 156

Z

Zemeckis, Robert 140
Zoller, John 115

About the Author

Page Putnam Miller grew up in Columbia, South Carolina, and vacationed as a young girl at Ocean Drive, Myrtle Beach and Pawley's Island. She graduated in 1959 from Dreher High School, from Mary Baldwin College in 1963, studied in 1964 at Yale Divinity School and received a PhD in American history from the University of Maryland in 1979.

For twenty years she headed the National Coordinating Committee for the Promotion of History, the national advocacy office in Washington for the historical and archival professions. She has written extensively on legislative issues and testified frequently before congressional committees on federal information policy, preservation and interpretation of culture resources and support of the National Archives and the National Endowment for the Humanities. Through her online publication, "NCC Washington Update," she kept historians and archivists informed of developments in federal policy. For her advocacy work, Miller received awards of distinction from the American Historical Association, Organization of American Historians, Society of American Archivists and National Council on Public History.

In 2000 Miller moved with her husband, Charlie Davis, to Fripp Island where, in addition to swimming in the ocean and taking beach walks, she helped start a book club and a women's tennis group and began playing duplicate bridge. Miller is also active in the Beaufort community, serving as an elder in First Presbyterian Church. From 2000 to 2005 she was a Visiting Distinguished Lecturer in the Public History Program at the University of South Carolina in Columbia.

Among other publications, Miller is the author of *A Claim To New Roles* and *Landmarks of American Women's History*.

Page Putnam Miller. *Courtesy of Julie Hodgson.*

Please visit us at
www.historypress.net